VANISHING ICE

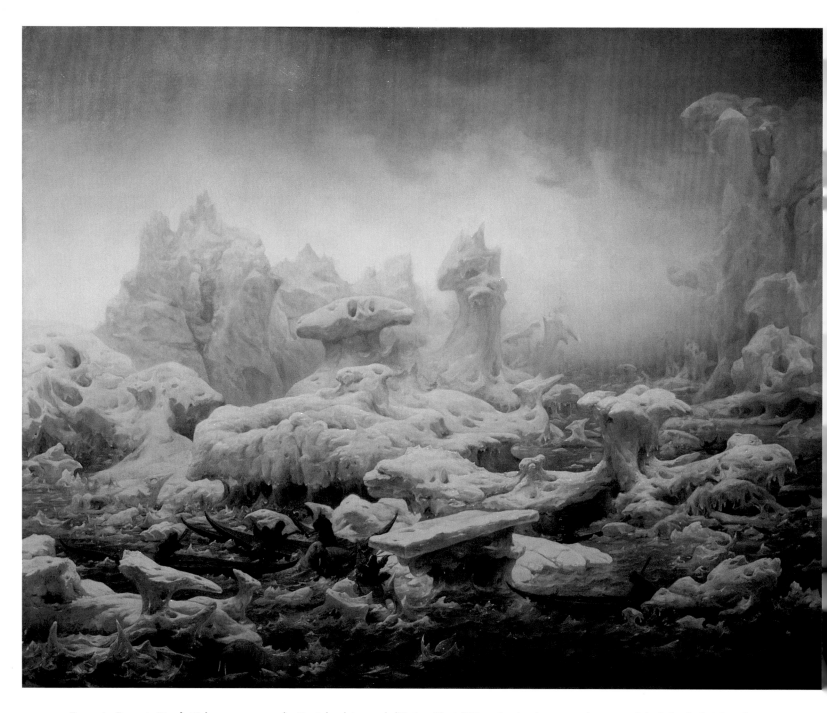

Francois-Auguste Biard, *Pêche au morse par des Groënlandais, vue de l'Océan Glacial (Greenlanders hunting walrus, view of the Polar Sea),* Salon of 1841.

VANISHING ICE

ALPINE AND POLAR LANDSCAPES IN ART, 1775-2012

BARBARA C. MATILSKY

WHATCOM MUSEUM, BELLINGHAM, WASHINGTON

This publication accompanies the touring exhibition, *Vanishing Ice: Alpine and Polar Landscapes in Art, 1775-2012*, organized by Barbara C. Matilsky, for the Whatcom Museum.

Major funding for the exhibition and catalogue has been provided by The Paul G. Allen Family Foundation and the National Endowment for the Arts, with additional support from The Norcliffe Foundation, the City of Bellingham, and the Washington State Arts Commission.

Additional funding for the catalogue has been provided by Furthermore: a program of the J.M. Kaplan Fund.

ART WORKS.
arts.gov

Furthermore:
a program of the J.M. Kaplan Fund

Whatcom Museum
Bellingham, Washington
November 2, 2013–March 2, 2014

El Paso Museum of Art
El Paso, Texas
June 1–August 24, 2014

McMichael Canadian Art Collection
Kleinberg, Ontario
October 11, 2014 –January 11, 2015

WHATCOM MUSEUM

Published in the United States by
The Whatcom Museum
121 Prospect Street
Bellingham, WA 98225
www.whatcommuseum.org

ISBN 978-0-295-99342-3

Library of Congress Control Number: 2013939890

First edition, 2013

Designed by Phil Kovacevich
Edited by John Pierce

Printed in Canada by Friesen's Book Division

Distributed by the University of Washington Press
P.O. Box 50096, Seattle, WA 98145
www.washington.edu/uwpress

The paper used in this publication has been certified by the Forest Stewardship Council.

MIX
Paper from
responsible sources
FSC® C016245

ENVIRONMENTAL BENEFITS STATEMENT
Whatcom Museum saved the following resources by printing the pages of this book on chlorine free paper made with 60% post-consumer waste.

TREES	WATER	ENERGY	SOLID WASTE	GREENHOUSE GASES
15	7,107	7	476	1,310
FULLY GROWN	GALLONS	MILLION BTUs	POUNDS	POUNDS

Environmental impact estimates were made using the Environmental Paper Network Paper Calculator 3.0. For more information visit www.papercalculator.org

Front cover: Jean de Pomereu, *Fissure 2 (Antarctica) from Sans Nom*, 2008, archival inkjet print.

Back cover: Lawren Harris, *Isolation Peak*, Rocky Mountains, 1930, oil on canvas.

CONTENTS

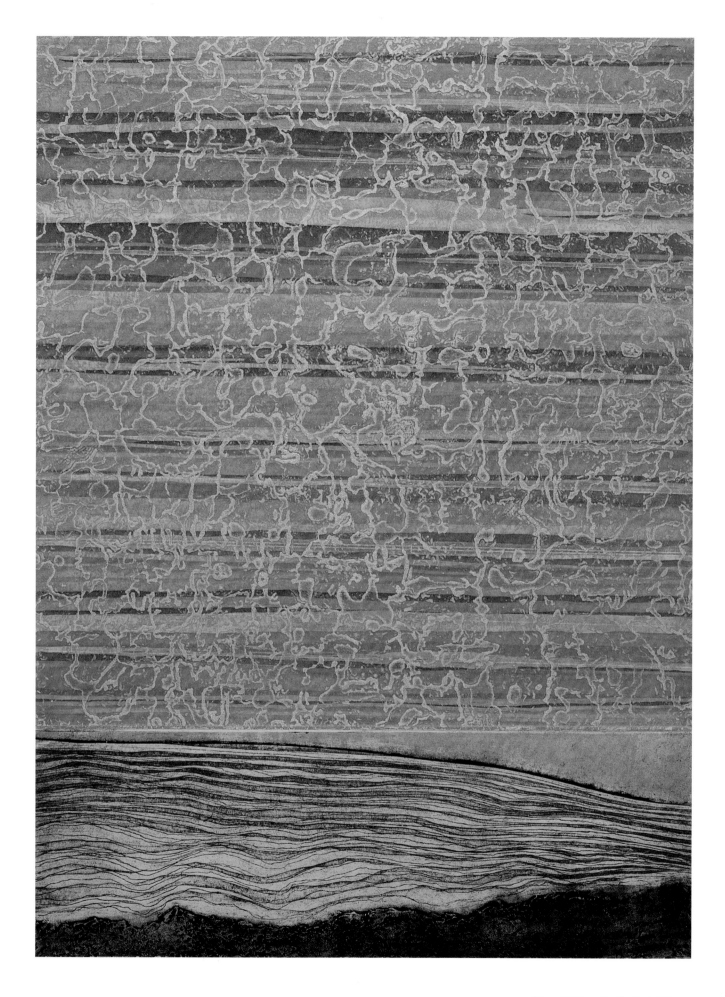

Anna McKee, *Depth Strata V*, 2011

FOREWORD

PATRICIA LEACH
EXECUTIVE DIRECTOR

AT THE HEART OF THE Whatcom Museum's mission lies the desire to fuel meaningful public conversations about art, nature, and history. What a thrill it is, then, to present *Vanishing Ice: Alpine and Polar Landscapes in Art 1775–2012*, an exhibition that brings all three of these elements together in an original way, on a topic that couldn't be more relevant: the effect of global warming on our world's frozen frontiers. By exploring this phenomenon through the lens of art, history, and science, we aim to expand people's understanding of the implications of a changing planet, and the role of the arts in increasing our awareness of alpine and polar landscapes.

Climate change is rarely out of the news nowadays, and almost everyone seems to have an opinion about it. However controversial this topic has been over the last several decades, few today disagree that carbon emissions have shown a causal relationship to climate change, evidenced by flooding rivers, record heat and changes in ocean levels and polar icecaps — all of these culminating in weather and other effects that disturb the world biologically, culturally, economically, and geographically.

The Whatcom Museum has selected the specific topic of icy landscapes as a focus of study and analysis by artists, historic and contemporary. *Vanishing Ice* traces the impact of these landscapes on the imaginations of artists over two hundred years, revealing the transnational movement that informs the environmental challenges we face today. Through the art on display, we can see how glacial and polar sites change over time.

The exhibition begins with early scientific/naturalist voyages launched during the eighteenth century that resulted in romantic artistic interpretations about the natural wonders of the world, and it culminates with contemporary works, many scientific, that highlight the vulnerability and fragility of polar environments, often using comparative images of the areas depicted earlier. Consisting of seventy-five works of art, the exhibition features artists from Australia, Canada, Finland, France, Germany, Great Britain, New Zealand, Norway, Peru, Russia, Switzerland, and the United States.

Vanishing Ice: Alpine and Polar Landscapes in Art 1775–2012 is the fourth exhibition organized and curated by Dr. Barbara Matilsky, curator of art at the Whatcom Museum. The exhibition is

the culmination of research she has conducted over seven years, a period that actually exceeds her tenure at the museum. My profound thanks go to Barbara for her amazing diligence, expertise, and patience in creating *Vanishing Ice*, a nearly four-year project for the Whatcom Museum. It is a treasure to find a curator so enthusiastic, passionate, and committed.

The details of mounting an exhibition of this magnitude are staggering, and the staff of the Whatcom Museum carried out the duties with professionalism and commitment. We are grateful for the ongoing support of the City of Bellingham and Mayor Kelli Linville. It is especially important to acknowledge the enormous generosity and support of The Paul G. Allen Family Foundation, the National Endowment for the Arts, and The Norcliffe Foundation, whose support made this exhibition a reality.

PROLOGUE

THIRTY YEARS AGO, I wrote my doctoral dissertation on the landscapes of French artist-naturalist-explorers who were among the first to depict glaciers, frozen sea ice, and the magical light of the aurora borealis. I presented their work within the context of the flourishing new field of natural history and the public's growing fascination with planet Earth. At the time, these artists were little known, although part of an international movement of more recognized artists, including Joseph Mallard William Turner (British, 1775–1851), Caspar David Friedrich (German, 1774–1840), and Frederic Edwin Church (American, 1826–1900), who introduced audiences to the enchanting world of ice. I could never have imagined that these artists would later provide insight into the scientifically significant alpine and polar regions currently threatened by a changing climate.

The idea for *Vanishing Ice* emerged about 2005 as I became aware of the increasing number of contemporary artists journeying to snowcapped mountains, the Arctic, and Antarctica. I began thinking about the similarities and differences among generations of artists who were drawn to icy climes. While examining these parallels, a cultural perspective crystallized that I believed could spotlight climate change in a new way.

Vanishing Ice suggests how the arts help galvanize environmental activism, a theme presented in my exhibition and catalogue *Fragile Ecologies: Contemporary Artists' Interpretations and Solutions* (1992). Artists who revitalize damaged habitats and sterile, urban sites through interdisciplinary collaborations were presented within the context of a millennial-long tradition of artists helping people maintain a balanced connection with the earth. The artists in *Vanishing Ice* continue this legacy at a critical point in the planet's evolution. Only with a gathering of voices and through concerted actions will a changing paradigm in our relationship to nature coalesce.

Vanishing Ice was truly a collaborative venture that depended on many people, from museum staff to community partners who embrace a collective vision of positive environmental change. Participants from the sciences, arts, and environmental and educational fields who attended focus groups and initiated public programs helped strengthen the exhibition's messages and broadened the audience.

Thanks to the staff at the Whatcom Museum for enthusiastically working together: Patricia Leach, executive director, for her recognition that the exhibition was meaningful in advancing the museum's mission; Chris Brewer, educator and program coordinator, who rallied and organized the Bellingham community and beyond in support of complementary projects and events; Mary Jo Maute, educator and program coordinator, whose

enthusiasm sparked programs; Scott Wallin, exhibitions designer, and David Miller, preparator, who contributed to the design and presentation of the exhibition.

I am grateful to Laura Johanson, marketing communications, whose creative ideas helped spread the messages of *Vanishing Ice*; Kristin Kostanza, former director of development, and Sheila Connors, currently director of development, who helped raise funds; and Becky Hutchins, curator of collections, for her conversations about the show's core values. The following staff members advanced the exhibition in their respective areas: Marilyn Burns, docent coordinator; Carrie Brooks, Family Interactive Gallery manager; Patrick Dowling, facilities manager; Judy Frost, accountant; Jeff Jewell, photo archive historian; and Rifka MacDonald, membership and marketing coordinator.

Vanishing Ice would not have been possible without the commitment and acumen of many curatorial interns from Western Washington University: Kaitlin Hays, Stephanie Pate Burgart, Philby Brown, John Lovejoy, Katherine Gleason, Zachary Johnson-Guthrie, Cheyenne Rose, Kyla Thompson, Emily Zach, Fiona Gleason, Amy Bozorth, Maureen McCarthy, Hilary Hamilton, Rebecca White, Tia Francis, Jase Ihler, Alexandra Steinberg, and Tanya Perkins.

Thanks to Phil Kovacevich, who designed a beautiful catalogue, and John Pierce, for sensitively editing the manuscript. I would also like to acknowledge Jim McDonald, Bruce Bradley, Mary Jensen, Ray Kamada, James Hyde, Stowe Talbot, Henry Stern, Dunham Gooding, Dean Wright, Sarah Clark-Langager, and Elsa Lenz Kothe for their help and support. I am also grateful to Chief Curator Patrick Cable and Director Jim Mohr at the El Paso Museum of Art, Texas, and Chief Curator Katerina Atanassova and Director Victoria Dickenson at the McMichael Canadian Art Collection, Ontario, who have been wonderful partners in traveling the exhibition.

The bibliography for *Vanishing Ice* indicates my debt to the many writers consulted for this project. Four sources were especially influential: Pierre Berton's *The Arctic Grail: The Quest for the North West Passage and the North Pole, 1818–1909* (1988); William L. Fox's *Terra Antarctica: Looking into the Emptiest Continent* (2005); Henry Pollack's *A World Without Ice* (2009), and the Linda Hall Library of Science, Engineering, and Technology's online site, *Ice: A Victorian Romance*. I appreciate the unique melding of climatology and art presented by Samuel U. Nussbaumer and other scientists, including Patrizia Imhof, whose research and correspondence informed the interdisciplinary aspect of *Vanishing Ice*.

Thank you to all the artists, museums, galleries, and private collectors who enthusiastically lent their art and time in working out the complicated logistics of this process. I also recognize the Whatcom Museum's board of directors and the City of Bellingham for their support.

I am especially grateful to the The Paul G. Allen Family Foundation, National Endowment for the Arts (NEA), The Norcliffe Foundation and Furthermore: a program of the J.M. Kaplan Fund for their generous funding that made this exhibition and catalogue a reality.

Vanishing Ice is dedicated to the artists, scientists, and explorers who sacrifice and sometimes risk their lives to work in hostile conditions so that the public can understand what is happening to life on Earth.

BCM

Subhankar Banerjee, *Caribou Migration* from *Oil & the Caribou* (detail), 2002

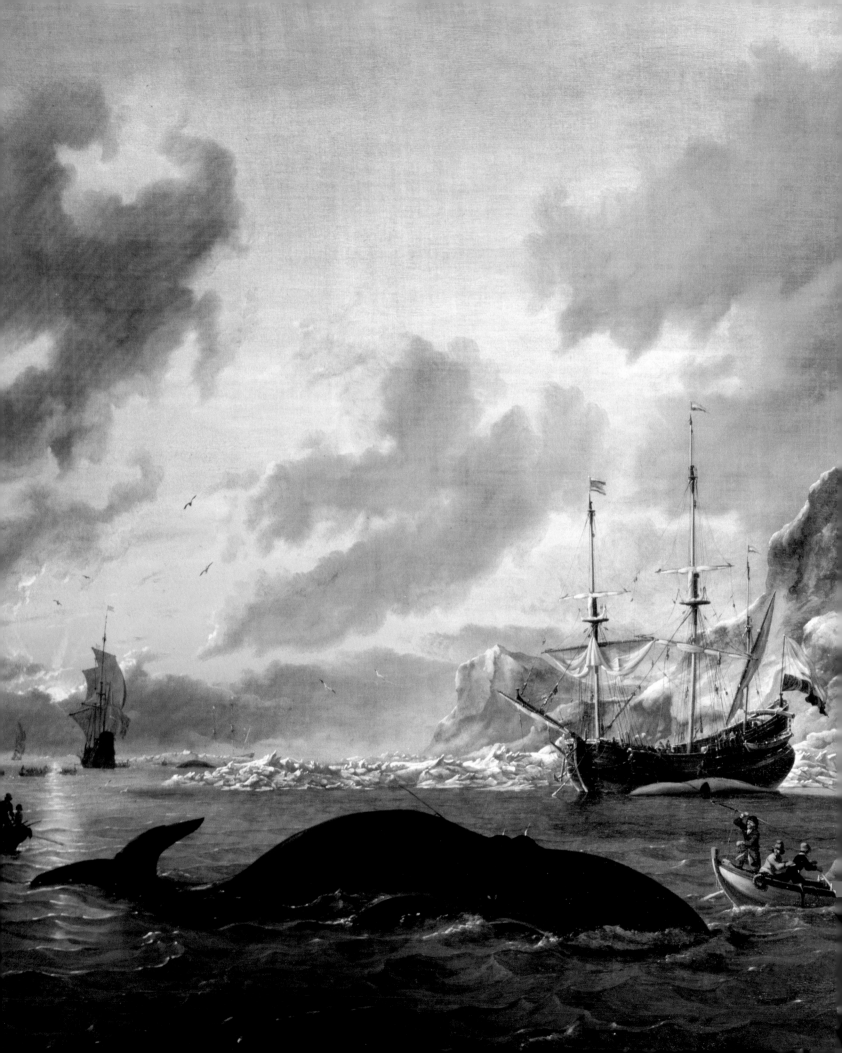

FROM THE SUBLIME TO THE SCIENCE OF A CHANGING CLIMATE

. . . but of all the pictures she [Nature] presents us, those of mountains covered with eternal snows, whose summits reach beyond the clouds, and whose forms are so majestic, are by far the most affecting, as they fill the mind with an idea of her grandeur and sublimity.

— MARC THEODORE BOURRIT, *A Relation of a Journey to the Glaciers in the Dutchy of Savoy,* 1775

VANISHING ICE INTRODUCES the rich artistic legacy of the planet's frozen frontiers now threatened by a changing climate. It traces the impact of glaciers, icebergs, and fields of ice on artists' imaginations and the connections between generations of artists over two centuries. This cultural perspective reveals the importance of alpine and polar landscapes in shaping Western consciousness about nature. *Vanishing Ice* offers a glimpse into a transnational movement that informs the environmental challenges faced today.[1]

Through the centuries, collaborations between the arts and sciences expanded awareness of Earth's icy regions. Early artists contributed to a geographic understanding of alpine mountains, the Arctic, and Antarctica, satiating popular demand for new images of little known territories. Artists' interpretations of the magical blue-green colors and fantastic shapes of ice, as well as auroras and other celestial displays, captivated the public. A resurgence of interest in these environments as dramatic indicators of climate change now galvanizes contemporary expeditions to the glaciers and the

poles. Today, artists, writers, and scientists awaken the world to both the beauty and increasing vulnerability of ice.

Vanishing Ice opens in the eighteenth century, when Western artists assumed the mantle of naturalist-explorer, venturing into regions where few nonnative inhabitants had gone before. During this period, the blossoming of the natural sciences, especially geology, liberated artists to paint unique landscape formations. Through realistic and often romantic interpretations of glaciers like the Mer de Glace (Sea of Ice), artists such as Caspar Wolf (Swiss, 1735–1783) and Jean-Antoine Linck (Swiss, 1766–1843) informed the public about Earth's natural wonders.

Artists also contributed to an expanded vision of the planet's history and ancient origins. Depictions of alpine landscapes by Joseph Bettannier (French 1817–after 1877) helped promote the revolutionary concept of an Ice Age governed by vast stretches of time. Artworks appeared in scientific publications, travelogues, popular magazines, and exhibitions.

Abraham Storck, *Dutch Whalers in Spitzbergen* (detail), 1690

Several artists, including Jean Charles Joseph Rémond (French, 1795–1875) and Claude Sebastian Hugard de la Tour (French, 1816–1885), were also commissioned to create mural-size landscape paintings for natural history museums and schools of higher learning. These works helped students and visitors visualize the movement of glaciers and the natural processes that created the specimens within these institutions' collections.

A similar coalescence of art and science indelibly marks contemporary culture. No longer concerned with distant geologic time, artists now call attention to the rapid transformation of nature occurring within a human lifespan. A sense of urgency and concern for the future of life on Earth underlines their work.

Chris Linder (American, b. 1972), a photographer and oceanographer, collaborated with scientists and journalists to publish *Science on Ice: Four Polar Expeditions*.[2] An intimate look into climate change research, this book celebrates the majesty and complexity of Arctic and Antarctic landscapes.

Linder also documents the experiences of young field researchers in such multimedia video presentations as *The Polaris Project: Science in Siberia* (2009). The artist worked alongside college students and scientists studying Arctic permafrost, layers of frozen soil rich in carbon (**fig.** 1). As rising temperatures melt the permafrost, which covers twenty-four percent of the Northern Hemisphere, carbon is released into the water and atmosphere. Linder introduces the public to this phenomenon, a story not as well known as the meltdown of the world's glaciers.

Many photographers and filmmakers, including David Breashears (American, b. 1955) and James Balog (American, b. 1952) have made it their mission to spotlight the fate of retreating glaciers. Balog and his associates have stationed twenty-six cameras around the world to capture images of calving glaciers every half hour during daylight hours. The artist then edits these shots into videos that document glacial recession. *Nova* and *National*

In order to obtain former glacier extents from pictorial documents, three criteria must be fulfilled: First, the dating of the painting has to be known or reconstructed. Secondly, the glacier and its surroundings have to be represented realistically and topographically correctly, which implies certain skills of the artist. Thirdly, the artist's position in the field should be known.

— Samuel U. Nussbaumer, World Glacier Monitoring Service, Department of Geography, University of Zurich

Geographic featured the artist's time-lapse photography project in the film *Extreme Ice* (2009).[3]

Scientists similarly study comparative photography to understand the acceleration of disappearing glaciers. Bruce Molnia, a geologist at the U.S. Geological Survey (USGS), has assembled an extensive inventory of early and contemporary imagery that documents glacial recession. H.J. Zumbühl, Samuel U. Nussbaumer, Daniel Steiner, and Patrizia Imhof track the loss of ice by comparing current photographs with early alpine artworks. Drawings, prints, paintings, and photographs help them determine the fluctuations of glacial length and mass before recorded measurements began at the end of the nineteenth century.

Simultaneously with the exploration of alpine landscapes, expeditions to Antarctica and the Arctic were launched by the United States and many countries in Europe. Artists such as William Hodges (British, 1744–1797) and Louis Lebreton (French, 1818–1866) accompanied journeys that generated new knowledge about the ends of the earth. Although voyages were often motivated by national and economic interests—the search for new trade routes to Asia and whaling grounds for baleen and

FIGURE 1

Chris Linder, *Siberian permafrost thaw, Duvannyi Yar, Kolyma River,* Siberia, July 21, 2010, archival inkjet print.

Since the last ice age, vast reserves of plant and animal matter have been locked up in frozen arctic soil, or permafrost. However, as temperatures rise, permafrost is thawing, and the gooey carbon-rich soil is becoming food for microbes. As they consume this ancient carbon, they respire methane and carbon dioxide, potent greenhouse gases. The amount of carbon stored in Arctic permafrost is estimated to be 1,500 gigatons—double what is currently in our atmosphere.

— CHRIS LINDER

oil—the public learned about the world's final frontiers through illustrated journals and atlases.

Like their predecessors, many contemporary artists join government-sponsored expeditions. The United States National Science Foundation Antarctic Artists and Writers Program provides opportunities for artists such as Stuart Klipper (American, b. 1941) to work on the Southern Continent as a way to increase awareness of polar research. Artists also organize their own expeditions. Since 2003, David Buckland (British, b. 1949) has coordinated voyages to the Arctic with artists, scientists, and educators through the Cape Farewell project.

The passion for alpine and polar landscapes contributed to the golden age of nineteenth-century landscape painting, which coincided with the growing industrialization of Europe and North America and the flourishing of romantic poetry and literature. People flocked to the countryside and to distant lands as a reaction to deforestation, crowded cities, and the increasing pollution from factories, described by the poet William Blake as "dark satanic mills."4

Nature offered emotional renewal and intellectual fulfillment as many educated men and women began examining the environment more closely, collecting specimens of flora, fauna, rocks, and fossils. They maintained travel journals and often illustrated them with drawings. Artists trekked the countryside in search of new subjects, painting landscapes *en plein air* (out-of-doors) for the first time. Scenic views graced the homes of urban dwellers who purchased reminders of their experiences in nature.

Alpine and polar environments fascinated the century's greatest landscape painters: Caspar David Friedrich (German, 1774–1840), Joseph Mallard William Turner (English, 1775–1851), Frederic Edwin Church (American, 1826–1900), and François-Auguste Biard (French, 1799–1882). While interpreting icy terrains, artists merged their quest to understand nature with the desire to experience feelings of elation.

Ice-capped mountains inspired heightened emotions as a growing number of visitors to the Alps expressed wonder at their immense scale, enchanting colors, and potential danger. Philosophers and writers, Jean-Jacques Rousseau (Swiss, 1712–1778) and Mary Shelley (British, 1797–1851) among them, used the word *sublime* to describe the feelings generated by these sights. Soon, European literature exuberantly brimmed with this word to the point of cliché.

The sublime stirred transcendence, the capacity to lose oneself in a spiritual experience. Journeying from the city to alpine peaks presented the potential for an encounter with the divine. Measuring one's insignificant self against the grandeur of these landscapes generated both awe and union with a numinous force embodied in the natural world.

Nineteenth-century explorers, writers, and artists, including Gustave Doré (French, 1832–1883), also identified polar terrain with the sublime. When free from the perils that it often posed, these artists appreciated the ice as a font of spirituality. Early twentieth-century Antarctic-expedition artists, such as David Abbey Paige (American, 1901–1979) and Edward Adrian Wilson (British, 1872–1912), captured the mystical essence of the region's otherworldly light effects.

In the 1920s and 1930s, Rockwell Kent (American, 1882–1971), Nicolas Roerich (Russian, 1874–1947), and Lawren Harris (Canadian, 1885–1970) made pilgrimages to the ice, where they found a spiritual refuge from the materialism of urban culture. Ansel Adams (American, 1902–1984) also sought the sacred in nature, inspiring him to photograph the frozen wilderness and champion its preservation.

Through the centuries, artists have demonstrated the limitless potential of alpine and polar landscapes to convey complex feelings, ideas, and messages. From Edwin Landseer, whose painting *Man Proposes, God Disposes* (1864) alludes to the folly of British Arctic exploration, to Isaac Julien, who in his video *True North* (2004) addresses

racism and the myth of the hero-explorer, artists use icy imagery to interpret social issues. Despite diverse themes and interpretations, almost all of the artists respond, in some way, to the beauty of ice.

Artists have adopted different styles, media, and approaches to interpret these unique environments. Barthélémy Lauvergne (French, 1805–1871) and Richard Brydges Beechey (British, 1808–1895) first captured the variety of ice formations in drawings, which were rendered into engravings and lithographs for illustrated books. Sketches were also assimilated into large oil paintings exhibited in European and American cities.

The introduction of new technologies expanded the communication between artists and the public. After the mid-nineteenth century, black-and-white photography became a favored medium for documenting alpine and polar landscapes.

The leading photographers of the day, including the Bisson Brothers (Bisson Frères, French, Louis-Auguste, 1814–1876 and Auguste-Rosalie, 1826–1900), made groundbreaking prints that look ahead to early Antarctic expedition photography by Herbert Ponting (British, 1870–1935) and Frank Hurley (Australian, 1885–1962). Eliot Porter (American, 1901–1990), one of the first artists invited to visit the Southern Continent by the United States National Science Foundation Antarctic Artists and Writers Program, employed color photography to great effect in his exhibition and influential book, *Antarctica* (1978).

Although many contemporary artists continue to utilize drawing, painting, and photography, others introduce new media and technologies to reference the ecological realities of climate change. Digital photography by Kahn and Selesnick (British and American, both b. 1954) and sound and video by Paul A. Miller (aka DJ Spooky, American, b. 1970) reflect the importance of layering imagery to address the environmental challenges faced at the poles. The data derived from innovative scientific tools—ice penetrating radar (IPR) and ice cores hundreds of thousands of years old—have also been

interpreted by Anna McKee (American, b. 1959) and Chris Drury (British, b. 1948).

Still other artists have adapted a wide array of contemporary art-making strategies to redefine alpine and polar landscapes. Helen and Newton Harrison (American, b. 1929 and 1932) create conceptual works that pose questions about and suggest solutions to large, endangered ecosystems. A site-specific installation/performance on the ice by Spencer Tunick (American, b. 1967) directed worldwide media attention to the vulnerability of Europe's largest glacier. Heather Akroyd (British, b. 1959), Dan Harvey (British, b.1959), and Xavier Cortada (American, b. 1964) extend the geography of the Earth art movement to the poles by sculpting and drawing with ice on site.

While the Internet provides virtually unlimited access to information and images, books continue to shape public consciousness about these regions. One important example, Gary Braasch's *Earth under Fire: How Global Warming Is Changing the World* (2007), functions as an illustrated primer on climate change. It includes the artist's photographs and accessible commentary accompanied by concise essays from scientists such as Sylvia Earle and Thomas Lovejoy and environmentalists like Bill McKibben.

In 2000, Braasch (American, b. 1950) began a worldwide expedition to photograph glaciers and other ecosystems suffering from global warming. Throughout his journeys, the artist accompanied scientists to their research sites. He took photographs to compare with historical views of the same subject, as in *Athabasca Glacier, Jaspar National Park* (**fig. 2**). Braasch's photograph of 2005 and Arthur Oliver Wheeler's (Canadian, 1860–1945) image, captured during his survey of the region in 1917, confirm the scientific data that Athabasca Glacier has lost half its volume and retreated almost a mile (1.5 km) since its discovery in 1898.[5]

A twenty-first century artist-naturalist-explorer, Braasch updates the tradition of early artists' contributions to expedition journals. By

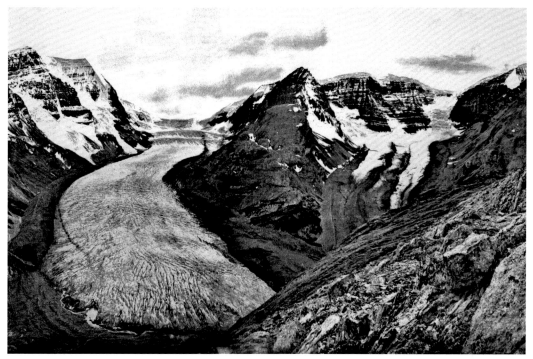

FIGURE 2

Gary Braasch, *Athabasca Glacier, Jasper National Park,* from *Earth under Fire: How Global Warming Is Changing the World,* 2005, archival inkjet print.

Arthur Oliver Wheeler, *Athabasca Glacier, Jasper National Park,* 1917, black-and-white photograph.

independently conceiving and producing *Earth under Fire*, he follows in the footsteps of William Bradford (American, 1823–1892), who published his landmark photographic account, *Arctic Regions,* in 1873.

In the same way that historical atlases covered the gamut of natural history, Braasch's book likewise examines a wide range of climate change phenomena: catastrophic weather events, vanishing ice, drought, upheavals in animal migration and plant survival, as well as the effect on human life and culture. *Earth under Fire* concludes by describing ways that people and communities can slow the effects of climate change.

The book explains the greenhouse effect and how expansive ice formations act as reflective shields, cooling and protecting the planet from excessive solar rays. Through graphs and charts, *Earth under Fire* pinpoints the sources of carbon dioxide, methane, and nitrogen released into the atmosphere by human activity.

These gases have transformed ecosystems around the world, but nowhere more dramatically than in the world's mountain regions and at the poles. Ice cores, composed of snow deposited in layers over thousands of years, reveal a forty percent increase in carbon emissions since the Industrial Revolution.

Braasch also covers the effects of climate change on the oceans, which have absorbed carbon dioxide and increased thirty percent in acidity. Rising ocean temperatures contribute to stormier weather, higher sea levels that threaten the coasts, coral reef die-off, and deleterious changes in the food chain.

In the past, the cyclical waxing and waning of ice ages occurred over long stretches of time and were governed by Earth's natural rhythms. The planet's orbit (particularly its proximity to the sun, which shifts every one hundred thousand years) and its tilt in space (varying by three degrees every forty thousand years) triggered climate changes.[6]

Humans have altered this natural process by burning fossil fuels, cutting down forests, and practicing unsustainable agriculture. In a geologic blink of an eye, the remaining coal, petroleum, and natural gas—formed over millions of years from forests that dominated the late Paleozoic landscape—will be gone. Earth and the life it sustains will be irrevocably altered with little chance of reforming its icy blanket of protection, which takes tens of thousands of years to build.

Vanishing Ice seeks to stimulate an appreciation for alpine and polar landscapes by revealing their significance for both nature and culture. In the eighteenth and nineteenth centuries, the public developed a passionate relationship to these regions thanks to the arts and natural sciences. Through similar interdisciplinary connections, contemporary artists increase awareness about these fragile environments and inspire activism toward bringing Earth back into balance.

1. The passion for ice touched artists in many Western countries. Because the subject is vast, *Vanishing Ice* concentrates on artists from England, France, and the United States. A focus on France reflects research from my doctoral dissertation, "Sublime Landscape Painting in Nineteenth Century France: Alpine and Arctic Iconography and Its Relationship to Natural History" (1983) at New York University's Institute of Fine Arts. Important early artists not discussed here include Peter Balke (Norwegian, 1804–1887), Johann Christian Dahl (Norwegian, 1788–1857), Ferdinand Hodler (Swiss, 1853–1918), Jens Ferdinand Willumsen (Danish,1863–1958), and Johann Heinrich Wüest (Swiss, 1741–1821), to name a few.

2. University of Chicago Press, 2011.

3. *Extreme Ice* aired December 28, 2011, on PBS. Another film, *Chasing Ice* (2012), presents a biographical account of the artist in his quest to inform people about climate change.

4. From William Blake's poem *Milton*, 1804–10.

5. "The Big Melt Down: Columbia Icefield, Canada," http://www.oneonta.edu/faculty/baumanpr/geosat2/ Big_Melt_Down/Big_Melt_Down.htm.

6. Brian Fagan examines how climate change has marked the planet's history in the book *The Complete Ice Age: How Climate Change Shaped the World.*

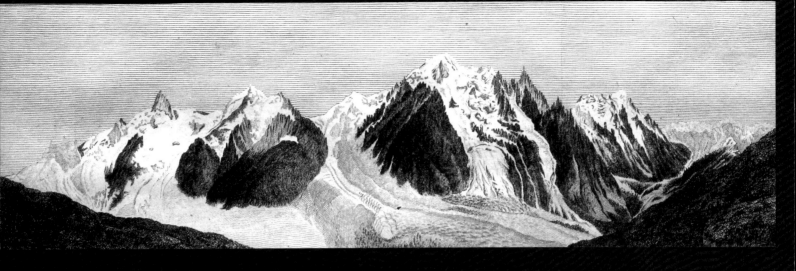

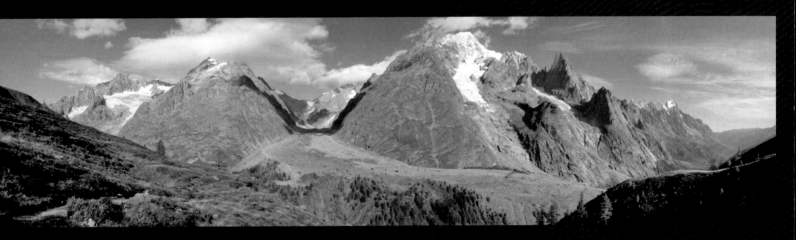

FIGURE 3
Marc Theodore Bourrit, *Le Mont Blanc vu en face du coté de l'Allée-Blanche (Mont Blanc's White Alley)*, from Horace-Benedict de Saussure, *Voyages dans les Alpes (Voyages in the Alps)*, 1786, engraving.

FIGURE 4
Patrizia Imhof, *Le Mont Blanc vu en face du coté de l'Allée-Blanche (Mont Blanc's White Alley)*, 2009, color photograph.

VOYAGE TO GLACIAL PEAKS

The oscillation of glaciers, because they are directly related to the
general problem of the earth's temperature, have always attracted the attention of naturalists.

—LOUIS AGASSIZ, *Etudes sur Glaciers (Studies on Glaciers)*, 1840

DURING THE NINETEENTH CENTURY, a passion for alpine landscapes spread throughout Europe (and later into North America) as people developed an appreciation for the beauty of these unique environments. The cross-fertilization of art, literature, and science sparked a cultural revolution, which transformed the public's perception of snowcapped mountains.[1]

Until the eighteenth century, many people harbored negative attitudes toward the Alps because of fear, superstition, and traditional religious beliefs. The Mont Blanc massif, once called the "Cursed Mountains" (*Montaignes Maudites*), was believed to be the abode of demons and dragons.

During the European Middle Ages, artists and writers reflected this worldview. Famous painters, such as Duccio di Buoninsegna (c.1255–1319), depicted the devil tempting Christ on the mountaintop.[2] Dante Alighieri (1265–1321), the influential poet of the *Divina Commedia (Divine Comedy, 1308–1321)* envisioned the depths of Hell—its innermost circle—as an icy lake gripping Satan and debased human souls for eternity.

This sentiment largely stemmed from the belief that Earth was originally smooth and free from the "warts" and "blisters" of mountains described by seventeenth-century English poets.[3] The popular book *Sacred Theory of the Earth* (1685) by Thomas Burnet, a Christian cleric and scientist, reinforced the popular notion that God ravaged the flat land of Adam and Eve by a cataclysmic flood. He wrote: [The moon and earth] are rude and ragged. . . they are both in my Judgment, the Image or Picture of a great Ruin, and have the true aspect of a World lying in its Rubbish.[4]

People's perceptions began changing toward the middle of the eighteenth century, when artists, writers, and scientists communicated their feelings of awe and spiritual communion with the Alps. Marjorie Hope Nicolson, in her pioneering book *Mountain Gloom and Mountain Glory* (1959), described the shift: "the aesthetics of the infinite was transferred from God to interstellar space, then to terrestrial mountains," thanks to new revelations in astronomy by Galileo during the seventeenth century and geology in the eighteenth century.[5]

The writings of Horace Benedict de Saussure (Swiss, 1740–1799), a pioneering geologist, contributed to a growing fascination with the Alps. The first to explore and map the Mont Blanc massif, he compiled his observations of glaciers, meteorology, and botany in *Voyages dans les Alpes . . . (Voyages in the Alps preceded by an essay on the natural history around Geneva, 1779–96)*. Saussure's internationally acclaimed work became the foundation for modern glaciology.

Saussure sparked public interest in the Alps, in part through the drawings of glaciers illustrated in his book. In *Le Mont Blanc vu en face du coté de l'Allée Blanche (Mont Blanc's White Alley, 1786)*, Marc Theodore Bourrit (Swiss, 1739–1819) depicts a panorama of the Miage Glacier snaking down the mountain from the Italian side of the range (**fig. 3**). The contemporary scientist Patrizia Imhof has consulted this drawing and photographed a comparative view in 2009 to document the glacier's recession (**fig. 4**).[6]

The grandeur of such sublime scenes thrilled Bourrit, who described the step-like ice leading up Mont Blanc's Mer de Glace (Sea of Ice) as "the throne of some divinity." Bourrit, who was also a naturalist, recorded his scientific observations and feelings of ecstasy in his book *A Relation of a Journey to the Glaciers in the Dutchy of Savoy* (1775).[7]

Saussure's fellow Genevan, Jean-Jacques Rousseau (Swiss, 1712–1778), the philosopher and catalyst of the romantic movement, also boosted the Alps by making the mountains appear magical. An amateur naturalist who set up a laboratory to study botany, he extolled the beauty of the mountains in his popular novel, *La Nouvelle Heloise. . . (The New Eloise: Letters of Two Lovers, Inhabitants of a Small Town at the Foot of the Alps, 1759)*.

Rousseau identified the region as a place of apparent contradictions where spring flowers, autumn berries, and ice could simultaneously be found. For the philosopher, the integration of all seasons and climates produced the effects of totality and harmony, purifying the mind and soul. The book has been credited with inspiring "secular mountain worship" in tandem with a "religiously-inspired doctrine of natural theology."[8]

In tune with this new direction, Swiss artists such as Caspar Wolf (1735–1783) and Jean-Antoine Linck (1766–1843), and later Francois Diday (1802–1877) and Alexander Calame (1810–1864), specialized in painting views of glaciated mountains. Prints of their work were published in magazines and sold in shops, contributing to the vogue for alpine peaks.[9] Linck was popular not only with the public but also with royalty, counting among his patrons the French Empress Josephine Bonaparte and Catharine II, Empress of Russia.

Linck painted in gouache (opaque watercolor) and encaustic (wax) and later engraved and hand-colored views of Mont Blanc's Mer de Glace, which was once called the *Glacier des Bois* when it extended as far as the town of that name (**fig. 5**). In *Vue prise de la voûte nommé le Chapeau, du glacier des Bois et des Aiguilles du Charmoz (View of the Glacier des Bois and the Needles of Charmoz from the arch, called the Cap, 1799)*, the artist delineates the longest glacier in the western Alps with great accuracy. He also portrays two well-dressed British tourists, dwarfed by the immensity of the glacier, who sport a telescope to marvel at the landscape.

Linck evokes a sense of wonder by positioning himself at the mouth of the arch to dramatically frame the structure and luminosity of ice. This work contrasts with Joseph Mallard William Turner's (1775–1851) interpretation of the Mer de Glace four years later, which synthesizes all of

> It seems that in being lifted above human society, one leaves behind all base and terrestrial sentiments, and that as one approaches the ethereal regions, the soul acquires something of their purity.
>
> —JEAN JACQUES ROUSSEAU, *LA NOUVELLE HELOISE (THE NEW ELOISE)*, 1759

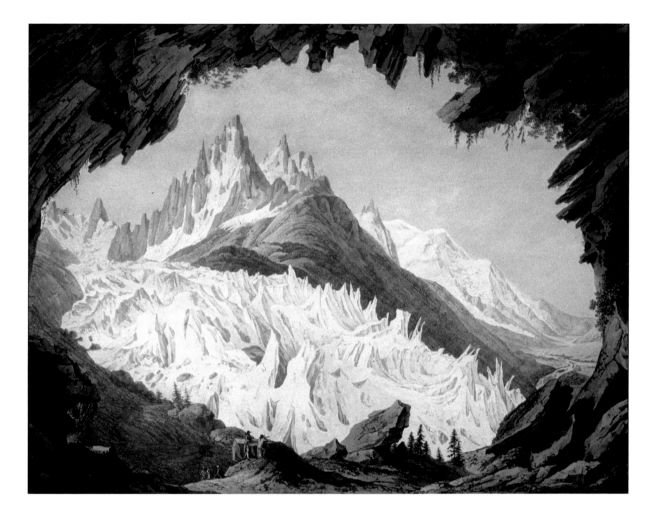

FIGURE 5

Jean-Antoine Linck, *Vue prise de la voûte nommé le Chapeau, du glacier des Bois et des Aiguilles du Charmoz (View of the Glacier des Bois and the Needles of Charmoz from the arch, called the Cap)*, 1799, colored etching.

FIGURE 6

Samuel U. Nussbaumer, *Vue prise de la voûte nommée le Chapeau du glacier des Bois et des Aiguilles du Charmoz (View of the Glacier des Bois and the Needles of Charmoz)*, 2005, color photograph.

nature's elements to express an overpowering mood (**fig. 14**).

After two hundred years, the view has dramatically changed. The Mer de Glace, seven-and-a-half miles long (12 km) and encompassing almost twenty square miles (32 sq. km), has receded by more than a mile (2 km). Dr. Samuel Nussbaumer, who has documented glacier recession by comparing early artworks with his own photographs, captured the same vantage point in 2005 to help visualize this drastic transformation (**fig. 6**).[10]

Over the next one hundred years, Mont Blanc would become the most popular and best-documented mountain because of its status as western Europe's tallest peak (15,782 feet, 4,810 meters), relative accessibility, and dramatic glaciers. The mountain's scientific and cultural appeal catalyzed a tourist boom to the small hamlet of Chamonix, from where the Mer de Glace was once visible. The bucolic village was transformed into a hub of hotels, eateries, and curio shops. The popularity of the region, in turn, stimulated the publication of travelogues and illustrated guidebooks.

Inspired by Rousseau's *La Nouvelle Heloise*, Mary Shelley (English, 1797–1851), Percy Bysshe Shelley (English, 1792–1822), and Lord George Byron (English, 1788–1824) visited Chamonix to taste the sublimity of the Alps in 1816. Their writings reflect the deep impact of glaciers on their aesthetic sensibilities. During their sojourn, Mary Shelley conceived her famous book *Frankenstein: or, The Modern Prometheus* (1818), which takes place in the Alps and the Arctic. Percy Shelley composed *Mount Blanc: Lines Written in the Vale of Chamouni* (1816) and Byron wrote *Manfred* (1817) and *Childe Harold's Pilgrimage* (1818), dramatic poems that unfold in the Alps.

Xavier Leprince (French, 1799–1826) interpreted the craze for alpine tourism in *Paysage du Susten en Suisse* (*Landscape of Susten, Switzerland*) in 1824, when adventurers from England crossed the continent in great numbers to experience the grandeur of glaciers (**fig. 7**). The artist amusingly depicts the collision of high-altitude travelers with

Above me are the Alps
The palaces of Nature, whose vast walls
Have pinnacled in clouds their snowy scalps,
And thron'd Eternity in icy halls
Of cold sublimity, where forms and falls
The avalanche – the thunderbolt of snow!
All that expands the spirit, yet appals,
Gather round these summits, as to show
How Earth may pierce to Heaven, yet leave vain man below

—LORD BYRON, *CHILDE HAROLD'S PILGRIMAGE*, 1818

goats and cows along a mountain pass. In this sublime narrative landscape, the towering icy peaks become a stage: one man gazes up at the scenery in awe, another pets a goat, while a third tourist lays down his umbrella to sketch the view. A Swiss guide, carrying the bulk of their gear, looks over his shoulder to examine the drawing. In the distance, a long line of animals animates the route and expands the perspective, while a huge boulder, perhaps deposited by an avalanche, reminds the viewer of the potential for danger.

In addition to artists' images and the ubiquitous books on travel, the public also followed the steady flow of information published during the formative years of the natural sciences through the writings of Georges-Louis Leclerc (Le Comte du Buffon, French, 1707–1788), whose multivolume *Histoire Naturelle* (Natural History, 1749–1788), published in many languages, helped readers visualize a proto-Darwinian history of life on Earth. Georges Cuvier's (French, 1769–1832) discovery and identification of fossils, along with Louis Agassiz's study of glaciers, offered readers an expanded concept of Earth's age.

Louis Agassiz (American, b. Switzerland, 1807–1873) focused the public's attention on

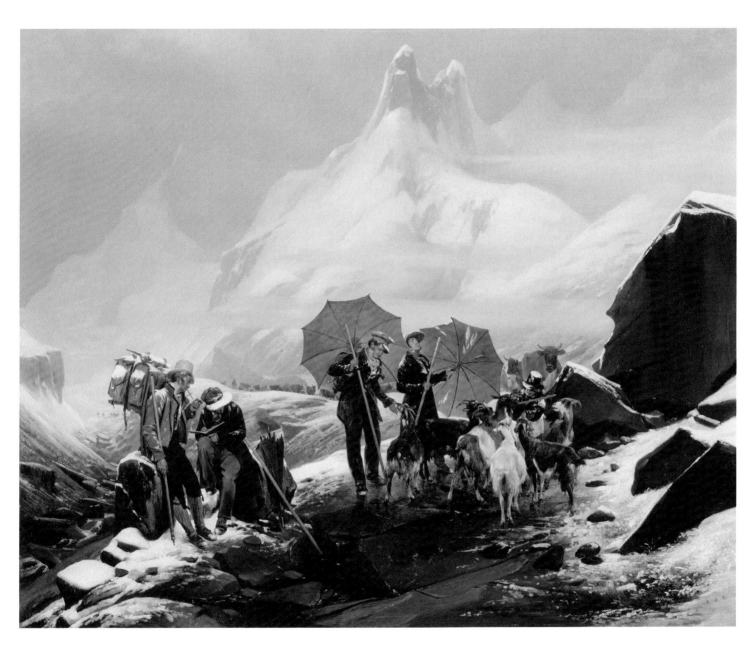

FIGURE 7

Xavier Leprince, *Paysage du Susten en Suisse (Landscape of Susten, Switzerland)*, 1824, oil on canvas, © Réunion des Musées Nationaux - Grand Palais / Art Resource, NY.

glaciers and influenced a generation of scientists and artists. While a professor at the University of Neuchâtel, he studied alpine glaciers and the scoured and striated rocks around them. Building on the work of naturalists such as Saussure, he popularized the idea of an "Ice Age." Agassiz surmised that northern Europe was once covered with a massive, Greenland-size sheet of ice that retreated upon the advance of a warm period.[11]

Agassiz compiled his observations in a series of essays, *Etudes sur Les Glaciers* (*Studies on Glaciers*, 1840), which was illustrated with large lithographs by Joseph Bettannier (French 1817–after 1877). His charming views dotted with small figures—from mountain panoramas with their long, meandering glaciers to close-up details of unusual ice and rock formations—were appreciated for their scientific and aesthetic value. Text and image outlined in great detail the dynamic movement of ice as it sculpted the landscape into valleys, moraines (rock and pebble mounds formed by the advance of glaciers), and erratic boulders deposited by ice.

In *Hugi's hut on a medial moraine of the lower Aar glacier*, Bettannier documents the confluence of two great glaciers and the rustic headquarters of Franz-Joseph Hugi (**fig. 8**). A mountaineer and professor of natural history, Hugi (Swiss, 1796–1855) was one of the first to study the flow of alpine glaciers, influencing Agassiz during their rambles together through the Alps. His stone shelter, originally constructed in 1830 farther up the valley, was moved 4,600 feet downhill by the action of the glacier. Agassiz measured the hut after ten years time and used it as further evidence that glaciers advanced and retreated.

Agassiz's *Studies of Glaciers* moved Ice Age theory to the forefront of scientific debate. Until this time, many people still believed that Earth was six thousand years old and created in six days. Proponents of the Ice Age pointed to a more ancient reading of the planet, which was now considered dynamic and subject to changes over time. Natural science provided an alternative to the strict biblical interpretations of Earth's origins. Not everyone was convinced; only when Arctic exploration provided further cumulative evidence would many Ice-Age deniers accept the scientific data.[12]

Glaciology was also introduced to the public through a unique collaboration between artists and scientists. In France, the government commissioned painters to interpret glaciers and other geologic wonders at two prominent Parisian institutions: the Muséum national d'Historie naturelle (National Museum of Natural History) and the Ecole des Mines (School of Mining). These projects provided a dramatic setting for the exhibition of rock and mineral specimens, helping students and visitors visualize geologic processes and discoveries.[13]

Paris emerged as an international center for the study of science when the revolutionary French government in 1793 transferred the King's garden (Jardin du Roi) to the state and established the Museum of Natural History. Alexander von Humboldt (German, 1769–1859), George Cuvier, Jean-Baptiste Lamarck (French, 1774–1829), and Louis Agassiz were active at the museum and helped bolster the institution's reputation.

In 1838, a master plan to create paintings for the museum's new Galérie de Minéralogie (Gallery of Mineralogy) was announced. Alexandre Brongniart (1770–1847), a professor of geology, arrived at a list of landscape subjects that included the most popular and scientifically important geologic wonders known at the time: Niagara Falls, the basalt grotto on the Island of Staffa, the cirque of Gavarnie, the great geyser in Iceland, the rocks of Carrara, and the glaciers of Grindelwald and Chamonix. Commissioned in stages, the project was completed in 1871.

Jean Charles Joseph Rémond (French, 1795–1875), selected to paint four landscapes, studied mineralogy with Brongniart. An understanding of the different types of rocks, their structures and conditions of formation, was considered essential for the success of the project. Rémond conceived *Cimes calcaires du Wetterhorn et glacier de Rosenlaui* (*Limestone Peak of the Wetterhorn and Rosenlaui Glacier*, 1842) as a pedagogic tool for aspiring

FIGURE 8

Joseph Bettannier, *Hugi's hut on a medial moraine of the lower Aar glacier*, from Louis Agassiz, *Etudes sur les glaciers (Studies on Glaciers)*, lithograph, 1840.

The medial moraine resulting from their junction rises like an immense ridge from in between these two glaciers. The hut shown here was originally built by Hugi at the foot of the rock called Abschwung, which forms the separating wall between the two glaciers. It is now located 4,600 feet away and has been displaced that far by the continuous down slope movement of the glacier...

—LOUIS AGASSIZ

FIGURE 9

Jean Charles Joseph Rémond, *Cimes calcaires du Wetterhorn et glacier de Rosenlaui (Limestone Peak of the Wetterhorn and Rosenlaui Glacier)*, 1842, oil on canvas, Museum of Natural History, Paris.

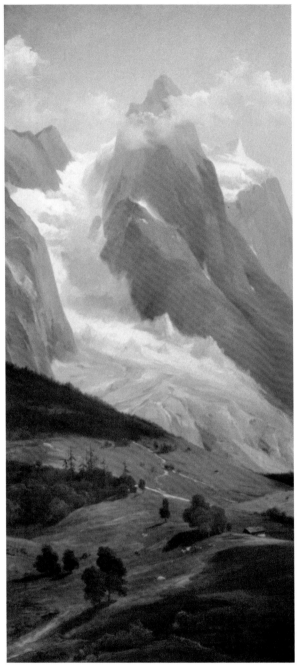

geologists (**fig. 9**). In contrast to the fragments of rock exhibited nearby, Rémond's painting represents an entire geological formation in situ, an opportunity to study the origin and configuration of alpine landscapes. For students and visitors who could not make the journey, these paintings were the closest substitute for firsthand observation.

The vantage point of *Limestone Peak of the Wetterhorn* emphasizes the path of the receding glacier and suggests how the valley in the foreground was carved. The melt water draining from the Rosenlaui Glacier, the source of the streams and river, represents another lesson in glacial dynamics.[14]

The project's teaching goals were enhanced by the desire to foster respect for and admiration of nature. Rémond's painting was calculated to appeal to the public's enthusiasm for sublime scenery. With its dramatic vertical dimension, the artist's work elevates the subject's grandeur.

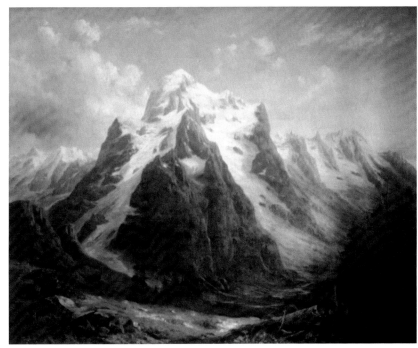

FIGURE 10

Claude-Sebastien Hugard de la Tour, *Mont Blanc,* 1853, oil on canvas, School of Mining, Paris.

Geology was, in essence, glorified by art, and the science, in turn, elevated landscape painting. For the first time in the venerable history of French patronage, nature becomes the exclusive subject matter for the decoration of a public space.

Like the Museum of Natural History, the School of Mining played an important educational role during the nineteenth century. Scientists here similarly believed that the work of artists could teach and inspire its students. Founded in 1783, the institution was directly linked to France's economic expansion. The increasing exploitation of coal, minerals, and metals demanded trained scientists. The School of Mining educated geologists who later explored the countryside for ore locations. Geology's utilitarian role in the advancement of industrial production in Europe and the United States fostered its growth and influence.

Claude Sebastian Hugard de la Tour (French, 1816–1885) completed ten paintings for the School of Mining's grand staircase that ushered visitors into the rock and mineral museum (**fig. 10**). Completed over a seven-year period, from 1852–59, the series was commissioned by the Inspector General of Mines, who believed that the work should reflect Earth's natural processes and complement the institution's courses. Only the most remarkable geological sites would be represented, and the jewel of the commission was Mont Blanc. According to the director: "The painting of the School of Mining's staircase will not be a simple decoration, but play a role in the instruction, seen by many people who

take courses on the phenomenon made classic by the work of Saussure and Ramond."[15]

Hugard was required to visit the sites first studied by the geologists Saussure and Ramond de Carbonnières (French, 1775–1827), who was the first to explore and study the Pyrénées. These journeys helped ensure a naturalistic interpretation of the landscape. As a native of Savoy, Hugard developed an early affinity for alpine terrain. Later, he studied painting with Alexander Calame, one of Switzerland's most notable landscape artists. His penchant for sketching rock formations contributed to his acute sense of detail, providing the foundation for the geological views demanded of him.

Jean-Baptiste Elie de Beaumont (1798–1874), principal geologist and subsequent director at the School of Mining, chose the landscape subjects. They corresponded to the scientist's core curriculum and lectures delivered to his students. In his research and writing, Beaumont acknowledged his debt to Saussure's pioneering efforts at interpreting the Alps. The subject of Mont Blanc was, in part, selected as a tribute to the early geologist.

Hugard's perspective of Mont Blanc, studied from the neighboring Mont Cramont, was described by Saussure in his *Voyages in the Alps* as the best view from which to appreciate the mountain's structure. Beaumont directed Hugard to make the climb to the summit—9,600 feet (2,926 m) in elevation—to sketch the scientist's recommended vantage point.

In his monumental geological portrait, Hugard confronts the mountain's tectonic structure, which becomes the focal point of the composition. Rather than include the valley of Chamonix, as others before him had done, the artist isolates the peak from the surrounding topography and concentrates on the rocks and glaciers that contribute to the mountain's distinctive appearance. In the painting, the north side of the mountain, heavily laden with glaciers, meets the barren, rocky slope of its southern flank. The startling contrast between the two sides was one reason why Saussure favored this view.[16]

Saussure's influence was felt not only in the scientific community but also in the emergence of mountain climbing as a sport. An avid mountaineer, he offered a cash prize to the first to forge a route to the top of Mont Blanc. In 1786, Jacques Balmat and Dr. Michel Paccard, who was driven to take barometric readings at the summit, achieved the goal.

The following year, Saussure made the ascent. Accompanied by guides who carried his scientific equipment, he remained on the peak for four hours to carry out experiments.[17] People were fascinated by Saussure's journey to the summit. Although he was the third to accomplish this feat, his reputation as a scientist prompted a fanfare of media attention. As late as the 1850s, illustrated articles detailing his famous climb and research appeared in the press.

The popularity of mountain climbing, particularly to the heights of Mount Blanc, resulted in a further influx of tourists to the region. Albert Smith (English, 1816–1880), a mountaineer and entertainer, both capitalized on and stimulated the public craze for Alpinism. After his own climb to the summit in 1851, he wrote a book (*The Story of Mont Blanc*), created a six-year-long exhibition and performance in London, and produced a snakes-and-ladder-type board game on the subject. The *New Game of the Ascent of Mont Blanc* (c. 1856) featured a board containing fifty-four squares with hand-tinted lithographs mounted on linen, which corresponded to scenic stops along the way to the summit.

The vogue for mountaineering spawned many organizations dedicated to the sport. London's Alpine Club, founded in 1857 by enthusiasts, including Smith, was the first of its kind. Its mission to "promote better knowledge of the mountains through literature, science, and art" underscored the early recognition of the alpine landscape's cultural significance.[18] By the end of the nineteenth century, many European countries had established their own climbing groups.

Even royalty succumbed to the mountain climbing fever when Emperor Napoleon III and Empress Eugenie made a symbolic ascent of Mont

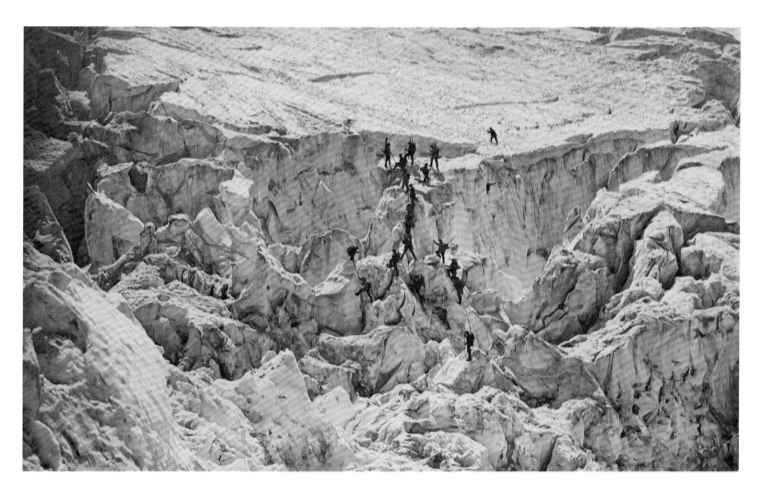

FIGURE 11

Bisson Frères (Bisson brothers: Louis-Auguste Bisson and
Auguste-Rosalie Bisson), *Ascension au Mont Blanc (Ascent of
Mont Blanc)*, 1860, albumen print.

Blanc to commemorate the reunification of Savoy
with France in 1860. Two photographers, known as
the Bisson Frères (Bisson brothers, Louis-Auguste,
1821–1893, and Auguste-Rosalie, 1859–1862
accompanied the couple and their sixty guides, who
hiked as far as Montenvers. At this point, the Bis-
son brothers continued their journey to the summit.

Although they failed to reach the top, the
photographers returned with twenty-four large
glass negatives documenting the royal climb,
which were published as *Haute Savoie: Le Mont
Blanc et ses glaciers: Souvenirs du voyage de LL.
MM. L'Empereur et l'Imperatrice* (*High Savoy:
Mont Blanc and its glaciers: Memories of the voy-
age of the Emperor and Empress*, 1860). Their

photographs were so popular that the two men
organized a second trek the following summer.
Auguste reached the summit, shooting three photo-
graphs before an onslaught of inclement weather.

The Bisson Frères, who were among the first
photographers to document alpine topography,
approached the landscape with documentary eyes
while framing their compositions to heighten the
dramatic moment (**fig. 11**). In the *Ascension au
Mont Blanc* (*Ascent of Mont Blanc, 1860*), they
captured the perilous crevasses encountered along
the route. Photographing from an elevated point a
short distance away from the miniscule figures, the
brothers focus on the chaos and instability of the
ice. To further magnify the danger, Bisson points

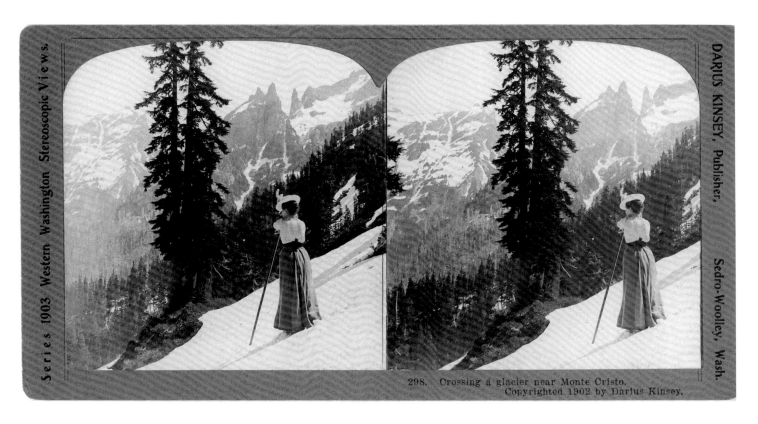

298. Crossing a glacier near Monte Cristo.
Copyrighted 1902 by Darius Kinsey.

FIGURE 12

Darius Kinsey, *Crossing a glacier near Monte Cristo*, 1902,
black-and-white stereograph.

the camera downward. This compressed view obliterates any visual relief that sky or surrounding panorama might offer.

Because of the reproductive capacity of the camera, scientists appreciated the importance of photography for their field. In 1863, the Bisson brothers presented proofs of their portfolio to Elie de Beaumont, who presented them to the Académie des Sciences (Academy of Sciences).

The Bisson brothers' photographs were a sensation with the public because of their accuracy and truth to nature. This desire for realism inspired landscape photographers to create stereographic prints of glaciers that could be viewed in three dimensions. In Darius Kinsey's (American, 1869–1945) portrait of his wife, Tabitha, who developed and printed his photographs, the viewer becomes part of the scene, pausing along the glacier on Wilman's Peak in the Washington Cascades (1902, **fig.**

12).[19] The difficulty of high-altitude climbing while wearing impractical clothing underscores the determination of women to experience mountaineering. Hundreds of photographs in museums and alpine club archives document the allure of climbing for European and American women.

Some of the first known alpine photographs were taken by John Ruskin (British, 1819–1900), artist, naturalist, and the nineteenth century's greatest art critic. Using the early daguerreotype process of one-off plates, he shot more than forty views of Switzerland between 1849 and 1858. Although Ruskin feared that photography would negatively impact art, he appreciated its utilitarian function. His photograph *Mer de Glace, Chamonix* was rendered into a watercolor in 1849.[20]

Ruskin later returned to the glacier, painting the same angle, in *Mer de Glace- Moonlight* (1863, **fig. 13**). In the intervening years, the artist

FIGURE 13
John Ruskin, *Mer de Glace-Moonlight,* 1863, watercolor,
9.44 x 14.17 in. (24 x 36 cm)
Courtesy of Alpine Club Photo Library, London

loosened up his style in homage to the late paint-
ings of Joseph Mallard William Turner. Ruskin
selects the viewpoint where the glacier wraps
around the mountain, which rises majestically
in an ethereal blue-gray atmosphere. Inspired by
lunar light, the artist imbues topography with a
mysterious, haunting quality that reflects his love
for the "snowy mountains shining like heavenly
castles far above."[21]

The artist expressed his ecstasy in the pres-
ence of Mont Blanc through sketches, poetry, and
journal writing following his first trip to the Alps

with his parents in 1833. After visiting the once-
secluded village of Chamonix nineteen times, he
later wrote regretfully about its development as a
mecca for tourism and mountaineering.

At fifteen, Ruskin read Saussure's *Voyages
in the Alps,* which inspired him to publish an illus-
trated scientific paper about the strata of Mont
Blanc in the *Magazine of Natural History* (1834).
Geologists admired his later book, *Deucalion:
Collected Studies of the Life of Waves and Stones*
(1879), which examined the forms and move-
ment of glaciers. It became assimilated into the

FIGURE 14

Joseph Mallard William Turner, *Mer de Glace, in the Valley of Chamouni, Switzerland*, 1803, watercolor and graphite with gum on wove paper, Yale Center for British Art, Paul Mellon Collection/The Bridgeman Art Library.

undergraduate geography curriculum at Oxford College, where Ruskin became the first Slade Professor of Fine Art in 1869.[22]

Advocating the close study of nature, Ruskin's influence spread in Europe and the United States through books like *Mountain Beauty* (1856), the fourth volume of *Modern Painters* (1843–1860). As an art critic, he championed Turner's landscape paintings, introducing the artist to an international audience.

Turner journeyed to the Alps in 1802 and returned several times between 1840 and 1844. The mountains profoundly affected his vision of nature, which blended topographically accurate details with a unique, expressionistic interpretation of light and atmosphere (**fig. 14**).

The artist's early alpine travels were recorded in a sketchbook dedicated to views of Mont Blanc and St. Gothard, many of which were translated into watercolors and engravings. In *Mer de Glace, in the Valley of Chamouni, Switzerland* (1803), Turner paints a realistic view initially based on a rough chalk drawing of the glacier. At the same time, he highlights its sublime features—the chaos of wind-blasted trees, erupting clouds speckled with sunlight, and jagged, smoky-blue mountains that measure the vast, distant space.

Turner emphasizes the diagonal movement of the glacier, which corresponds to the "oblique line" that "may rise to infinity," described in his lectures on art.[23] This compositional format helped the artist capture the vista's awesome dimension. In contrast

to Linck's inviting landscape with tourists (see **fig. 5**), Turner includes a shepherd and his goats, native inhabitants of the region. A snake uncoiling guards the landscape against outside intruders.

While Linck records an enchanting geological marvel with extreme clarity, Turner interprets nature's nuances defined by the energy of changing meteorological phenomena. In his later work, the poetry of atmosphere dissolves figures and details of landscape in a way that Ruskin absorbed.

While crossing the Mer de Glace, the artist also sketched a view from within the formation itself. He transcribed the glacier's energy into oceanic waves of ice. In 1812, Turner engraved this sketch for his *Liber Studiorium (Books of Studies)*, a series of seventy-one prints published between 1807 and 1819 that documented and compiled diverse landscapes into a visual treatise. Stirred by the interconnectedness of the natural world, Turner imbibed concepts of geology through his friendship with Sir Anthony Carlisle, professor of anatomy at the Royal Academy, and John MacCulloch (1773–1835), president of the Geological Society in Scotland.[24]

The works of Turner, Ruskin, and Agassiz, who joined the Harvard University faculty in 1848, influenced the intellectual milieu of the United States and strengthened the cultural link between Europe and the Americas. Artists such as Thomas Moran (1837–1926) adapted Turner's approach to light and color to capture the sublimity of the western frontier. His paintings, such as *Grand Canyon of the Yellowstone* (1872), purchased by the United States Department of the Interior, helped catalyze the national parks movement.

Agassiz's ideas about glaciers and Ruskin's approach to nature shaped the career of Clarence King (American, 1842–1901), scientist and explorer who led the geological survey of the 40th Parallel Expedition from 1867 to 1879.[25] Although Congress funded the voyage to uncover the country's "mineral wealth," the field of geology benefited from King's journeys.

The Alps and the glaciers together are able to take every bit of conceit out of a man and reduce his self-importance to zero if he will only remain within the influence of their sublime presence long enough to give it a fair and reasonable chance to do its work.

—MARK TWAIN, *A TRAMP ABROAD*, 1890

In 1870, he allocated time to the study of Mount Shasta, in northern California, believed to be the tallest peak in the country at that time. It held considerable importance for King, who questioned the conclusion of earlier explorers that no glaciers blanketed the mountain. He subsequently discovered Whitney Glacier, which became the first scientifically observed glacier in the United States. These alpine experiences led to the publication of *Mountaineering in the Sierra Nevada* (1872) and his appointment in 1879 as the first director of the U.S. Geological Survey (USGS), which today provides important data on glacial activity and climate change.

King traveled through the mountains with the photographers Timothy O'Sullivan (1840–1882) and Carleton Watkins (1829–1916), whose images of Yosemite Valley inspired its preservation in 1864. Using mammoth 18-by-22-inch glass plate negatives and a specially designed darkroom wagon, Watkins captured Whitney Glacier in both large-format photographs and three-dimensional views created with a stereoscopic camera. In *Mount Shasta and Whitney Glacier seen from the crater (Shastina)*, the artist dramatically documents the glacier's 50-foot-wide crevasses (**fig. 15**). By framing the diagonal flow of ice punctuated by Mount Shasta's exposed rock face rising in the distance, Watkins accentuates the expanse and movement of Whitney Glacier.

FIGURE 15

Carleton E. Watkins, *Mount Shasta and Whitney Glacier in California, seen from the crater (Shastina)*, from US Geological Exploration of the 40th Parallel (King Survey), 1870, black-and-white photograph.

As a geology student who also sketched from nature, King read Ruskin's books and attended the Harvard University lectures of Louis Agassiz, who later became a friend. These formative experiences inspired King to cofound, in 1863, the Society for the Advancement of Truth in Art, which was based on Ruskin's belief that the "ultimate job of the realist is not photographic duplication but creation of internal truths through faithfulness to nature's."[26] The concept of "internal truth" encouraged the creative interpretation of landscape within the parameters of naturalism.

King's ideas must have resonated with his friend Albert Bierstadt (1830–1902), celebrated as the premier painter of the American West. The artist juggled a reverence for sublime wilderness with its promise of wealth, privileged power, and potential for development. At this time, the American landscape, its wildlife, and its native peoples teetered on a critical threshold of ecological transformation, paralleling the challenges facing the planet's environment today.[27]

Bierstadt's career was wedded to Manifest Destiny, America's mid-century obsession with continental expansion. The movement toward building an empire was motivated, in part, by the promise of riches obtained through the exploitation of natural resources. Expansionism was fueled by the whaling industry, which affected polar ecosystems during the zenith of Manifest Destiny.[28]

Bierstadt contributed to America's march across the continent through his participation in government expeditions. In 1859, he journeyed west with Colonel Frederick W. Lander's survey of the Nebraska Territory. The artist's masterpiece of the period, *Landers Peak Rocky Mountains* (1863, Metropolitan Museum of Art), made his reputation while introducing Easterners to the country's grandeur and natural abundance.

Bierstadt was also patronized by railroad executives, who capitalized on the popular allure of alpine landscapes by establishing lodging along their transportation corridor through the Rockies. Mount Sir Donald, almost 11,000 feet (3,352 m)

in elevation, was painted during Bierstadt's junket with the Canadian Pacific Railroad in 1889 (**fig. 16**). The peak rises majestically in Glacier National Park, which was established the same year that the transcontinental railway was completed in 1886.[29] Bierstadt stayed in the official railroad lodging, called Glacier House at that time. Located near the Illecillewaet Glacier, it commanded a full view of the mountain and proved a perfect perch for inspiration and study.

In *Mount Sir Donald, Asulkan Glacier* (c. 1890), the artist divides his vertical canvas into two contrasting realms that draw the eye from the dark depths of the forest to the glistening pyramidal peak silhouetted against an azure sky. Although he used an amalgam of different views to create the composition, the artist portrayed the mountain with complete accuracy. Bierstadt offered a larger painting of this subject to the mountain's namesake, Sir Donald Smith, the entrepreneur of the Canadian Pacific Railroad. The sale was never made, and the painting currently hangs at the New Bedford Free Library in Massachusetts.

Bierstadt's highly polished style was based on realistic details from nature inserted into compositions that were imaginatively interpreted for dramatic effect. This approach also defined the work of many other artists working on the East Coast, including Frederic Edwin Church and William Bradford, who created many of America's greatest Arctic paintings.

Thomas Hart Benton (American, 1889–1975) also traveled to the Canadian Rockies, which inspired *Trail Riders* (1964–65), a sweeping, cinematic view of Mount Assiniboine (**fig. 17**). The artist faithfully documents the landscape and the mountain's conical shape resembling the famous Matterhorn in the Alps.[30] In contrast to the approach taken by Bierstadt, Benton abstractly renders individual elements into curving forms that express nature's energy.

Casting a nostalgic look at American history, Benton presents an unusual mid-twentieth century interpretation of Manifest Destiny. The artist, a

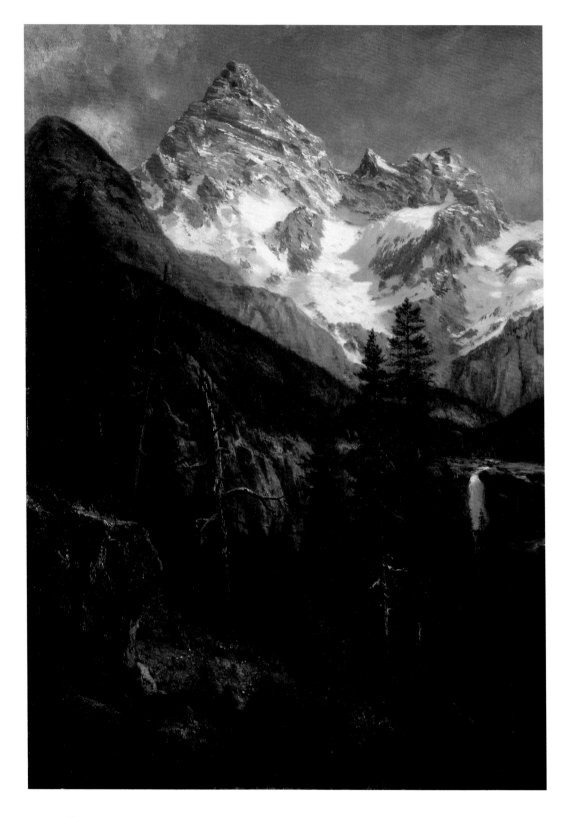

FIGURE 16
Albert Bierstadt, *Mount Sir Donald, Asulkan Glacier*, c. 1890,
oil on canvas.

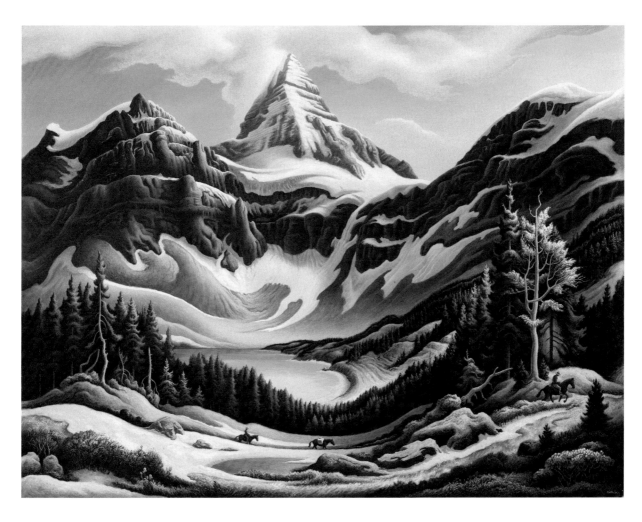

FIGURE 17
Thomas Hart Benton, *Trail Riders,* 1964–65, oil on canvas.

grandnephew of a prominent, populist Missouri senator who helped shape the policies of American expansionism, looks back to a time when trailblazers settled the American West. Throughout his life, he mythologized this theme, beginning with early paintings like *The Pathfinder* (1926) and culminating in the grand-scale mural, *Independence and the Opening of the American West* (1959–62), commissioned for the Truman presidential library in Independence, Missouri. In the 1930s, such themes earned Benton recognition as a "regionalist" artist who celebrated Middle American values by depicting rural culture.

Trail Riders also draws upon classic Hollywood westerns that celebrate the loners and

nomads along pioneer trails. The artist's gigs in Hollywood for *Life* magazine and Walt Disney enabled him to see firsthand the creation of these idealized heroes.

In this painting, Benton meditates on his personal relationship to the land: the protagonists riding along the trail represent the artist and his friend, who explored the Banff region of the Canadian Rockies on horseback in 1963. Benton turned to the mountains for solace after his regionalist aesthetic was scorned by an art world enamored with another movement, abstract expressionism, in the 1950s. The landscape assuaged the artist's loneliness and distaste for America's increasing urban culture.[31]

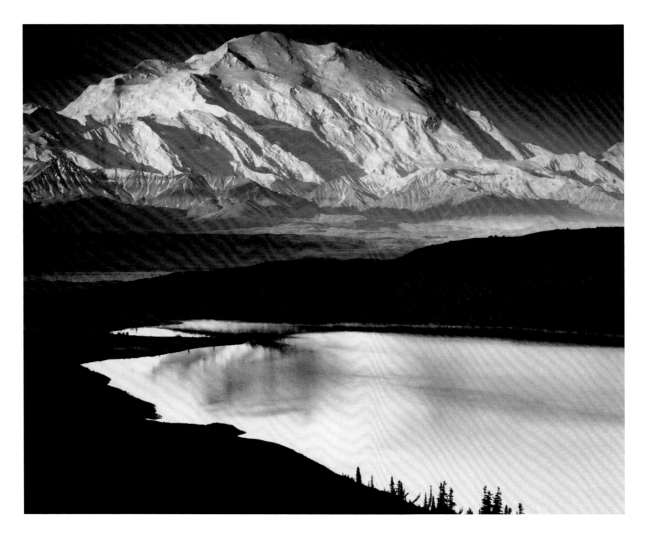

FIGURE 18
Ansel Adams, *Mount McKinley and Wonder Lake, Denali National Park and Preserve, Alaska,* 1947, printed c. 1972, gelatin silver print, © 2012 The Ansel Adams Publishing Rights Trust.

Many artists have embraced the idea of an alpine pilgrimage to escape civilization and experience spiritual awareness. Ansel Adams (1902–1984) frequented the magisterial heights of the American West and dedicated his career to its preservation. Although most well known for his views of Yosemite, which he visited annually over a period of sixty-eight years, Adams journeyed to Alaska during the summers of 1947 and 1949.

For the artist, Alaska represented the quintessential wilderness, and Mount Denali, the highest peak in North America, symbolized Earth's sovereignty. In *Mount McKinley and Wonder Lake,*
Denali National Park and Preserve, Alaska (1947), Adams interprets the mountain as a glowing, celestial form rising from the shadows of an embryonic landscape (**fig. 18**). The awesome magnitude of Mount Denali's 20,000-foot (6,096 m) elevation and five glaciers inspired the artist to advocate for greater wilderness protection in Alaska.

Adams took three exposures of *Mount McKinley and Wonder Lake* at the onset of dawn at 1:30 a.m. during a break in cloud cover.[32] The sublime beauty of the mountain's glaciers proved a perfect vehicle for his style, which was based on heightening dramatic contrasts of light and shadow.

FIGURE 19

Chris Jordan, *Denali Denial*, 2006, archival inkjet print.

(right) Detail of *Denali Denial*

The artist's close relationship to the Sierra Club, which he joined in 1919, helped define his career. The Sierra Club, founded in 1892 by the naturalist John Muir (Scottish-American, 1838–1914), was one of the first organizations dedicated to the preservation of nature.[33] Adams and the Sierra Club rallied public support to protect the southern flank of California's Sierra Nevada mountains, which were dramatically sculpted by glaciers. In 1940, these lands became Kings Canyon National Park. The Sierra Club also published Adams's photography books, including *This Is the American Earth* (1960), which along with Rachel Carson's *Silent Spring* (1962) helped galvanize the mid-twentieth century environmental movement.

Mount McKinley and Wonder Lake inspired Chris Jordan (American, b. 1963) to create *Denali Denial* (2006, **fig. 19**). The artist digitally transforms Adams's image by incorporating twenty-four

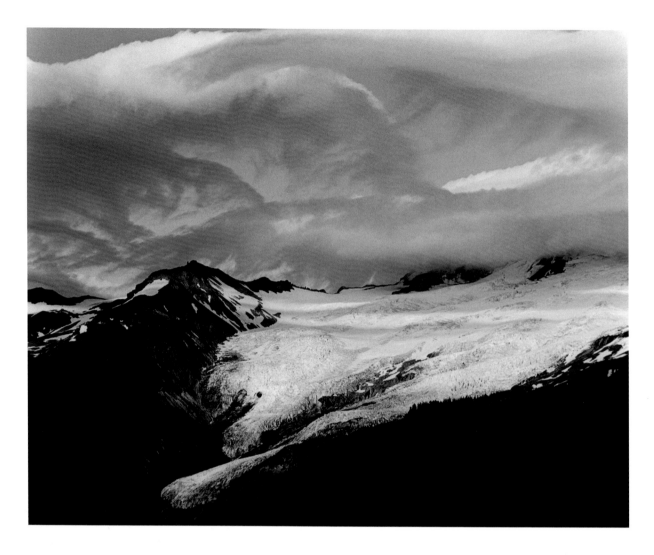

FIGURE 20
Eliot Porter, *Noctilucent Clouds over Mount Baker,*
Washington, July 30, 1975, imbibition print.

thousand GMC Yukon Denali logos, which equaled
six weeks of sales of that model SUV in 2004. Half
of the logos have been changed to the word *denial*.
The irony of a pristine peak being the source of the
name of a low-mileage, gas-guzzling vehicle that
contributes to climate change becomes magnified by
Jordan's reinterpretation of Adams's iconic image of
wilderness.

The photograph belongs to a series titled
Running the Numbers: An American Self-Portrait
(2006–9), based on statistical research gathered by
the artist to comment on America's consumptive
behavior. While photographing garbage landfills,
Jordan was astonished at the sheer bulk of their

contents. This led him to photograph single objects
and then digitally repeat them en masse to visualize
conspicuous consumption and our reliance on non-
biodegradable goods.

Like Ansel Adams, Eliot Porter (American,
1901–1990) believed that the preservation of
wilderness was a spiritual necessity. He also col-
laborated with the Sierra Club to save critical lands
from development and served as its director from
1965 to 1971. The artist produced several books,
including *In Wildness Is the Preservation of the
World* (1962), which celebrated New England's
woodlands through his photography and quota-
tions from the transcendental philosopher Henry

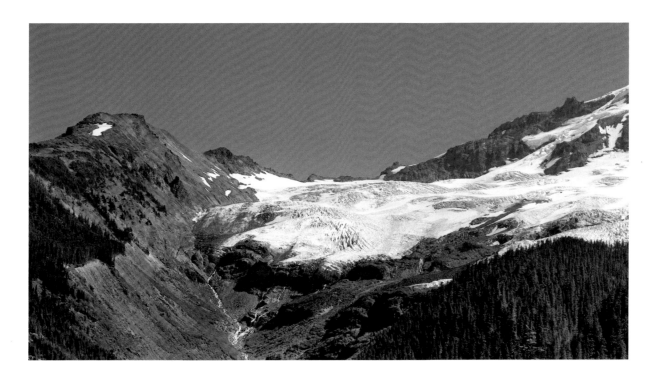

FIGURE 21
Brett Baunton, *Coleman Glacier, Mount Baker,* 2007, archival inkjet print.

David Thoreau (American, 1817–1867). Porter's work helped introduce the Sierra Club to a wider audience.

In contrast to Adams, Porter pioneered color landscape photography. He documented the natural world's deeply saturated colors through the complex process of dye transfer prints. In 1974–75 and 1975–76, Porter was the first photographer to work in Antarctica as a fellow of the National Science Foundation Antarctic Artists and Writers Program. His images appeared in a landmark book and exhibition, *Antarctica* (1978).

In the summer of 1975, Porter journeyed to the Pacific Northwest. Fascinated by the region's glaciers, he visited Mount Rainier and Mount Baker. In his view of Mount Baker, Washington, the artist captured Coleman Glacier and the dramatic cloud formations swirling around the 10,781-foot (3,286 m) peak (**fig. 20**). Thirty-two years later, Brett Baunton (American, b. 1959) documented the glacier from a slightly higher vantage point (**fig. 21**). By comparing the two views, one can see clearly that Mount Baker's glaciers have lost close to twenty percent of their volume in the intervening years.[34]

Baunton, whose photographs have appeared in *National Geographic*, has devoted much of his career to photographing glaciers. He has climbed Washington's highest mountains, including Mount Rainier and Mount Olympus. As a backcounty ranger in Denali National Park, the artist found solitude in the icy landscape of the Far North.

The quest for spiritual experiences in icy climes attracted three artists from different cultural backgrounds—Rockwell Kent (American, 1882–1971), Lawren Harris (Canadian, 1885–1970), and Nicholas Roerich (Russian, 1874–1947). They painted alpine and polar landscapes in a representational style that also assimilated aspects of modern art: its simplification of forms, emphasis on geometry, and expansive areas of color. The artists loved the cool, clear northern light that sharpened the outlines of glaciated mountains and icebergs.

For Kent, who like Thomas Hart Benton felt himself an outsider, the frozen frontiers offered a refuge from the trivialities of life. The artist traveled in the Alps and lived for brief periods in Newfoundland, Alaska, and Greenland. In these northern realms, his feelings of alienation melted away, and the remote environment made him feel whole.

The artist considered Fox Island, located in Resurrection Bay, thirteen nautical miles from Seward, Alaska, a paradise. Here, he could measure himself against the elements, fell trees to heat his tiny cabin, and take baths in the snow. His day-to-day survival and art making were documented in *Wilderness: A Journal of Quiet Adventure in Alaska* (1920), a nine-month sojourn during 1918 and 1919 with his nine-year-old son. This journal reflects the writings of the American transcendental philosophers, particularly Thoreau, whose *Walden; or, Life in the Woods* (1854) celebrated self-reliance and an intimate relationship to nature.

Kent painted from the land and in small boats, bringing back sketches that would inspire him throughout his life. In the 1970 edition of *Wilderness*, Kent lamented the environmental changes caused by development over the fifty years since his first visit. He might find it hard to imagine that the site of his rustic cabin, now part of the Kenai Fjords National Park, is home to a resort.

In *Resurrection Bay, Alaska* (c. 1939), Kent paints the remarkable Bear Glacier, which is visible in the distance (**fig. 22**). Although he regretted the impossibility of getting closer to the ice, he navigated his small boat off Fox Island's dangerous coast to a nearby cove where he made a sketch of the glacial tongue reaching toward the water. Kent must have been impressed with this view because a similar depiction of Bear Glacier and its surrounding peaks was selected as the title page of *Wilderness*.[35]

The 15.5-mile long (25 km) Bear Glacier, among the best-documented fields of ice in the United States, has been rapidly retreating. Between 2000 and 2007, the ice receded two miles (3.5

And so this sojourn in the wilderness is in no sense an artist's junket in search of picturesque material for brush or pencil, but the fight to freedom of a man who detests the petty quarrels and bitterness of the crowded world— the pilgrimage of a philosopher in quest of Happiness!

— ROCKWELL KENT, *WILDERNESS: A JOURNAL OF QUIET ADVENTURE IN ALASKA*, 1918

km), producing large icebergs now visible in NASA Landsat photographs.[36]

There are no icebergs calving off the formation in this 1939 landscape, which appears to be a composite view that includes tree snags once located near Kent's cabin. The artist may have arrived at the composition in the manner described in his journal page dated January 23, 1919:

> For the past three weeks I have made an average of no less than one good drawing a day. . . . During the day I paint out-of-doors from nature by way of fixing the forms and above all the color of the out-of-doors in my mind. Then after dark I go into a trance. . . . I lie down or sit with closed eyes until I "see" a composition, — then I make a quick note of it, maybe give an hour's time to perfecting the arrangement on a small scale.[37]

Kent completed *Resurrection Bay, Alaska*, four years after his return from Greenland, where he lived on two occasions (1931–32 and 1934–35). Home again in the ice and far from the exigencies of civilization, Kent relished the land that nourished his soul and basked in the friendship of its native people.

Lawren Harris, who identified the north as a source of cosmic power, owned thirteen artworks of

FIGURE 22

Rockwell Kent, *Resurrection Bay, Alaska,* c. 1939, oil on canvas
on board.

Tierra del Fuego by Rockwell Kent. In their passion for interpreting the spiritual beauty of frozen landscapes, the artists were kindred spirits. As the most prominent member of Canada's Group of Seven, Harris voyaged to the Rockies and the eastern Arctic to celebrate the northern landscape.

The artist was motivated to create a national style distinct from the dominance of European culture. Nonetheless, he was inspired by Casper David Friedrich (German, 1774–1840) and the Scandinavian landscape paintings that he encountered in a large exhibition at the Albright-Knox Art Gallery, Buffalo, New York, in 1913.

Harris's search for spiritual truth led him to reduce forms and colors to their most elemental essence. His art reflects the influence of Theosophy, a late nineteenth-century movement that blended the mysticism of eastern spiritual traditions.

In *Isolation Peak*, based on a panoramic drawing of the Rocky Mountains, Harris presents a distant view of Mont des Poilus in Alberta's Yoho National Park (1930, **fig. 23**). He pares the mountain down to a simple triangular shape.[38] Its serpentine glaciers and moraine flow directly toward the viewer, who experiences the image suspended above the field of ice. The artist's universal mountain, not unlike the Mount Meru described in ancient Hindu and Buddhist texts, exists in a rarified, cloudless atmosphere. Dramatically illuminated by no visible light source, *Isolation Peak* loses it naturalism and becomes a bridge to a higher consciousness.

After spending four summers in the Canadian Rockies beginning in 1924, Harris set off with his friend, the artist A.Y. Jackson, for the more frigid climes along Baffin and Ellesmere Islands and the northwest Greenland coast. As passengers aboard the *Boethic*, an Arctic supply ship, they spent two months exploring land and sea in 1930. In his cabin, by porthole light, Harris painted fifty small oil sketches from pencil drawings made with difficulty on deck. In contrast to most of Kent's paintings, where the artist often integrates figures into the landscape, Harris's works rarely admit humans.

Like Harris, the art of Nicholas Roerich was inspired by Theosophy.[39] After immigrating to the United States, Roerich established an art school and dedicated his life to the pursuit of peace through art. He garnered support for the Roerich Pact (1930–present), a treaty designed to protect the world's art, historic monuments, and cultural institutions. In recognition of his pioneering work, he was nominated several times for the Nobel Peace Prize.

Roerich developed a passion for the Himalayan Mountains and its cultures. In 1924, he and his wife, Helena (Russian, 1879–1955), a Buddhist scholar, embarked on an epic expedition to Central Asia, which was described in his book *Heart of Asia: Memories from the Himalayas* (1929). Over four years and thirty-five mountain passes, Roerich documented the region's cultural artifacts and tribal customs and made sketches that resulted in close to five hundred paintings. He eventually settled in Kullu, Northern India, in view of the Himalayas, which he would paint for the remainder of his life.[40]

In *Tibet Himalayas* (1933), Roerich portrays a mystical Shangri-la defined by the Vajrayana Buddhist tradition (**fig. 24**).[41] Prayer flags, stupas, and monastic buildings nestle harmoniously among the glaciers of the world's highest mountains rising as steep, inaccessible needles. As with Harris's *Isolation Peak*, the viewer hovers in space absorbing the landscape.

Not rooted in any specific geography, *Tibet Himalayas* may represent the utopian Shambhala described in Buddhist sacred texts. James Hilton's novel *Lost Horizon* (1933), which was adapted to film, popularized this idea in the West. Roerich personally believed in a coming age of enlightenment, which would usher in a golden age of peace.

Roerich shapes the ice-capped mountains to resonate with the two foreground stupas, architectural mandalas that house the relics of spiritual teachers. Mountains informed the symbolism of the mandala, a sacred diagram that represents the universe embodying the four sacred directions and central core of cosmic union. Roerich's painting reflects

FIGURE 23

Lawren Harris, *Isolation Peak, Rocky Mountains,* 1930, oil on canvas.

FIGURE 24

Nicholas Roerich, *Tibet Himalayas*, 1933, tempera on canvas.

FIGURE 25

Jyoti Duwadi, *Red Earth-Vanishing Ice* (detail), 2008, mixed-media installation, Sundaram Tagore Gallery, New York.

the reverence toward the Himalayas that attracts pilgrims to circumambulate the base of such important peaks as Mount Kailash.

Growing up in the shadows of the Himalayas, Jyoti Duwadi (American, b. Nepal, 1947) developed an appreciation for alpine mountains while living in Darjeeling, India. Duwadi was also inspired by the art of Nicholas Roerich, whose paintings he knew indirectly through a signed illustrated book that was a gift of friendship from the Russian artist to his grandfather. After attending a Theosophical school in Varanasi and immigrating to the United States, Duwadi began painting cosmic landscapes inspired by Mount Kanchenjunga.

In 2008, Duwadi addressed climate change in *Red Earth-Vanishing Ice*, a mixed-media,

site-specific installation at the Sundaram Tagore Gallery in New York City (**fig. 25**). The artist suspended a block of ice from a water pipe in the gallery's ceiling that he wrapped in yak-hair rope. Each day, the ice was replenished and left to slowly melt on a rock from the Narmada River. It was nestled within a sculptural assemblage of hand-made wooden containers, copper cauldrons, and brass vessels with flowers floating on water from Kathmandu and New York. A fifteen-foot, draping canvas painted with Guggul, turmeric, and earth pigments represented nature's regenerative powers. The installation symbolized the purity of water, its scarcity as a natural resource, and the meltdown of glaciers around the world.

Duwadi's installation *Melting Ice* will be sited

in the Whatcom Museum's Lightcatcher courtyard for the opening of *Vanishing Ice*. He will create a large block of ice that will be left to melt. The artist first used art to call attention to environmental issues after he became acquainted with Helen and Newton Harrison, pioneers of ecological art who currently focus on climate change in regions around the world.[42]

The Harrisons (American, b. 1929 and b.1932) address the effects of climate change in the Himalayas in *Tibet Is the High Ground, Part IV*, which is part of a larger project called *Force Majeure* (2008–present, **fig. 26**). Annotating a large-scale map of the region with poetic text, they spotlight an area containing fifteen thousand glaciers. As the source of major rivers—from the Indus, Ganges, and Bramaputra in South Asia to China's Yellow and Yangtze and Vietnam's MeKong—glaciers provide sustenance for millions of people. Freshwater shortages have been identified as potential sources of future conflict in the region.

The artists not only draw attention to climate change, they also propose a solution based on adaptation: reintroduce the forests and grasslands that once dominated an interglacial period with a warmer climate. This concept "assists the migration of a palette of species" and creates "a 2 million square kilometer sponge to normalize rivers and secure the lands from flood and drought."

The Harrisons' artworks, which encompass large ecosystems that transcend national boundaries, result from research and cross-disciplinary collaboration. Exhibited in a public forum, their art, embedded in the story of place, functions as a catalyst for conversation.

While the Harrisons' works are conceptual, David Breashears (American, b. 1955), a celebrated mountaineer and filmmaker, takes a more documentary approach. Both are concerned that a changing climate will destabilize the teeming populations that depend on water from the glacier-packed Himalayas for survival.

Breashears, who has been journeying to the Himalayas for decades, has personally experienced

global warming. While preparing for expeditions to Mount Everest and reaching its summit five times over the course of thirty years, he became intimate with the landscape and the unique cultures it supports. His experience led him to direct the IMAX documentary *Everest* (1998), which made a significant contribution to the 70mm format, the successor to stereoscopic photographs. The artist recorded the first 360-degree view from the summit.[43]

While preparing for the IMAX film project, Breashears tucked away a 1921 photograph of Rongbuk Glacier taken by the mountaineer George Mallory (British 1886–1924), who attempted the first ascent and disappeared on Mount Everest in 1924. After trekking to the same viewpoint eighty-six years later, the artist was astonished by the more than half-mile extent of glacial recession.

Making a commitment to document the vanishing Himalayan glaciers, Breashears organized *The Glacier Research Imaging Project*, which "retraced the steps of some of the world's greatest mountain photographers as they took pictures—many of them not previously published or displayed—over the past 110 years across the Himalaya and the Tibetan Plateau."[44] Breashears compares his 2008 panoramic photograph *West Rongbuk Glacier, 227°59'17"N, 86°55'31"E* with the view captured by Edward Oliver Wheeler (Canadian, 1890–1962), who was a member of the first topographical survey of Mount Everest in 1921 (**figs. 27 and 28**). Its wide format enables the artist to dramatically expose the glacier's vertical loss of 341 feet (104 m).

Like the Himalayas, the Andes have also experienced severe glacial recession with dramatic consequences for an important Peruvian celebration and ritual, called *Qoyllur Rit'i* (Snow Star). Eirik Johnson (American, b. 1974) and Martin Chambi (Peruvian, 1891–1973) have photographed this centuries-old pilgrimage, which is based on an

FIGURE 26
Helen and Newton Harrison, *Tibet Is the High Ground Part IV: The Force Majeure,* 2008–present, archival coloring on vinyl.

Research indicates on the Tibetan Plateau

glaciers will shrink so much

That their melting borders will dry up

Profoundly affecting

The Salween, MeKong, Huang-Ho

Brahmaputra, Yangtze, Ganges

And Indus River systems

That traverse inner Mongolia,

China, Tibet, Autonomous-zone India

Burma, Laos, Cambodia, South Vietnam,

Bangladesh, Kashmir and Pakistan

A Force Majeure has come into being

In the form of global warming

That will work to the disadvantage

Of 1/16th of the earth's population

Or about 1.2 billion people

Who live in the 7 drain Basins

That comprise over

2.4 million square miles

Thus we make an unlikely proposal

in this highly stressed probable future

by generating

the paleoecological research

in order to locate forest

And Savannah ecosystems

Which existed in Eemian Interglacial period

When temperatures were

Similar to those predicted in the near future

And thereafter

to search to locate local similar

ecosystems that Exist in our now

And to begin designing and in part

Creating the process to Assist the

Migration of a palette of species

Able to replace or restate

Those now coming under Extreme stress

Thereby Generating new forest

And grassland

which will in good part replace

The slow water releasing

Properties of glaciers

and snowmelt by in part creating

a 2 million square kilometer sponge

To normalize rivers

and secure the lands from flood and drought

—HELEN AND NEWTON HARRISON

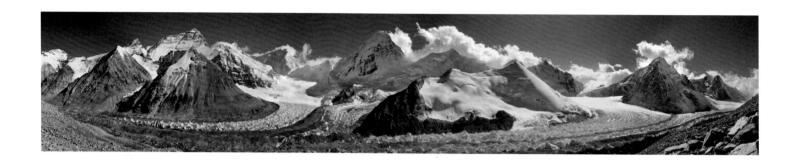

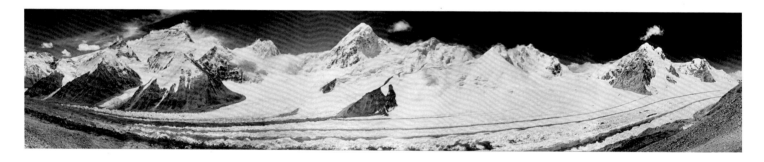

FIGURE 27

David Breashears, *West Rongbuk Glacier*, 227°59'17"N,
86°55'31"E, 2008, inkjet print on canvas.
Location: Northern Slope of Mount Everest, 29,028 ft.
(8847.7 m) Tibet, China
Range: Mahalangur Himal
Elevation of glacier: 17,300–20,341 ft. (5,273–6,200 m); average
vertical glacier loss: 341 ft. (104 m), 1921–2008

FIGURE 28

Edward Oliver Wheeler, *West Rongbuk Glacier*, 1921, black-
and-white photograph.

FIGURE 29
Eirik Johnson, *La Cordillera Colquepunko, Peru,* from the
series *Snow Star,* 2004, archival pigment print.

FIGURE 30
Martin Chambi, *Peregrino en Qoyllor Rit'i (Pilgrim at Qoyllur
Rit'i),* 1930s, gelatin silver print.

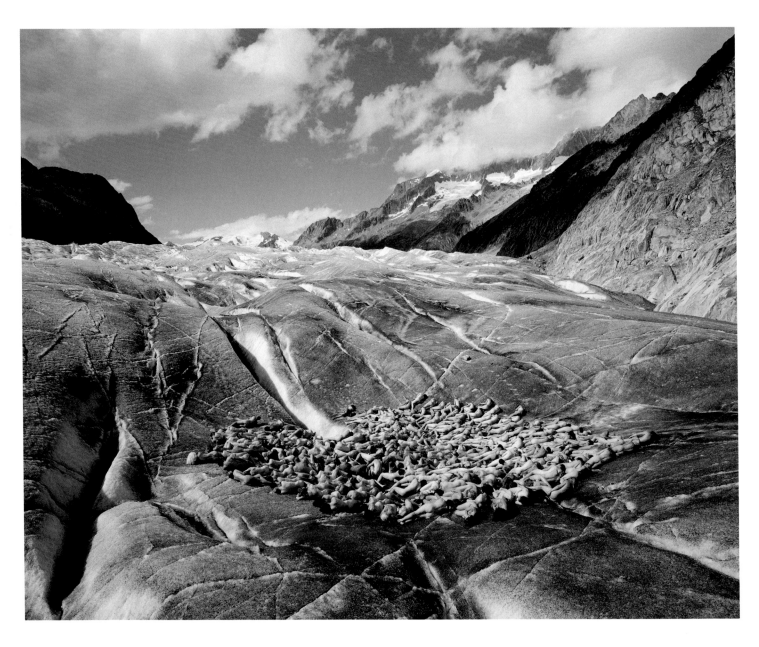

FIGURE 31

Spencer Tunick, *Aletsch Glacier #4, Switzerland,* 2007, inkjet
print on canvas.

amalgam of Catholic and pre-Columbian beliefs. In juxtaposition, these photographs make clear the dramatic loss of ice on the slopes of Mount Colquepunku (**figs. 29 and 30**).

Chambi, the first indigenous photographer to document life in his own country, captured the annual festivities in the 1930s. In *Peregrino en Qoyllur Rit'i (Pilgrim at Qoyllur Rit'i)*, he portrays a contemplative moment amidst the pageantry. From a rocky promontory, a pilgrim, surveys the gathering that attracts thousands of people. Climbing to altitudes of more than 16,000 feet (4876.8 m), participants engage in continuous singing and dancing to ensure well-being and prosperity.

In *La Cordillera Colquepunku* (2004), one of a series of photographs interpreting the Snow Star festival, Johnson presents an expansive alpine panorama, the sublime backdrop to the human activities in the Sinakara Valley. The pilgrims are now mere specks within the mountain sanctuary grounds. In the distance, snaking lines of people define a path to the glaciers.

A selected group of young male dancers, called *ukukus*, trek to the glacier to retrieve pieces of ice, which symbolize health and fertility. An essential component of the ritual, the ice is believed to possess magical healing powers. The Andean glaciers, shrinking since the mid-1970s, have retreated approximately six hundred feet (182 m) in the last twenty years. The ritual collecting of ice has now been abandoned.[45] By photographing the spiritual life of the Andean people, Chambi and Johnson call attention to the importance of glaciers and the cultural implications of climate change.

Spencer Tunick (American, b. 1967) documents a very different kind of pilgrimage, one in which the participants literally exposed themselves as a strategy for bringing public attention to the effects of a changing climate on alpine glaciers (**fig. 31**). On August 19, 2007, the artist staged an installation on the Aletsch Glacier in Switzerland in association with the environmental organization Greenpeace. He directed six hundred volunteers to pose without clothes and lay down their bodies on selected areas of ice.[46]

The Aletsch Glacier, the largest in the Alps and a protected UNESCO World Heritage site, retreated approximately 377 feet (115 m) in just one year, 2005 to 2006. Tunick broadcast this phenomenon as news of his performance spread through media channels around the world.[47]

Known for his documentation of live nudes in public settings, Tunick creates a "living sculpture," where volunteers become temporary performance artists. In this work, he metaphorically compares the fragility of human life without protection from clothing to that of the earth without glaciers. The artist states, "I want my images to go more than skin-deep. I want the viewers to feel the vulnerability of their existence and how it relates closely to the sensitivity of the world's glaciers."[48]

Although Tunick's installation of live nudes seems light-years away from many nineteenth-century landscape paintings, they share one thing—the inclusion of human figures to suggest the immensity of glaciers. The crowd of people cradled in a small pocket of the Aletsch Glacier appears as dwarfed as the tiny tourists gazing at the Mer de Glace in Jean-Antoine Linck's painting (**fig. 5**). In spite of the changes in style, media, and approach, generations of artists underscore both the sublimity of mountain glaciers and their importance for understanding the history and future of the planet.

1. As landscape painting ascended in popularity, it challenged the hierarchy of European art, which was founded on classical ideals of the human form. Until the nineteenth century, official art academies considered the interpretation of nature a lowly pursuit. Narrative painting, based on biblical stories and historical events, was the favored genre. Depicting nature was considered imitation compared to the higher level of imagination required to paint heroic themes that glorified man.

2. Duccio's *The Temptation of Christ on the Mountain* (1308–1311) is on display in the Frick Collection, New York. Centuries later, Pieter Bruegel the Elder (Flemish, c. 1525–1569), one of the first artists to cross the Alps on his way to Italy in 1552–1553, drew some of the earliest panoramic alpine landscapes. In these views, which were engraved, glaciers are not prominent. The first known close-up of a glacier is a topographical watercolor of the Rofener Glacier, drawn by Abraham Jäger in 1601 and housed in the Tiroler Landesmuseum, Innsbruck, Austria.

3. See Nicolson, *Mountain Gloom and Mountain Glory* (142), where she describes the change of attitude through literature and science toward mountains.

4. Ibid., 197.

5. Ibid., 273.

6. See Imhof, "Glacier Fluctuations."

7. See Bourrit, *Journey to the Glaciers.*

8. Beattie in *The Alps* (122), examines the importance of Rousseau for generating new perceptions of the Alps.

9. British artists, such as Francis Towne (1739–1816) also influenced this trend. One of his most accomplished works, *Source of the Aveyron*, is housed at the Victoria and Albert Museum, London.

10. This earlier view was taken during the Little Ice Age, a "glacier-friendly period" described by Nussbaumer as lasting a few centuries from the late Middle Ages (1300–1500) to the late nineteenth century. It was distinguished by cold summers and winters with lots of snow. The Mer de Glace reached its maximum in the 1640s and was followed by two other peaks around 1820 and 1855. Since the 1850s, the glacier has retreated by more than 2 km until the present day. See Nussbaumer, et al., and http://www.swissinfo.ch/eng/Glaciers_seen_through_the_eyes_of_old_masters.html.

11. Karl Schimper (German, 1803–1867) first used the word *EisZeit* (Ice Age) in 1837.

12. See Fox, *Terra Antarctica*, 151. Elisha Kane's scientific observations of Greenland's massive ice cap and outlet glaciers, accompanied by artist's images, helped convince many people that immense ice sheets had once blanketed large sections of Earth. His two-volume *Arctic Expeditions* (1850–51), illustrated with three hundred engravings of the region, became one of the most popular books of its time. Kane's own drawings provided the illustrations for the engravings made by the artist James Hamilton (Irish-American, 1819–1878), who was inspired by JMW Turner and became the teacher of Thomas Moran.

13. See Matilsky, "Sublime Landscape Painting in Nineteenth Century France," 104–34.

14. To appreciate Rémond's extraordinary naturalist approach, see the same subject painted by Joseph Anton Koch, *Das Wetterhorn von der Rosenlaui*, 1824, oil on canvas, Museum Oskar Reinhart am Stadtgarten, Winterthur.

15. Translated from a letter written by Ours-Pierre-Armand Dufrénoy (1792–1857), Inspector General of Mines and director of the School of Mining, dated May 28, 1852, in the National Archives, Paris.

16. The architect Eugene Viollet le Duc (1814–1879) may have been inspired by Hugard's work. He completed a watercolor of Mont Blanc in 1871 as a study for a projected series of panel paintings for his residence in Lausanne, Switzerland. The writings of Saussure were also a source of inspiration. In 1875 and 1877, his exhaustive book, *Mont Blanc: A Treatise on its geodesical and geological constitution,* was published in French and English. It was accompanied by 112 illustrations that he sketched himself. Viollet le Duc was one of the founders of the French Alpine Club in 1874.

17. Saussure was one of the first scientists to design "hot boxes" made from glass, which simulated the atmospheric greenhouse effect. He concluded that particles in the atmosphere helped trap solar radiation, thus heating Earth's surface.

18. Gamble, "John Ruskin, Eugene Viollet-Le-Duc and the Alps," 185.

19. Kinsey is recognized for his photographs of the Pacific Northwest logging industry. Like many Americans, the photographer both appreciated the beauty of nature and was complicit in its exploitation. He was hired by logging companies to document the felling of old-growth trees and also earned money by making portraits of the loggers. The Whatcom Museum holds the largest repository of the artist's work.

20. For a comparison of the two early views, which are in the Ruskin Library, Lancaster, England, see http://www.lanccca.ac.uk/users/ruskinlib/Pages/treasures.html.

21. See Ruskin, *Modern Painters* (345), for his response to nature's sublimity.

22. Gamble, 188.

23. Wilton, *Turner and the Sublime*, 121.

24. Gage, *J.M.W. Turner*, 218–19.

25. For a biography of Clarence King, see: http://www.siskiyous.edu/shasta/art/cla.htm.

26. Ibid.

27. Many of the century's greatest American landscape painters contributed to the exploitation of nature through their intimate association with real estate magnates, railroad executives, and government surveyors. For compelling research into this subject, see Boime, *The Magisterial Gaze*.

28. The importance of whale oil for the American economy is documented in the film *Into the Deep: America, Whaling and the World*, 2011, which was produced for the *American Experience* series on PBS.

29. See the Haggin Museum website: http://www.hagginmuseum.org/collections/bierstadt_mount_sir_donald_asulkan_glacier.shtml.

30. According to the U.S. Geological Survey, glaciers on Mount Assiniboine have decreased 820 feet in twenty-three years, an average of more than 35 feet per year.

31. See Wolff, *Thomas Hart Benton*.

32. Brinkley, *The Quiet World*, 333.

33. Muir's study of geology led him to surmise that Yosemite was formed by glaciers, a theory rejected by many experts, including Josiah Whitney, the director of the California Geological Society. Louis Agassiz sided with Muir in this debate. Muir's numerous trips to Alaska, where he visited Glacier Bay, were undertaken to learn more about the action of glaciers. A large painting of Muir Glacier (1889) by Thomas Hill, was commissioned by Muir. It belongs to the Oakland Museum of California with another version at the Anchorage Museum in Alaska. The Muir Glacier has since retreated dramatically and can now no longer be classified as a tidewater glacier.

34. According to the North Cascades Glacier Climate Project, terminus observations on nine principal Mount Baker glaciers, 1984–2009, indicate retreat ranging from 240 to 520m, with a mean of 370m. For more information, see http://www.nichols.edu/departments/glacier/mount%20baker%20hyp.9453.pdf .

35. In this version, the artist paints Sunny Cove, the spot where he once landed for a hilltop hike. In the foreground, Kent positions a huge bamboo pole, swept up on the beach from Japan, which was noted in his journal.

36. Bruce Molnia, a geologist with the U.S. Geological Survey, photographed the glacier in 2005 to compare it with a 1920 postcard of the image, see http://www.usgs.gov/climate_landuse/glaciers/repeat_photography.asp#bear_glacier.

37. Kent, *Wilderness*, 150.

38. See Townshend, *Canadian Parks* .

39. In Saint Petersburg, Nicholas Roerich met the leading figures in both art and science. Most notable were his costumes and set designs for Igor Stravinsky's *Rite of Spring*, performed by Alexander Nijinsky in Paris, 1909, for Sergei Diaghilev's Ballet Russes. His early paintings also reflect the influence of Russian folk art and the landscape of the Siberian tundra.

40. It is now the site of the Urusvati Himalayan Research Institute, which Roerich founded for scholars to study the notes of his expedition.

41. James Baillie Fraser, the first artist to document the Himalayas, provided lithographs for *Views of the Himalaya Mountains*, London, 1802. See Jacobs, *The Painted Voyage*, 66.

42. In *Myth of the Nagas and the Kathmandu Valley Watershed* (1993), Duwadi and the author interpreted indigenous Buddhist and Hindu art and beliefs to rekindle environmental awareness in Nepal. See Matilsky, "The Survival of Culture and Nature," 14–15.

43. A scientific component also defined the IMAX expedition mission, with the geologist Roger Billings placing GPS satellite receivers on the summit to study earthquakes. Another film by Breashears, *Storm over Mount Everest* (2005), documented the deadliest Everest climb, in May 1996, and aired on the PBS series *Frontline* in 2008.

44. See http://www.glacierworks.org/.

45. The Ukukus Wonder Why a Sacred Glacier Melts in Peru's Andes," *Wall Street Journal*, June 17, 2005, http://online.wsj.com/article/0,,SB111896313493862032,00.html?mod=todays_us_page_one.

46. The artist explains that participants put on slippers to walk to the designated spot and laid on special glacier-covering material to protect their bodies from direct contact with the ice. From conversation with the author on September 20, 2012.

47. Statistics from Greenpeace International, http://www.greenpeace.org/international/en/news/features/naked-glacier-tunick-08182007/.

48. In collaboration with Greenpeace, Tunick has also used his art to draw attention to climate change and its effects on the wines of Burgundy, France (2009). In Israel, he staged an installation that called attention to the importance of water and the disappearing Dead Sea (2011).

Map of Antarctica (Landsat Image Mosaic of Antarctica)
Courtesy of the US Geological Survey, National Science
Foundation, National Aeronautics and Space Administration,
and the British Antarctic Survey

MAGNETIC ATTRACTION: THE ALLURE OF THE POLES

I believe that after the heroic part of the expedition has been forgotten, these color records which
I have will long be remembered by the future generations. I say this as a student of history: art
and science always are more successful when they are joined together, because without graphic
illustrations of its results, science is less comprehensive and sometimes very dry. All through the ages,
the civilized world has left its best results graphically whether in print or in pictorial form.

—DAVID ABBEY PAIGE, FROM A LETTER TO ADMIRAL RICHARD BYRD, DATED 1937

PRIMARILY AN OCEAN surrounded by land, the Arctic is about the same size as the continental United States. The tips of three continents—North America, Europe, and Asia—penetrate its boundaries, enabling humans to populate the lands within the Arctic Circle. By contrast, Antarctica is a huge continent (about one and three-quarters the size of the United States) encompassed by the Southern Ocean. It marks the point where the Atlantic, Pacific, and Indian waters converge and submerged rivers circulate warm and cold currents around the planet. Antarctica became home to humans only in the mid-twentieth century, when nations established permanent bases for scientific research.

The Arctic and its opposite, Antarctica (anti-Arctic), help to regulate Earth's climate, which is why the environmental changes happening there will ultimately affect life everywhere. Scientists, artists, and writers voyage to the poles to study and interpret the effects of increasing levels of carbon dioxide on ice and the history of Earth's climate. Conscious of the fragility of ice, many artists make their journeys simply to experience and capture the magnificent landscape. Regardless of their motivation, they follow the path of earlier explorers who first shared images and information about these extreme, beautiful regions with the rest of the world.

The Arctic

The polar environment entered the public imagination during the seventeenth century, when Dutch artists painted the earliest sea- and landscapes of the Arctic.

They depicted the icy waters navigated by explorers searching for a northern passage to Asian markets and the hunting grounds of a booming whaling industry. These expeditions were sometimes illustrated by hand-colored engravings. Dutch merchants and traders whose wealth was linked to related commercial ventures proved a ready market for this art.[1]

In 1596, the explorer Willem Barents (Dutch, 1550–1597) discovered the Arctic island of Spitsbergen, which he named after its "sharp mountains." One of the closest lands to the pole, it was later incorporated into the larger Norwegian archipelago, known today as Svalbard. The landscape has inspired dozens of artists, including François-Auguste Biard, Christian Houge, Nerys Levy, and travelers with the Cape Farewell project, who have documented the island's transformation over the centuries.

Barents's expedition heralded Spitsbergen's fertile whaling grounds. By the late seventeenth century, close to 150 whaling ships plied the Arctic waters, providing the wealth that fueled the Dutch economy and its golden age of culture. This brutal enterprise, staining large bays of water red with blood, displayed little concern for the animal or recognition of sustainable practices.[2] Overhunting resulted in the near extinction of bowhead whales. Seamen soon moved on to other regions for their prey, including the oceans off Antarctica. This pattern of natural resource exploitation and depletion mirrors fossil fuel extraction today.

In a remarkable early painting, Abraham Storck (Dutch, 1644–1708) portrays the hunt of a bowhead whale off the icy coast of Spitsbergen (fig. 32). With one harpoon already embedded in its body and another on the way, the whale's sentient eye pierces the viewer. The artist's arresting close-up view of the animal dominates this combination sea- and landscape. Storck also presents a view of an onshore processing plant that rendered whale blubber into oil. *Dutch Whalers in Sptizbergen* (1690) contains all the features that would appeal to wealthy mercantile-patrons: a dramatic sunset, unique environment, and the hunt of an exotic animal in a signature trade that boosted the country's economy.

Early polar paintings were based on oral and written accounts of mariners. Not until the eighteenth century were artists commissioned to accompany expeditions. The precedent was set by the English during the three epic voyages of Captain James Cook (British, 1728–1779), who explored the Pacific (where he witnessed the transit of Venus

along the sun in 1769), crossed the Antarctic Circle in 1773, and charted the coasts of Alaska and northeast Siberia in 1778.

Defining the age of discovery, Cook revolutionized the notion of the expedition itself by including scientists and artists who advanced public understanding of the planet's geography, anthropology, and fauna and flora. His expeditions marked a milestone in scientific and artistic achievement. Setting a standard of interdisciplinary collaboration that many voyages later emulated, Cook's journeys marked the emergence of the artist-naturalist-explorer.

The poles became popular subjects during the late eighteenth and the nineteenth centuries at the same time that artists, naturalists, and mountaineers were discovering mountain glaciers.[3] The similarities between the Alps and Arctic topography were under investigation by scientists at this time.

After Cook's voyages, John Ross (Scottish, 1777–1856) and William Edward Parry (British, 1790–1855) rekindled an interest in Arctic exploration in 1818. Their quest, like many explorers two centuries earlier, centered on discovering a potential northwest route to Asia. The English Admiralty was obsessed by this idea even though many experienced whalers and naturalists dismissed its commercial viability. The feat remained unclaimed until 1906, when Roald Amundsen (Norwegian, 1872–1928) forged the passage that continues to defy maritime transport.[4] The Admiralty was also motivated by the glory of fame, fortune, and immortality identified by then poet laureate Alfred Lord Tennyson, who wrote: "There is nothing worth living for but to have one's name inscribed on the Arctic chart."[5]

During the nineteenth century, artists invited to participate in polar expeditions, often sponsored by government, were the mission's "documentary eyes." Before the advent of photography, drawing was the most adaptable medium for quickly capturing a motif. The British Admiralty and the French navy hired artists to teach young recruits to draw. Many naval officers—James Ross, the Beechey brothers, Charles Wilkes, and Barthélémy

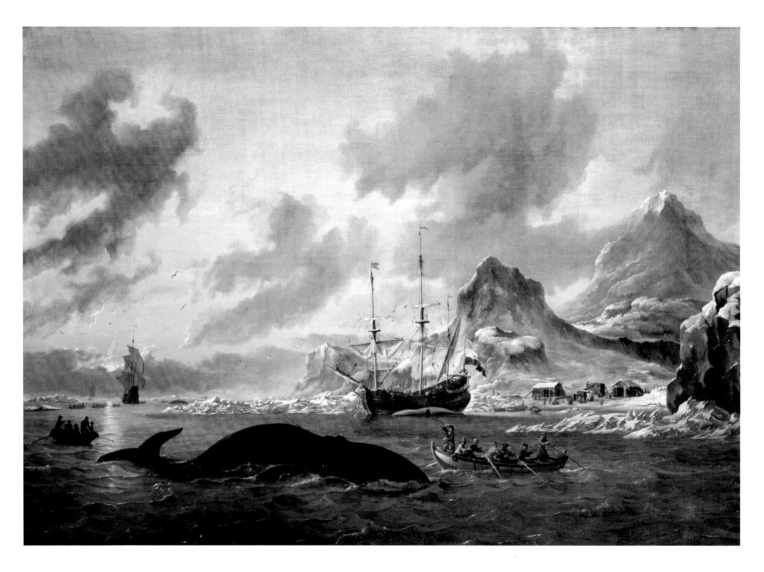

FIGURE 32

Abraham Storck, *Dutch Whalers in Spitzbergen*, 1690, oil on canvas, Stichting Rujksmuseum het Zuiderzeemuseum, Amsterdam.

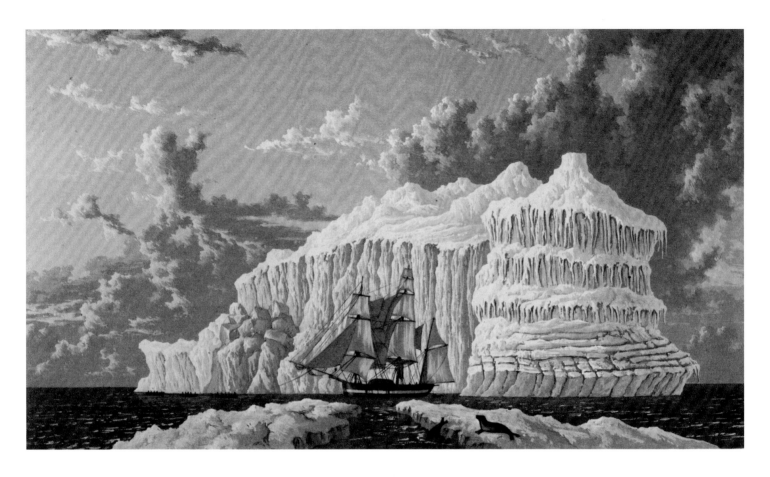

FIGURE 33
Frederick William Beechey, *HMS Hecla in Baffin Bay,*
illustration from *Journal of a Voyage for the Discovery of a
Northwest Passage from the Atlantic to the Pacific Performed in
the Years 1819-20 in His Majesty's Ships Hecla and Griper,* 1821.

Lauvergne, among them—were also artists whose
sketches were often made into prints for publication
and paintings for exhibition.

The work of Frederick William Beechey (British, 1796–1856), a naval officer and artist and
president of the Royal Geographical Society, stands
among the earliest examples of this nineteenth-
century trend. Beechey accompanied Parry on his
famous Arctic journey and contributed drawings
reproduced in *Journal of a Voyage for the Discovery of a Northwest Passage from the Atlantic to
the Pacific Performed in the Years 1819–20 in His
Majesty's Ships Hecla and Griper.* The publication,
describing the exploration of eight hundred miles
of uncharted coastline and the discovery of the
entrance to the Northwest Passage, catapulted Parry
to fame. He became the nineteenth century's first

hero-explorer, and his exploits inspired one of the
greatest polar landscapes, Caspar David Friedrich's
Das Eismeer (The Sea of Ice) in 1824 (**fig. 41**).

Part of the public adulation stemmed from
the danger faced by mariners, providing artists with
dramatic subject matter that riveted readers. In
HMS Heckla in Baffin Bay (1821), Beechey depicts
Parry's ship silhouetted against a towering iceberg
and penned in by floating sea ice complete with
resident seals (**fig. 33**).

The ship, almost crushed between these formations, was saved by the heroic rowing efforts
of the crew in small boats that towed the *Hecla*
to safety.[6] The men repeated this rescue procedure
through ice-choked channels. Anchoring his ships
as far as Melville Island, Parry was the first white
man to reach beyond 110 degrees latitude.

Melding fantasy and observation, Beechey captures the iceberg's bizarre shape. In the same way that no snowflake looks the same, each iceberg has its own character, which perpetually changes as it journeys from the tongue of a glacier through the open waters. Thrashed by waves, incised by the sun's heat, and sculpted by the wind, icebergs were the perfect motif to satisfy the curiosity and romanticism of Western viewers.

Building on English precedent, the French government under King Louis Philippe (1773–1850) invited artists to participate in Arctic voyages. The Commission scientifique du Nord (Scientific Commission of the North) traveled to Scandinavia, Lapland, and Spitsbergen during the years 1838–40. The expedition's highlight was the exploration of Spitsbergen in 1839, when the crew anchored at Magdalena Bay. They pitched their tents for thirteen days after two weeks crossing the polar sea. During this voyage, comparisons between the glaciers of Switzerland, Norway, and Spitsbergen were recorded by scientists.[7]

Headed by the naturalist and physician Joseph Paul Gaimard (1796–1858), the commission included a botanist, geologist, meteorologist, physical hydrographer, the linguist and writer Xavier Marmier (1808–1892), and the artists Charles Giraud (1819–1892) and Barthélémy Lauvergne (1805–1871). King Louis Philippe also invited one of his favorite artists, François-Auguste Biard (1799–1882), to join the expedition on its Arctic leg.

Biard did not serve the expedition in any official capacity and independently financed his passage. He was accompanied by his wife-to-be, Léonie d'Aunet, eighteen years old, who later wrote a travelogue titled *Voyage d'une femme au Spitzberg* (*Voyage of a Woman in Spitzberg*, 1855). She was probably the first European woman to explore the Arctic.

The artists considered themselves essential to the expedition because of their ability to visually communicate new discoveries to the public. According to the official expedition account, artists were the hardest-working members of the crew. Faced with countless views to document, the artists' speed and accuracy were highly valued. These abilities earned Lauvergne the title "living daguerreotype," after an early photographic process. The artist, a veteran explorer who participated in three circumnavigations before joining the Scientific Commission of the North, dedicated his life to the French navy as an administrative officer until his retirement in 1863.

A lithograph by Lauvergne depicts Giraud and Biard sketching, oblivious to Mme d'Aunet arm-in-arm with Xavier Marmier and Paul Gaimard (**fig. 34**). In this topographically accurate yet evocative landscape, the artist inspires meditation on humanity's fragile presence within nature. He selects a vantage point that draws the viewer into a forlorn sailor's cemetery. Open coffins and crosses marking graves challenge assumptions about man's dominion over nature.

Sketchbooks composed of quickly drawn landscapes were the foundation for Lauvergne's polished lithographs, which appeared in profusely illustrated atlases. In addition to the traditional journal of the voyage, these multivolume atlases presented the region's landscape, inhabitants, flora, and fauna. A selected group of images also appeared in illustrated newspapers and magazines.

The atlases of the Scientific Commission of the North aroused the interest of the Académie des Beaux-Arts (Academy of Fine Arts), which elected a special committee to evaluate the expedition's artistic achievements. Martin Conway (British, 1856–1937), a geographer, mountaineer, and art critic claimed that this voyage made the greatest artistic contribution of any nineteenth-century expedition.[8]

The most remarkable painting resulting from this expedition, François-Auguste Biard's *Pêche au morse par des Groënlandais, vue de l'Océan Glacial* (*Greenlanders hunting walrus, view of the Polar Sea*), was exhibited at the 1841 Paris Salon (**fig. 35**). In this protosurrealistic narrative based on human survival in a little-known environment, the artist melded fact and fantasy, naturalism and romanticism.

FIGURE 34

Barthélémy Lauvergne, *Vue prise dans la baie de Smeremberg
(View of the Smeremberg Bay)*, 1839, from *Voyages de la
Commission scientifique du Nord en Scandinavie, en Laponie,
au Spitzberg, et aux Feroe, pendant les annees, 1838, 1839 et
1840, sur la corvette la Recherche*, commandee par M. Fabvre/
publies par order du Gouvernment sous la direction de Paul
Gaimard, Paris: Arthus Bertrand, *Atlas Pittorèsque*, c. 1842–55,
lithograph.

FIGURE 35

Francois-Auguste Biard, *Pêche au morse par des
Groënlandais, vue de l'Océan Glacial* (*Greenlanders hunting
walrus, view of the Polar Sea*), Salon of 1841, oil on canvas,
Musée du Chateau, Dieppe, France. Photo credit: Erich
Lessing / Art Resource, NY.

FIGURE 36
Len Jenshel, *Narsaq Sound, Greenland,* 2001, C-print.

The Arctic stimulated Biard's imagination and freed him from traditional conceptions of landscape painting. Interpreting the hallucinatory effect of sea ice and icebergs on his senses, the artist conjured fantastic forms. At the same time, he sensitively documents meteorological conditions—the oppressive gray sky and magical blue-green tints of ice. The painting reflects the work of scientists, who were studying Arctic light during the expedition.[9]

Biard was not the only polar traveler to respond to the dreamlike qualities of ice. Explorers to both the North and South Poles described in journals the strange and marvelous shapes and colors they saw there. Photography would later authenticate the veracity of views depicted by early artists.

Biard's interpretation of ice is not far removed from the photographs of icebergs by Len Jenshel (American, b. 1949), who began his career in 1974

and helped color photography gain acceptance as a fine-art medium. In *Narsaq Sound, Greenland* (2001, **fig. 36**), the artist vividly captures the fantastic structure and deeply saturated colors of an iceberg. Focusing on the luminous blending of water, ice, and sky, he magnifies the Arctic's extraordinary atmospheric effects.

During his journey, Biard sketched native peoples, their weapons, clothing, and kayaks (*umiaks*), which were purchased for his personal ethnographic museum containing more than one thousand objects. Although the artist did not witness an actual hunt on his Arctic voyage, he was able to observe walrus upon the expedition's return to Hammerfest, Norway, where mariners brought their catch. In Biard's painting, two walrus uncannily peer at the viewer from the edge of the painting.[10]

Biard's passion for the Far North culminates in the 360-degree panorama of Magdalena Bay, Spitsbergen, on display in the vestibule of the Gallery of Mineralogy at the Museum of Natural History, Paris (**fig. 37**). Commissioned in 1851 and completed in 1864, the four paintings that surround the visitor represent what the artist observed and imagined the Arctic to be. Referencing more than six hundred drawings and thirty-eight oil sketches from the expedition, the artist faithfully represents the elevations of mountains, locations of glaciers, and outcrops of rock along the coastline. In each of the four wall paintings, the artist portrays one of the scientists at work in the field.

By contrast, the hunting scenes of reindeer, polar bear, and walrus inserted by Biard into the composition never occurred. The artist's liberties reflect his passion—and the public's demand—for dramatic, adventurous imagery.[11] Biard's landscapes reflect the ideas of the celebrated scientist Alexander von Humboldt (German, 1769–1859), who encouraged artists to paint panoramas that fostered the public's respect for and admiration of nature. By locating his paintings in the Museum of Natural History, where Humboldt had lectured and worked, Biard advanced the scientist's interdisciplinary vision.[12]

Francois-Auguste Biard, *Panorama of Magdalena Bay, Spitsbergen* (detail), 1852, Museum of Natural History, Paris.

A new portrait of Spitsbergen emerges in Christian Houge's (Norwegian, b. 1972) panoramic photographs, where technology and once-pristine nature collide. During the course of eight years and ten trips, Houge became fascinated by the island's Soviet-era coal-mining town of Barentsburg, and later by the presence of international scientific activities. In images measuring as large as twelve feet, Houge interprets the industrial ruins on an island that was first home in the seventeenth century to a whale-processing plant, realistically depicted by Cornelis de Man (Dutch, 1621–1706)

in his landscape painting *Whale Oil Factory of the Amsterdam Chamber of the Northern Company at Smeerenburg* (1639, Rijksmuseum, Amsterdam).

Although Spitsbergen's abundance of natural resources, from whales to coal, led to its early exploitation, the island has become a mecca for scientists who study astronomy and atmospheric chemistry. Scientific apparatus has been hauntingly interpreted by Houge in his series titled *Arctic Technology* (**fig. 38**). In *Winternight* (2001), the viewer confronts an uncanny portrait of a radio telescope isolated and timelessly bathed in an ethereal blue atmosphere. Attracted to night scenes that dramatize an eerie light, the artist purposely contrasts the ultra-high technology of contemporary science with the elemental aspects of the natural world. This science-fiction-like photograph would have thrilled the author Jules Verne (French, 1828–1905), whose futuristic vision merged with polar sublimity in such books as *The Adventures of Captain Hatteras* (1866).

Like Biard, Frederic Edwin Church (1826–1900), America's leading landscape painter, was similarly inspired by Humboldt. In contrast to the French artist, whose naturalistic landscapes were the settings for dramatic narratives, Church infused geology with divinity (**fig. 39**). The majesty of *The Icebergs* (1861) reflects the spiritual experience of nature described by American transcendental philosophers Henry David Thoreau (1817–1862) and Ralph Waldo Emerson (1803–1882).[13]

In 1859, Church traveled from New York City to Battle Harbour, Labrador, via Newfoundland, specifically to paint icebergs. During his self-financed, six-week journey, the artist completed more than a hundred pencil and oil sketches that reveal the evanescent effects of light on icebergs adrift from Greenland glaciers. As an amateur naturalist, Church keenly observed details of the environment, depicting from all angles the complex shapes and irregular profiles of ice mountains.

The artist was forced to sketch quickly amid extreme cold and fast-moving weather systems that vexingly obscured the view. Rocky seas added an

The green waters of the fiord were filled with sun-spangles; the fleet of icebergs set forth on their voyages with the upspringing breeze; and on the innumerable mirrors and prisms of these bergs, on those of the shattered crystal walls of the glaciers, common white light and rainbow light began to burn, while the mountains shone in their frosty jewelry, and loomed again in the thin azure in serene terrestrial majesty.

—JOHN MUIR, *TRAVELS IN ALASKA*, 1915

element of danger, especially when the artist commanded the crew to navigate more closely to an iceberg for a better view. Given the right conditions, Church would work for up to two hours on a sketch. When complete, the artist called to the oarsmen to scout another angle or side of the iceberg. Depending on the formation, the iceberg could recall the wonders of architecture—mosques, cathedrals, the Parthenon, castles. And the colors kept changing according to the position of the sun and atmospheric conditions: purples, blues, emeralds—a jewel box of tints and tones.[14]

The Icebergs reveals how Arctic imagery could be employed for symbolic and expressive purposes. The painting was exhibited to the public in New York on April 27, 1861, fifteen days after the advent of the Civil War. Sympathetic to the Union cause, Church originally titled his painting *The North*, and advertised that viewer admission charges would aid the families of soldiers through a donation to the Patriotic Fund. Fascinated viewers paid twenty-five cents to view the painting. Although favorably reviewed by the press, the painting failed to fetch its $10,000 asking price, a victim of the toughening wartime economy.[15] In pursuit of a collector, Church later exhibited his painting in Boston and shipped it to London a year later. Always the astute

FIGURE 38
Christian Houge, *Winternight,* 2001, digital C-print.

FIGURE 39
Frederic Edwin Church, *The Icebergs,* 1861, oil on canvas.

businessman, Church renamed his painting *The Icebergs*, recognizing that British public opinion favored the Confederacy.[16] The artist made a more significant change by adding a ship's mast to the foreground, a symbolic nod to Sir John Franklin, who perished in the Arctic. His widow, Lady Jane Franklin, the force behind the explorer's heroic status, attended the exhibition's opening reception.

Although the history of *The Icebergs* continues to fascinate, most revealing is the artist's statement that accompanied the painting at its New York debut. This one-page document, divided into seven sections, describes the work's various aspects: "The Form of the Iceberg," "Motion of the Iceberg," "Surface of the Iceberg," "Colors of the Iceberg," "The Sea," "The Sky," "Expression of the Scene."

The painting and statement together read as a natural treatise on the characteristics of icebergs,

influenced by geological processes and primeval time. Traveling great distances, this iceberg becomes a specimen of transformation. The eroding boulder, precariously balanced at the cavern's edge, provides evidence of the slice of land from which it emerged. This rock, embedded in a glacier that calved into the sea, reflects Church's understanding of the birth of icebergs.

Although Church painted *The Icebergs* with naturalistic finesse, the purely imaginary composition was created from a composite of several views, none based on surviving sketches. This approach enabled the artist, a religious man, to present the Arctic as a symbol of nature's grand unity, the handiwork of the ultimate Creator.

Church's sketches of icebergs inspired Cynthia Camlin (American, b. 1960), who uses a variety of media to create ethereal images of dissolving ice. In

Melted 4 (2008), one in a series of watercolors called *Extremities*, the artist reveals the formation beneath the waterline, making palpable the fact that the tip of the iceberg represents only one-eighth of its volume (**fig. 40**). Camlin presents a cross section of its inner core through a network of geometry that suggests the crystalline nature of freezing water.

FIGURE 40

Cynthia Camlin, *Melted 4,* 2008, watercolor and acrylic on paper.

Melted 4, an unusual view of a solitary iceberg floating in undefined space, springs from the imagination and the technique that Camlin developed to evoke the ever-changing nature of frozen formations. After spontaneously dropping opaque watercolors into pools of water dripped on the paper, she discovers and then begins defining the iceberg's forms. This chance-based process becomes a metaphor for the life of an iceberg.

Before Frederic Edwin Church was born, Caspar David Friedrich (German 1774–1840) painted some of the earliest pure landscapes inflected with divinity. The artist believed that the North nurtured the greatest possibility for spiritual experience. For this reason, Friedrich planned a trip to Iceland, which unfortunately never materialized. The artist had to be content with sketching ice floes along the Elbe River near Dresden, which would freeze during winter.

News of Parry's 1819–20 expedition partly inspired Friedrich's greatest tribute to the region, *Das Eismeer* (*Sea of Ice*, 1823–24), whose thick slabs of ice were based on his frozen river studies (**fig. 41**). Piled into the shape of an alpine peak, the rock-like mass recalls cemetery gravestones. Like apparitions along the horizon, distant icebergs echo the triangular central image. Symbols of death appear in the mast and barely visible hull of a ship crushed by the ice.

Sea of Ice corresponds to Friedrich's withdrawal from society and his state of mind after his art became neglected. During his melancholic final year, the artist continued to sketch ice floes along the Elbe. These studies would later inspire Gerhard Richter (German, b. 1932) to paint romantic interpretations of icebergs. In such works as *Ice* (1981), the artist pays homage to the master. His vaporous light similarly invites contrasts with the solidity of solitary formations.

Many art historians have speculated on the meaning of Friedrich's painting: its implications of human vulnerability, death, and potential redemption through faith. Some believe that its foreboding

To that white region where the Lost lie low,
Wrapp'd in their mantles of eternal snow;
Unvisited by chance, nothing to mock
Those statues sculpted in the icy rock,
We pray your company; that hearts as true
(Though nothings of the air) may live for you;
Not only that on our little glass
A faint reflection of these wilds may pass
But, that the secrets of the cast Profound
Within us, an exploring hand may sound,
Testing the region of the ice-bound soul,
Seeking the passage as its northern pole,
Soft'ning the horrors of its wintry sleep,
Melting the surface of that "Frozen Deep."

—CHARLES DICKENS, *PROLOGUE TO THE FROZEN DEEP*, 1856

quality alludes to the clampdown on political freedom in Prince Metternich's Germany.[17]

The significance of the *Sea of Ice* resides in how Friedrich infused the Arctic landscape with a multitude of metaphorical and symbolic meanings. Documenting icy landscapes and creating geographical awareness cedes to a new conceptualization of the Far North as a vehicle to express emotions, issues, and ideas.

Continuing to mine the public fascination with the poles, later artists, such as Edwin Landseer (British, 1802–1873), would similarly imbue new meaning into Arctic imagery. In response to the loss of life and wealth searching for Sir John Franklin, presumed lost during his search for the Northwest Passage, Landseer painted *Man Proposes, God Disposes* (1864), a commentary on hubris and humanity's ultimate powerlessness against nature (**fig. 42**).

Amidst a desolate landscape of sea ice and bergs, the vestiges of a ship's mast and sail occupy the center of the composition, flanked by two polar

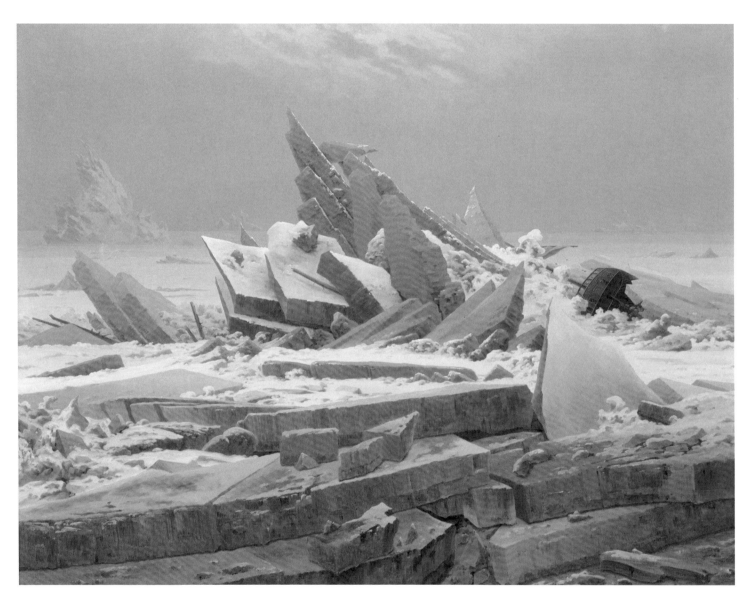

FIGURE 41

Caspar David Friedrich, *Das Eismeer (Sea of Ice),* 1823–24, oil on canvas, ©Hamburger Kunsthalle. Art Resource, NY.

FIGURE 42
Edwin Landseer, *Man Proposes, God Disposes*, 1864, oil on canvas.

FIGURE 43
Nicholas Kahn and Richard Selesnick, *Currency Balloon*, from *Eisbergfreistadt,* 2008, archival pigment print.

bears. The artist gruesomely depicts the animals devouring the Union Jack and a human rib. A broken telescope and lens lie on the ice nearby.

During the painting's exhibition at the Royal Academy, the public would have understood its association with the missing Arctic explorer, who departed England in 1845. A departure from Landseer's usual portraits of dogs and horses for the aristocracy, *Man Proposes, God Disposes* captures the heightened fear and fascination with the frozen North that gripped Britain after Franklin's disappearance.

Viewers may have associated the bears' carnivorous act with the rumors of cannibalism surrounding Franklin's voyage, which resulted in the death of 129 men. Proof of the explorer's demise was finally discovered in 1859. During the intervening fourteen years, fifty rescue expeditions were launched to no avail. The folly of spending vast sums of money and sacrificing more men in an attempt to discover the explorer's whereabouts may also have crossed the artist's mind.

Similarly, Nicholas Kahn and Richard Selesnick (British and American, both born 1964) appropriate Arctic imagery for commentary on contemporary issues. In their art installation *Eisbergfreistadt (Iceberg Free-State*, 2008), they critique greed and materialism and their connection with climate change. Known for their montaged panoramic photographs shot on location, the artists insert themselves into compositions by assuming the personas

of explorers. In *Currency Balloon*, the artist becomes a suave aviator scouting out the landscape from his dirigible, plastered with real and fictional bank notes from German city states (**fig. 43**).

Currency Balloon is just one of the photographs and artifacts constructed to illustrate a historical narrative that never happened. Responding to the history of polar explorations and the majestic Arctic environment, Kahn and Selesnick address humanity's response to past and contemporary events.

The artists set the stage as 1923 Weimar Germany by imagining a scenario of events after a massive iceberg from Spitsbergen runs aground at the Baltic port of Lubeck. According to their account, "Some German scientists postulated that the heat from factory smoke may have caused abnormally high breakup of the Arctic ice pack that year."[18]

The iceberg soon becomes a site of free trade and a haven for offshore banking. The actions of greedy brokers provoke rapid currency devaluation and hyperinflation. For the project, Kahn and Selesnick printed fake bank notes (featured on the balloon and the explorer's uniform), emblazoned with images of towering factories spewing smoke, with texts that warn: "To burn oil from Azerbaijan to Tibet puts the world on fire."

In *Iceberg Free-State*, the artists directly link the industrial growth of the early twentieth century to contemporary climate change. Not coincidentally, the installation's themes of profiteering and

devouring natural resources reverberate today.

The status of the polar bear, once a ferocious symbol of the Arctic in Landseer's hands, has been transformed in *Currency Balloon*. No longer menacing, the animal, turning from our gaze, appears isolated in an empty expanse of ice. Kahn and Selesnick poignantly allude to its endangered status.

Earlier appropriated as a symbol of nature's destructive forces, the polar bear is currently listed as threatened under the Endangered Species Act. The World Conservation Union (IUCN) predicts that populations will decline by about thirty percent over the next forty-five years due to climate change.

The loss of keystone Arctic species—polar bears, caribou, and sea mammals—gravely impacts the life of native peoples who experience climate change every day. Indifference to their plight reflects the marginalized status of aboriginals from the days of first contact with explorers. Mariners often ignored the Inuit people's unique adaptation to the polar environment, but ultimately both men and women played a critical role in Arctic exploration.

Early explorers, such as Parry, encountered native people, whom they called Eskimos. Parry's compatriot, John Ross, even named them Boothians after his friend Felix Booth, who financed his expedition. During Ross's Northwest Passage expedition in 1829–33, his crew became trapped by the Arctic ice for four years. They survived thanks to native skills and knowledge, learning that oil and fat (containing high quantities of vitamin C) were essential to prevent the dreaded disease of scurvy that had vanquished so many seamen. During their long encampment, the men relied on the Inuit's supply of fresh meat and on furs for clothing, once their navy woolens deteriorated.[19]

The boredom of wintering in the Arctic was relieved by visits to and from the Inuit. The men taught the aboriginals football and were permitted to indulge in the sexual favors of Inuit women. Despite their role in keeping his men alive, Ross considered them "barbarians." Once he exhausted

their knowledge of local geography, he refused them entry to his ship.

Ross made more than eighty drawings and watercolors (now owned by the Scott Polar Research Institute, University of Cambridge) to accompany his expedition account (**fig. 44**). The captain's charming, spontaneous style portrays native life before Western intrusion. *Snow Cottages of the Boothians*, illustrated in his *Narrative of a Second Voyage* (1835), depicts one explorer, perhaps Ross himself, greeting the Inuit who emerge from a cluster of igloos.

Since the nineteenth century, Western attitudes toward aboriginals have slowly evolved toward a greater consciousness of their unique and environmentally sustainable cultures. Contemporary artists such as Tiina Itkonen (Finnish, b. 1968) have adopted a more open approach. Inspired by the creation story of Sedna, Mother of the Sea, Itkonen made her first trip to Greenland in 1995. Captivated by the light and solitude of the icy terrain, as well as the accepting nature of its people, the artist traveled seven times to the region and lived within the Inuguit communities for six-week periods.

One of Itkonen's favorite places in Greenland is Uummannaq, located 366 miles (590 km) north of the Arctic Circle and home to thirteen hundred inhabitants of both Danish and Inughuit descent. In her portrait of the town, *Uummannaq 6* (2010), houses nestled on the edge of a promontory command a cinematic view of the ice floes below (**fig. 45**). While the introduction of colorful Western-style buildings adds vibrancy to this stark landscape, the way in which the artist crops the photograph dramatizes the precariousness of their existence. Itkonen's photographs reflect her observations and conversations with local people about the destabilizing effects of climate change on the region.

The artist's portraits of people and their intimate relationship to the environment appear in the book *Tiina Itkonen: Inughuit*, which includes an essay by the anthropologist Jean Malaurie (French, b. 1922), who authored *The Last Kings of Thule* (1955). He examined the changing culture

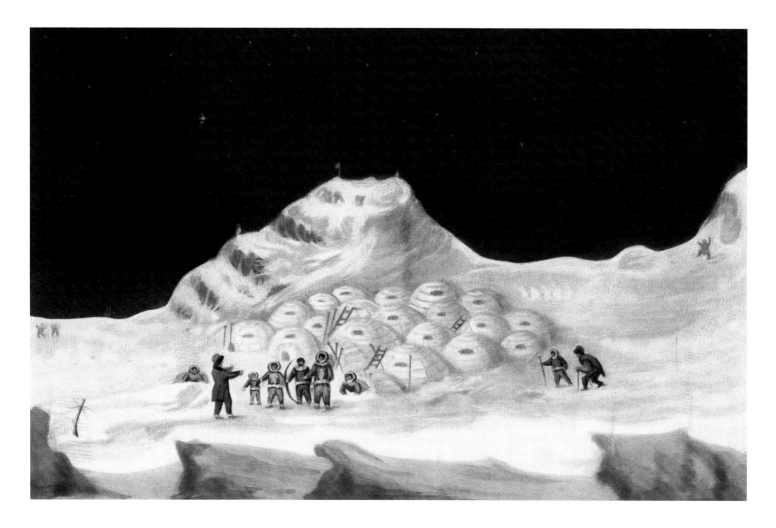

FIGURE 44

Sir John Ross, *Snow Cottages of the Boothians,* illustration from *Narrative of a Second Voyage in Search of a North-west Passage, and of a Residence in the Arctic Regions during the Years 1829, 1830, 1831, 1832, 1833.* London: A.W. Webster, 1835.

FIGURE 45
Tiina Itkonen, *Uummannaq 6,* 2010, C-print.

of western Greenland aboriginals forced to host a secret US military base used for nuclear bombers in the early 1950s. Itkonen similarly bears witness to a way of life under threat.

While living in Alaska's Arctic National Wildlife Refuge for almost two years, Subhankar Banerjee (American, b. India 1967) developed a relationship with two indigenous communities, the Gwich'in and the Iñupiat. He photographed their daily life and the diverse ecosystem they depend on for sustenance. In 2003, the artist produced an illustrated book, *Seasons of Life and Land,* which was accompanied by essays written by scientists and writers, including George Schaller and Peter Matthiessen. The refuge, captured by Banerjee in all four seasons, is the most biodiverse conservation region in the circumpolar north.

During his explorations, Banerjee had no way of knowing that his photographs would one day be used by California senator Barbara Boxer to draw attention to the refuge's abundance of life and avert exploratory drilling for oil. In response to Alaska senator Ted Stevens's description of the area as a "wasteland," Boxer presented Congress such

Caribou are not just what we eat; they are who we are. They are in our stories, songs and whole way we see the world. Caribou are our life. Without caribou we wouldn't exist.

—Sarah James, *Arctic Voices,* 2012

photographs as *Caribou Migration* from *Oil & the Caribou* (2002), which illustrates the majesty of wildlife and the necessity of a large expanse of land for their survival (**fig. 46**).

Arriving along the coast in time to bear their young, the Porcupine Caribou herd migrates four hundred miles in long lines over snow and ice every spring. Gwich'in people call the coastal plain where the Caribou roam and give birth the "Sacred Place Where Life Begins."

Banerjee's bird's-eye view of a vast caribou herd crossing a frozen river has become an iconic Arctic image. In 2005, the photograph was used in a *New York Times* advertisement, funded by an

alliance of environmental organizations, to alert the public to the issue of oil drilling in the Arctic National Wildlife Refuge.

Concern that fossil-fuel development will disrupt the migration route of the Porcupine herd conjures memories of the buffalo that roamed the Great Plains in vast numbers. In 1840, George Catlin (1796–1872), the artist known for his Native American portraits, proposed a park for the buffalo's preservation. No action was taken, and the animal dangled at the cusp of extinction.

By contrast, the US Congress established the Arctic National Wildlife Refuge in 1960 and widened its boundaries in 1980. The question of whether this land will be compromised by oil and mineral extraction remains unresolved. In Catlin's time, the concept of extinction failed to penetrate people's consciousness. In 1973, the US Congress passed the Endangered Species Act, and for the first time, a federal law was enacted to protect life other than human beings.

In the spirit of Ansel Adams and Eliot Porter before him, Banerjee's photographs are deeply embedded in the tradition of wilderness preservation. What sets him apart from these earlier photographers is his conscious inclusion of aboriginals in this equation.

The role of native people in the narrative of discovery has mostly been ignored. Until the twentieth century, regarded as the heroic age of polar exploration, most expedition crews refused to adopt indigenous clothing, food, transportation, and shelter that would have saved lives.

Admiral Richard Brydges Beechey (British, 1808–1895), an accomplished painter who exhibited at the Royal Academy, provides a fascinating glimpse into the British style of expedition (**fig. 47**). In *Captain Markham's most northerly encampment* (1877), he shows that explorers preferred wearing tight wool and flannel with no hoods rather than warm fur or sealskin parkas. Their heavy expedition sleds, pulled by men, contrasted with the Inuit's light, flexible sledges powered by dogs.

FIGURE 46
Subhankar Banerjee, *Caribou Migration* from *Oil & the Caribou,* 2002, color photograph from *Arctic National Wildlife Refuge: Seasons of Life and Land,* 2003.

Explorers lived in freezing tents instead of learning to build igloos.[20]

Beechey documents George Nare's North Pole expedition, sponsored by the British navy in 1875–76, which achieved the farthest footprint north. The ship *Alert* spent the winter on the north coast of Ellesmere Island at the record latitude 83°20.' From this point, Albert Markham and his team man-hauled their sled to the spot depicted here.[21]

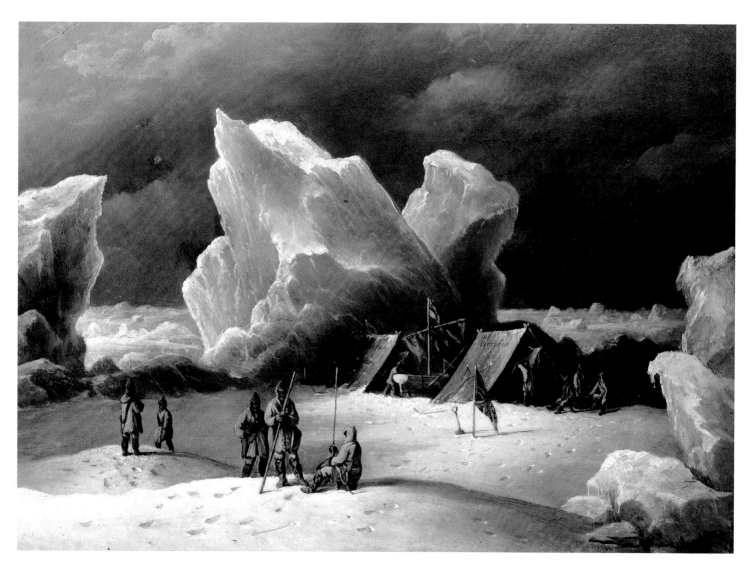

FIGURE 47

Admiral Richard Brydges Beechey, *Captain Markham's*
most northerly encampment, 1877, oil on paper, 22.8 x 34.3 cm,
National Maritime Museum, Greenwich, London.

Robert Edwin Peary (American, 1856–1920)
was the first to break Markham's record in 1891.
Following the route of Nare's expedition, Peary left
from Ellsmere Island on his final push to the North
Pole in 1909. He was accompanied by the African-
American explorer Matthew Henson (1866–1955)
and four Inuit men who forged the path.[22]

Peary, fixated on obtaining his goal, was not
very interested in scientific discoveries. Appealing
to patriotic ambitions of having an American be the
first to the pole, he was eager for fame. A thorough
planner and well-outfitted explorer, he succeeded in

reaching the farthest point north by adopting native
survival skills and relying on a coterie of Inuit men
and women to provide the fundamental elements of
existence: food, shelter, clothing, and sex. Both he
and Henson fathered Inuit children who later vis-
ited the United States.[23]

While Peary appropriated the lifestyle of the
Inuit, he did not particularly care for their welfare
and treated them as anthropological specimens.
In collaboration with a curator of ethnography at
New York's American Museum of Natural His-
tory, Peary brought home several aboriginal men,

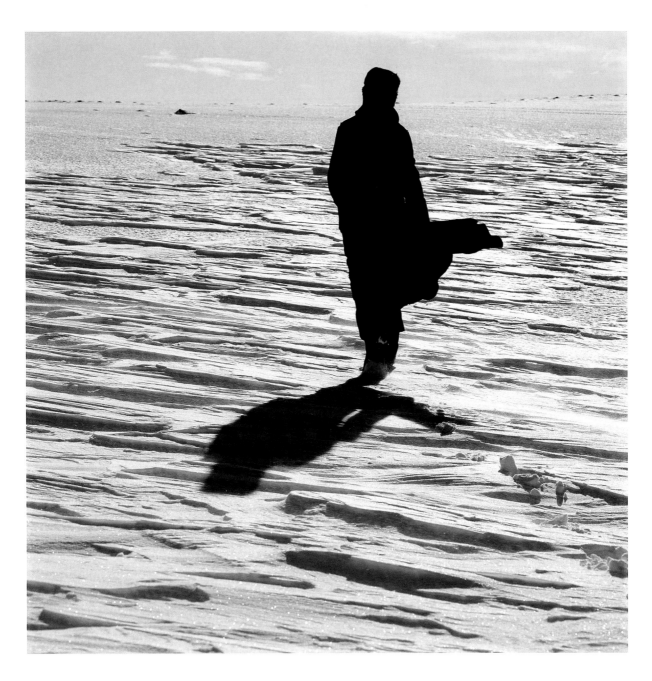

FIGURE 48
Isaac Julien, *Untitled (True North* series), 2004, cibachrome laminated on aluminum.

women, and children, who were housed in the museum basement and soon died from disease.

In his video *True North* (2004), Isaac Julien (British, b. 1960) poetically questions the myth of the hero-explorer and exposes the realities of racism that taint its glory. He resurrects Robert Peary's quest for the North Pole by retelling this saga from the point of view of Matthew Henson (**fig. 48**). Henson, who accompanied Peary on all his expeditions during twenty years of service, also wrote A *Negro Explorer at the North Pole: The Autobiography of Matthew Henson* (1912). A photograph snapped by Peary of Henson and his Inuit comrades at the pole appears in the book.

Julien offers a new take on Peary's expedition, which was financed by wealthy millionaires and big corporations. Filmed in Iceland, the video presents the wanderings of a regal, slightly androgynous woman, who mystically moves across iceberg-strewn ocean shores and white expanses of ice. Dressed in fur and later in a sheer, white dress, the surrogate-explorer hears Henson's thoughts softly spoken in her mind. Sharing Peary's excitement about reaching the North Pole, he also feared, as a black man, being the first. (Peary had warned Henson to stop shy of the pole.) The protagonist in the video hears a voice that says:

> I said, I think I've overrun my mark. I think I am the first man to sit on top of the world. I didn't know what he would do. I didn't know what he would do. I took all the cartridges out of my rifle before I went to sleep. Took them out and buried them in the snow. After that, we found out we overshot the mark.[24]

Henson, who had learned the Inuit language and built the sledges for their four-hundred-mile, dog-team-led trek, scouted the coveted North Pole in advance.[25] As a black man, the explorer never experienced the glory of his accomplishment until receiving a belated medal in 1944. He eked out a meager living as a messenger in the federal customs house in New York City. By shattering the myth of white supremacy traditionally associated with polar exploration, Julien gives voice to a largely unknown historical fact.

In *True North*, Julien also interprets the beauty of the Arctic landscape and subtly alludes to climate change. By filming a scene inside a chapel where every architectural feature is carved out of ice, the artist connects to the spirituality experienced by many who pass through the frozen polar gates. At key interludes, the artist shifts his focus from a towering waterfall to the flowing water from a mundane kitchen tap, underscoring the human dependence on ice.

Many explorers, such as Peary, lobbied to raise money to finance their expensive expeditions. Artists who longed to voyage to the Arctic also independently staged their own journeys with help from invited participants and sponsors. One of the most successful was William Bradford (1823–1892), whose trip in 1869 became famous through his paintings, public lectures, and a remarkable photographic expedition account.[26]

Bradford was shaped by the commercial milieu of New Bedford, Massachusetts, which became the wealthiest city in the United States thanks to whaling during the mid-nineteenth century. The artist dedicated his life to exploring and painting the Arctic waters off Newfoundland and Greenland. He launched his first voyage in the summer of 1861, after Church exhibited *The Icebergs*. Traveling seven times to the Arctic between 1861 and 1869, the artist hired photographers to accompany him on several occasions.

Many paintings by Bradford were inspired by mariners' firsthand accounts of sealing exploits off the Canadian coast of Labrador, where hundreds of thousands of Greenland harp seals were slaughtered over a month-long period. A sealing vessel often transported a dozen small boats, each manned by four people, who clubbed to death or shot with a rifle the unsuspecting animals before skinning them.[27] By 1863, when larger, steam-powered vessels were introduced, human casualties also escalated.

Although Bradford never painted the actual hunt, his paintings conceal the darker side of the Euro-American presence in the Arctic. In *Caught in the Ice Floes* (c. 1867), he dramatizes the disaster faced by three sealing ships off the Labrador coast (**fig. 49**). Stranded crewmembers tent near their abandoned ship, heaved up on blocks of ice. In the foreground, men haul small boats across the pack ice to open water, their only route for escape. They set fire to a distant ship to keep navigation clear for passage. This painting relates to Bradford's *Sealers Crushed by Icebergs* (1866), which was based on a three-day event in 1863 when a thousand men from the Newfoundland fleet scrambled for survival after

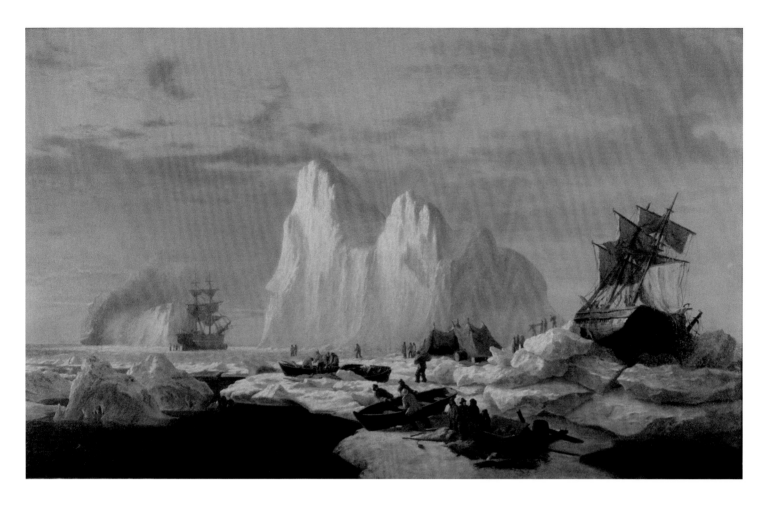

FIGURE 49
William Bradford, *Caught in the Ice Floes*, c. 1867, oil on canvas.

forty vessels succumbed to the ice.[28]

In part, Bradford painted these Arctic disasters that appealed to the public because they helped him earn a living. However, the beauty of the region—its color and light effects—fascinated him as much as the stories. *Caught in the Ice Floes* takes place at sunset, when a golden aura bathes the frozen sea. The artist attends to such details as the enchanting green hues of ice forming small caverns as well as the seals who witness the event.

On his final voyage, Bradford and the Arctic explorer Isaac Hayes (American, 1832–1881), recruited twenty-four crewmen and commissioned two photographers, John L. Dunmore

(active 1850s–1870s) and George Critcherson (1823–1892), to accompany them aboard a sealing steamer called the *Panther*. From July through October 1869, they ventured as far north as Melville Bay off the western Greenland coast.

Dressed in Inuit sealskins, Bradford sketched outdoors in pencil and oil while the photographers captured the Arctic landscape using big glass plates. Bradford published about three hundred copies of his journal of the voyage, *Arctic Regions*, in 1873. Illustrated with 141 large albumen prints, this oversized book (20 by 25 inches) is considered a milestone in the history of photography. Referencing the expedition's photographs and his own

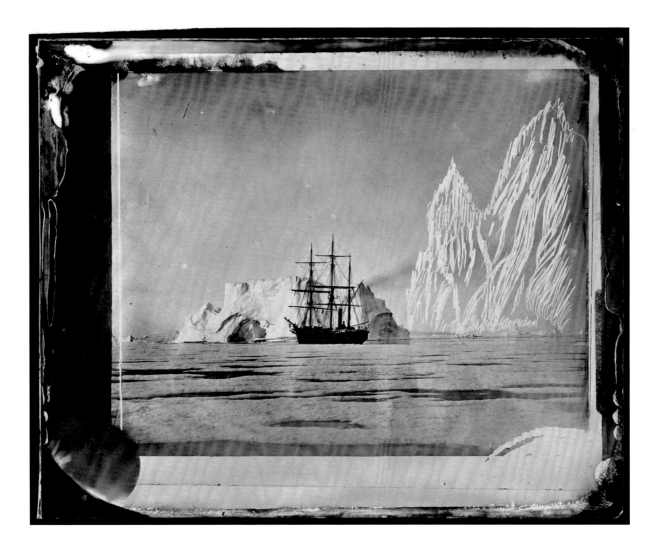

FIGURE 50
John L. Dunmore and George Critcherson, Untitled, copy
negative from *The Arctic Regions* with drawing on the original
plate, c. 1873.

sketches, Bradford painted many seascapes inspired
by his trip.

Although Bradford was lauded for his truth-
fulness to nature (and some paintings do precisely
correspond to photographs), both the artist and the
photographers were not adverse to altering the glass
plate. An example was brought to this author's
attention by the artist Rena Bass Forman (Ameri-
can, 1948–2011), who acquired a collection of
Critcherson and Dunmore's plate negatives (**fig. 50**).
In a view of the *Panther* silhouetted in front of an
arched iceberg, either the painter or photographer
scratched a gigantic, twin-peaked mountain of ice
on the surface of the glass to elevate the landscape's

majesty. The original image was included in *Arctic
Regions*, but the altered view may have served only
as a reference for Bradford's work.[29]

Arctic Regions inspired Forman, who died at
the height of her career. Passionate about all things
Arctic, she organized her own expeditions to Green-
land in 2007 and Spitsbergen in 2008 and 2010. The
artist traveled with her family to Spitsbergen during
two opposite seasons—the onset of polar winter and
in spring—to capture different light conditions mani-
fested by the last and first rays of the sun.

During the summer of 2007, Forman pho-
tographed icebergs calved from the Jakobshavn
Glacier, the fastest-moving glacier in the world and

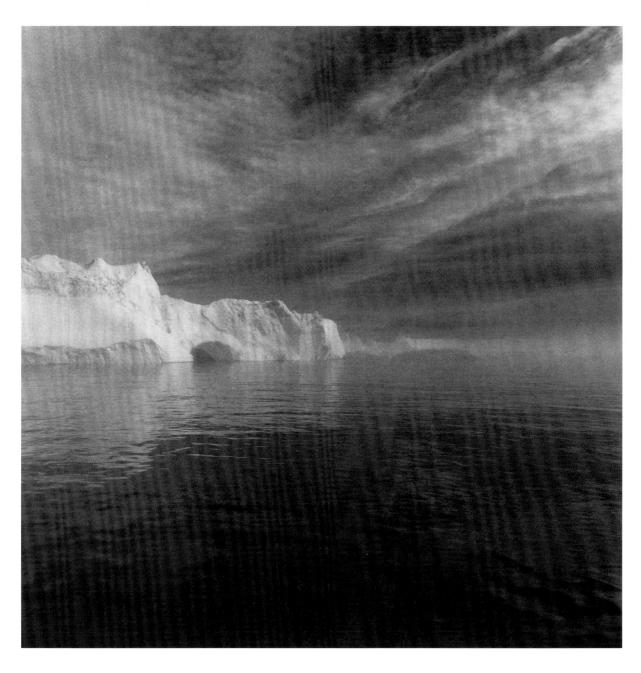

FIGURE 51

Rena Bass Forman, *Greenland #3 Illulissat*, 2007, toned gelatin silver print.

in rapid retreat. In *Greenland #3*, she presents a portrait of an iceberg scoured into the shape of a cavern (**fig. 51**). The artist described such formations as "apparitions, hauntingly glorious in the mystical light."[30]

Forman's sepia-toned prints impressionistically interpret a fleeting moment in time, in contrast with the timelessness of the hard-edged documentary look of Critcherson and Dunmore's work. The tonality of Forman's photograph references a more romantic sensibility, when early twentieth-century photographers emulated painting. Infused with a sense of reverie, the photograph reflects the artist's concern for the fate of the Arctic.[31]

David Buckland (British, b. 1949) has also initiated a series of contemporary expeditions inspired by nineteenth-century artist-explorers. These voyages, known as the Cape Farewell project, host teams of artists and scientists to the Arctic and other regions affected by climate change. The project draws support from a wide range of private and public entities.

The organization, which is based in the Science Museum's Dana Centre in London, aims to catalyze a global conversation about our changing climate through exploration, research, and art making. It reflects Buckland's philosophy that the scale of environmental problems cannot be comprehended when presented only in factual, scientific terms. He believes that art offers a more accessible, personal, and visceral means for inspiring engagement on an individual level.

In 2003, the first Cape Farewell project traveled to Spitsbergen with sixteen artists as well as teachers, writers, and oceanographers. Since the maiden voyage aboard a Dutch nineteenth-century schooner, Buckland has led nine other expeditions, seven of them in the Arctic, including two youth expeditions. A total of seventy-seven artists have participated. Their work and experiences are featured in a film, *Art from the Arctic* (2005), and a book, *Burning Ice: Art and Climate Change* (2006).

Buckland's own art reflects the collaborative nature of the Cape Farewell project. In *Burning Ice* (2004–5), the artist documents text that he projects on the face of a glacier in Spitsbergen (**fig. 52**). For this series, Buckland used sixteen short excerpts from Gretel Ehrlich's book *The Future of Ice* (2005), which was inspired by her participation in the 2003 voyage. Using digital projection, Buckland poignantly gives voice to the warming glaciers.

The team of Heather Ackroyd (British, b.1959) and Dan Harvey (British, b.1959), who joined the first Cape Farewell expedition and have traveled two other times to the Arctic, has also expanded the iconography of polar landscapes through nontraditional art-making approaches. In *Ice Lens* (2005), they create an ephemeral disk carved from a small iceberg to focus on the beauty of Arctic light (**fig. 53**). Their "suncatcher," described by the artists as a "cracked, ancient mosaic of light," metaphorically alludes to climate change.

In contrast to earlier artists who documented the landscape of Spitsbergen, Ackroyd and Harvey created a site-specific sculpture on the island. They extend the locale of Earth art, a movement that emerged in the 1960s when artists first began making art directly on the land, sometimes from natural materials.

Complementing these more recent interpretive strategies, contemporary artists continue to employ traditional media to capture places like Spitsbergen. In the spirit of Biard and Lauvergne, who made the first drawings of this region *en plein air*, Nerys Levy (American, b. Wales, 1945) uses watercolor and ink to document the polar landscape in her *Arctic Sketchbook, Hornsund, Spitzbergen, Norway,* July 2009 (**fig. 54**). This intimate, quickly drawn study bursts with the energy of both the maker and the place. From such spontaneous images, Levy creates larger watercolor and acrylic paintings in her studio.

The artist is one of a growing group of contemporary artists whose concern about the

FIGURE 52

David Buckland, *Burning* Ice, 2004–5, archival inkjet print of a
projection on the wall of a glacier.

FIGURE 53
Heather Ackroyd and Dan Harvey, *Ice Lens, Svalbard
Archipelago*, 2005, archival inkjet print.

FIGURE 54
Nerys Levy, *Arctic Sketchbook, Hornsund, Spitzbergen, Norway,* July 2009, watercolor and water soluble ink.

changing climate compels them to explore both poles. Levy's maiden voyage to Antarctica in 2007 marked the beginning of a passion for ice.

Antarctica

The first expedition to Antarctica that included artists was organized by Captain James Cook, whose Second Voyage of Discovery (1772–75) was charged with discovering whether a southern continent existed and establishing trade with its inhabitants. On January 17, 1773, Cook became the first explorer to cross the Antarctic Circle, but he concluded, "no continent was to be found in this ocean but must lie so far south as to be wholly inaccessible on account of ice."[32]

Cook invited William Hodges (British, 1744–1797) and Johann Georg Forster (German-Polish, 1754–1794) to join the expedition in 1772. These artists played a pivotal role by documenting its discoveries. More information and images relating to the anthropology, geography, botany, and zoology of Oceania were generated during Cook's journeys than all prior navigations combined.

William Hodges, a student of the painter Richard Wilson (British, 1714–1782), breathed new life into the topographic landscape tradition, which was based on rigid lines that conformed as

closely as possible to a motif.[33] His lively interpretation of Antarctica derived from the fluidity of the watercolor medium in which British artists excelled (**fig. 55**). In *The Resolution and Adventure, 4 January 1773, taking ice for water, latitude 61 degrees South*, Hodges interprets the movement of Antarctic light penetrating clouds and reflecting off the ice and the ship's sails. Rather than drawing static, topographical details, Hodges expresses nature's mood: the calm before a storm and the perfect weather to perform tasks essential for survival. Cook describes the subject depicted by the artist in his journal:

> [They] hoisted out three boats; and in about five or six hours, took up as much ice as yielded fifteen tons of good fresh water... and the water which the ice yielded was perfectly sweet and well-tasted... the most expeditious way of watering I ever met.[34]

In the spirit of the seventeenth-century seascape tradition, Hodges also presents a detailed portrait of the wooden-hulled *Resolution*, exposing the beauty of its construction. The *Discovery*, off in the distance, provides the perspective against which to fathom the immense iceberg's scale. The

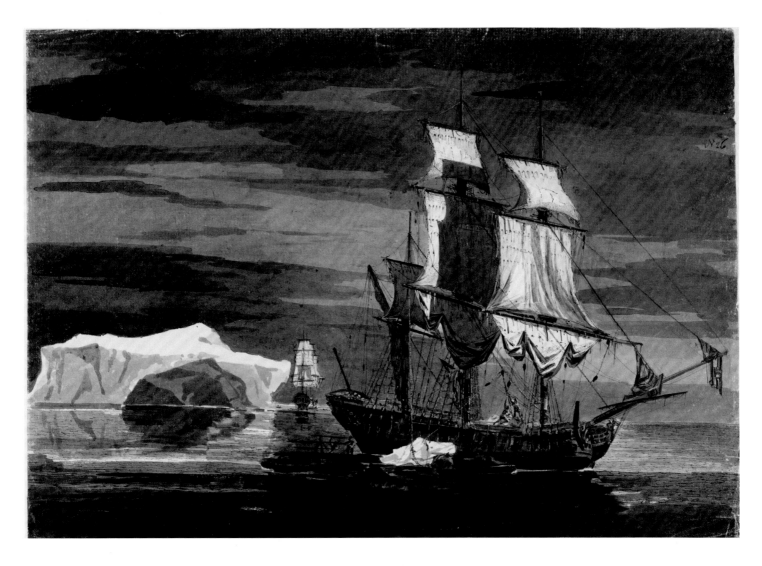

FIGURE 55
William Hodges, *The Resolution and Adventure, 4 January 1773, taking ice for water, latitude 61 degrees South*, ink and wash on paper.

expedition's narrative plays out in the foreground, where tiny figures raise a chunk of an iceberg that will be made into drinking water.

During the voyage, Hodges tutored Captain Cook and Johann Georg Forster, the naturalist on board, who at seventeen years old assisted his father, Johann Reinhold Forster (German, 1729–1798). Early in the voyage, Forster worked primarily in pencil. Under Hodges influence, he began highlighting in watercolor and relying less on simple outlines.[35] His freely executed *Ice Islands with ice blink* (1773), painted in opaque watercolor (gouache), was initially attributed to Hodges (**fig. 56**).[36] Forster naturalistically records the region's quickly changing weather conditions, showing winds battering brilliant blue waters and sculpting the ice. The phenomenon of light bouncing off icebergs to the underside of clouds, known as ice blink, occupies center stage.

Along with his father, Forster maintained a diary and list of scientific discoveries as well as seven hundred drawings of flora and fauna

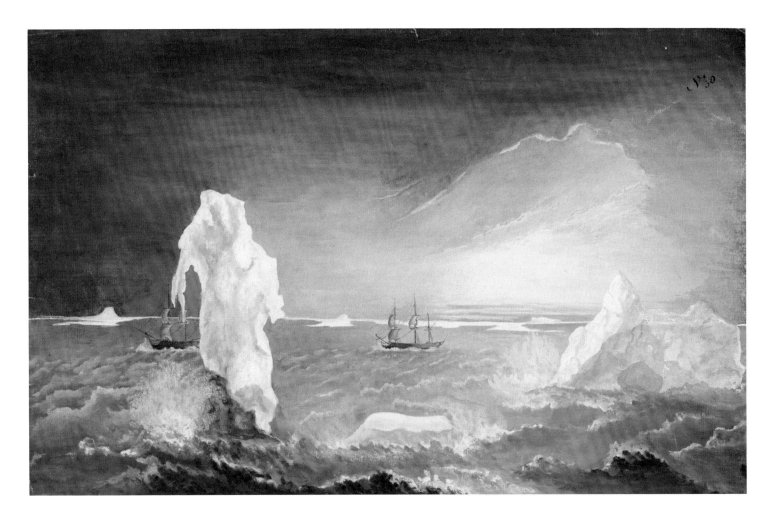

FIGURE 56
Johann Georg Adam Forster, *Ice Islands with ice blink,* 1773,
gouache on paper.

observed or collected. He later wrote *A Voyage*
round the World in his Britannic Majesty's sloop
Resolution, commanded by Captain James Cook,
during the years, 1772–1775 (1777), which became
one of the period's most popular travelogues.
Forster's work influenced the renowned naturalist
Alexander von Humboldt.

 After Cook's voyages, official Antarctic
exploration receded and commercial ships domi-
nated the waters surrounding the continent. His
popular expedition account, *A Voyage towards the*
South Pole and Round the World, Performed in
His Majesty's Ships the Resolution and Adventure
(1777), was responsible for the rush of English and
American whalers and fur sealers to the area. By the

1820s, with more than two hundred ships plying
the waters around Antarctica, the fur seals became
virtually extinct.[37]

 Between 1837 and 1843, Antarctic explo-
ration was revitalized by three rival expeditions
financed by the American, British, and French
governments. They competed with each other to
find the magnetic South Pole, partly in response to
von Humboldt's call to establish an international
network of geomagnetic observatories. Although
unsuccessful in this mission, they each charted sec-
tions of Antarctica's coast. Not until Ernest Shack-
leton's first voyage aboard the *Nimrod* in 1907–9
was the location of the magnetic pole determined.[38]

 The United States Exploring Expedition

(1838–42), the country's first official scientific voyage, was commanded by Lieutenant Charles Wilkes (1798–1877). Congress reluctantly approved the journey after pressure from the whaling industry to locate new sources of oil. The artists Alfred Thomas Agate (1812–1846) and Titian Ramsey Peale (1799–1885), who was also the chief naturalist for the expedition, were invited to participate. The knowledge gained from this expedition was vast, and the specimens discovered during this voyage launched the Smithsonian Institution as a national museum.

For unknown reasons, Agate and Peale remained in Australia during the final push to the Southern Continent. Perhaps Wilkes, who also studied art, believed that he could record Antarctica's sights. An undated oil painting of his ship, *USS Vincennes in Disappointment Bay, Antarctica* (Peabody Essex Museum, Salem, Massachusetts) has been attributed to him.

The British expedition was led by Sir James Clark Ross (British, 1800–1862), who had located the North Magnetic Pole in 1839. The first to encounter the Great Ice Barrier, the towering cliffs of the largest ice sheet in the world (later named the Ross Ice Shelf), the voyage also discovered Mount Erebus, a glaciated mountain volcano.

The artist on board was the naturalist, Joseph Dalton Hooker (1817–1911), who would become a renowned botanist. His drawings of plants and landscapes were included in his own book, *The Botany of the Antarctic Voyage of H. M. Discovery Ships Erebus and Terror in the years 1839–1843, under the Command of Captain Sir James Clark Ross*. London: Reeve Brothers, 1844–1860.[39]

The French expedition, led by Captain Dumont d'Urville, headed south with two corvettes, the *Astrolabe* and the *Zélée*. Two artists accompanied the expedition, Ernest Goupil (1814–1840) and Louis Lebreton (1818–1866), who was employed in the navy as a draftsman at the Dépôt des Cartes et Plans de la Marine (Depot of Navy Maps and Plans) until 1866.

Although Lebreton was initially hired as the *Astrolabe*'s surgeon in 1838, his drawing skills were immediately noted by Dumont d'Urville. The captain invited Lebreton to document the expedition, and upon the death of his colleague, he assumed the expedition's artistic responsibilities. For the rest of his career, he divided his time between medicine and art. Like many of his fellow artist-explorers, Lebreton made sketches that were later expanded into large salon paintings, which were exhibited in the annual Paris exhibitions.

On January 21, 1840, the crew landed on an island in sight of mainland Antarctica, a region claimed for France and named Terre Adélie, after the captain's wife (**fig. 57**). Lebreton's lithograph marking the event, published in the expedition's atlas and in Parisian illustrated newspapers, was based on a series of spontaneous drawings made on the spot.

In *Débarquement sur la Terre Adélie, le 21 Janvier 1840* (*Landing on Adelie Land, January 21, 1840*), the artist documents the crew who leave their mother ships to explore their newly discovered slice of polar terrain. He dramatically plunges the men and rocky promontory into shadow while illuminating the spectacular, towering icebergs beyond. The now-famous Adelie penguins, congregating on a tabular iceberg, bear witness.

Later explorers and artists were similarly smitten with penguins. Emperor penguins were intensely studied during Robert Falcon Scott's *Terra Nova* expedition (1910–12). Scientists risked their lives during a dark, winter sledging journey to the Cape Crozier rookery to obtain egg specimens, which were believed to contain evolutionary information about early birds. Apsley Cherry-Garrard (British, 1886–1959) wrote an account of their trek in *The Worst Journey in the World* (1922), which has become a polar classic.[40]

Although many contemporary artists, including Paul D. Miller, known as DJ Spooky (American, b. 1970) and Alexis Rockman (American, b. 1962), find penguins fascinating, they abandon

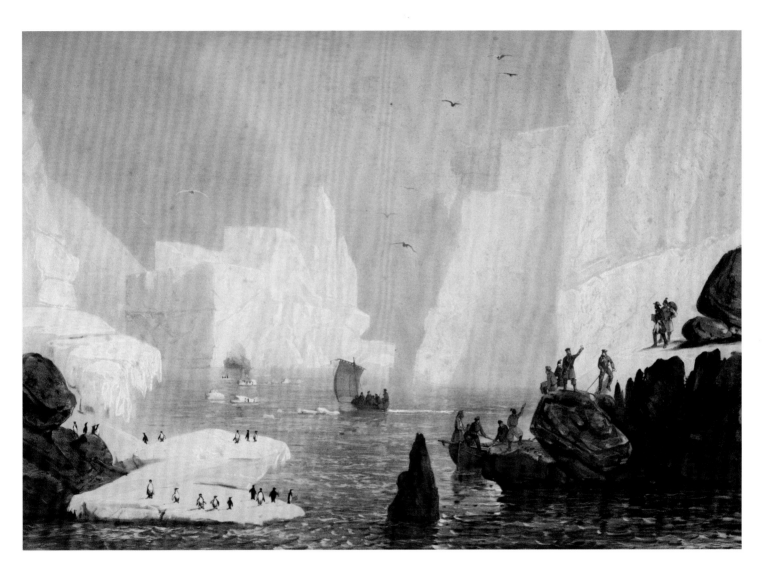

FIGURE 57

Louis Lebreton, *Debarquement sur la Terre Adélie, le 21 Janvier 1840 (Landing on Adelie Land, January 21, 1840)* from *Voyage au Pôle Sud et dans l'Océanie sur les corvettes L'Astrolabe et La Zélée... 1837–1840 sous le commandement de M. Dumont d'Urville, Atlas Pittorèsque,* Paris, 1846, lithograph.

a documentary approach to invest the animal with a more nuanced power. In *Adelies* (2008), Rockman portrays the penguins congregating on top of a towering cube of ice (**fig. 58**). Recognizing that these unique creatures are threatened by a changing climate, the artist devises an unusual composition to suggest their precarious status.[41]

Dependent on ice as a feeding platform, the penguins appear to drift in isolation without sight of the mainland. The idea for the painting was based, in the artist's words, on ideas of "fragmentation and scarcity."[42]

Although without direct references, Rockman's painting calls to mind the dramatic cleaving of the continent's massive ice shelves from the Western Antarctic Peninsula. The Larsen B ice shelf (similar in area to the state of Rhode Island) collapsed in 2002 and was followed by the Wilkins ice shelf (roughly the size of Vermont), which separated from the continent in 2010.

Rockman traveled to the Southern Continent on board a Lindblad Expedition Cruise ship and explored the region in kayaks and zodiacs. During his twelve days on the ice, the artist made watercolor sketches of the blue-green Antarctic environment that glowed "luminous like jewelry." This quality of light and color informs *Adelies*, which also references Morris Louis (American, 1912–1962), the color-field painter whose abstract pours and veils evoke sensations of transcendence.

Rockman nurtures his passion for art and the natural sciences by frequent visits to the American Museum of Natural History, where he studied the renowned painted dioramas. He was also attracted to the art of Frederic Edwin Church and the other Hudson River school landscape painters on display at the Metropolitan Museum of Art. Although engaged in field observations and drawings, he does not consider his work "scientific." Instead, he aims to make "art about the history of science."

After the three rival expeditions in the early 1840s, Antarctic exploration aroused little interest until 1895, when the Sixth International Geographical Congress called for the continent to be explored by the turn of the century. This ushered in the twentieth century's heroic age of polar exploration.

Earlier expeditions had concentrated on charting the continent's coastline. The impetus to explore the interior catalyzed Robert Falcon Scott's British National Antarctic Expedition (1901–4). Dedicated to the advancement of science, the mission's ship was christened the *Discovery*. Many explorers gained valuable experience participating in this voyage—which forged a route into the heart of the continent—including Ernest Shackleton, Roald Amundsen, Edward Adrian Wilson, and George Marston.

Scott's final expedition (1910–12) on board the *Terra Nova* employed more scientists than any previous polar journey. The captain charged Dr. Wilson, who was also an artist, to organize and direct the scientific crew. The photographer Herbert Ponting, invited by Scott to join the voyage, was listed among the scientists and called a "camera artist."

Although the expedition's motivation was essentially research-based, Scott eyed the South Pole as a conquest for the British Empire, a goal pitched to potential funders. Unlike with his first *Discovery* expedition, the government did not support the captain's final journey.

Scott and his four comrades reached their destination on January 18, 1912, after man-hauling supplies on sledges for three months. Upon arrival, they found a Norwegian flag and note written by Amundsen, who had organized his own expedition and reached the pole a month earlier. On the eight-hundred-mile slog back to base camp, a four-day storm prevented the crew from reaching its final depot of food and fuel, a mere eleven miles away. On March 29, 1912, Scott and three of his crew, including Wilson, perished in their tent. Until the end, Scott maintained his journal and wrote official and personal letters.

His harrowing account concludes the explorer's two-volume official journal, titled *Scott's Last Expedition* (1912), which was lavishly illustrated with Ponting's black-and-white photographs and reproductions of watercolors by Wilson. The first

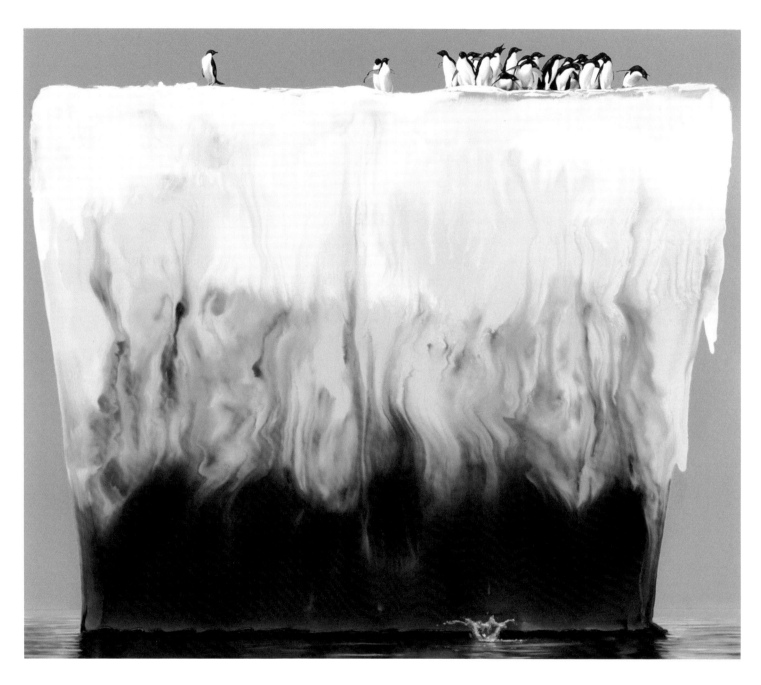

FIGURE 58

Alexis Rockman, *Adelies,* 2008, oil on wood.

page in the book lists the number of reproductions by each of the artists. Wilson's artistic contribution, represented by 6 pencil sketches and 16 watercolors, contrasts with the 260 photographs by Ponting, culled from a collection of over 1,700 glass-plate negatives. This striking disparity between the two media suggests the growing ascendency of polar exploration photography, which was believed to offer a greater degree of truth to nature and proof of accomplishments.

Although Ponting's work is deservedly celebrated, Wilson's watercolors expressively capture the essence of the polar experience. In his haunting *Paraselene January 15, 1911, 9:30 pm Cape Evans McMurdo Sound*, the artist interprets an optical phenomenon, called *paraselene,* which illuminates five sets of skis and poles staked in the ice (**fig. 59**). Casting a double halo, the moon cloaks the scene in a spiritual aura. At the time of the work's execution, the artist had no way of knowing his ultimate fate and that of his comrades, but the drawing stands as a premonition—and memorial—of their tragic demise.

Wilson's work reflects the impressive legacy of British watercolor painters extending back to William Hodges and JMW Turner. John Ruskin, whose art and writings melded the art and science of alpine landscapes, was another formidable influence on the artist-physician.

Herbert Ponting (British, 1870–1935), Wilson's colleague, was the first polar photographer hired to concentrate exclusively on taking pictures. Already recognized in the field, his work appeared in major magazines, newspapers, and a highly acclaimed book, *In Lotus-Land Japan* (London, 1910).[43]

Antarctica heightened Ponting's aesthetic awareness, which was expressed in his book *The Great White South* (1921). Here he describes his favorite photograph of a grotto carved into an iceberg, which has become one of the continent's most iconic images (**fig. 60**):

In one of these bergs there was a grotto. This, I decided, should be the object of my first excursion. It was about a mile from the ship, and though a lot of rough and broken ice surrounded it, I was able to get right up to it. A fringe of long icicles hung at the entrance to the grotto and passing under these I was in the most wonderful place imaginable, from the outside, the interior appeared quite white and colourless, but, once inside, it was a lovely symphony of blue and green. I made many photographs in this remarkable place— than which I secured none more beautiful the entire time I was in the South. By almost incredible luck the entrance to the cavern framed a fine view of the *Terra Nova* lying at the ice foot, a mile away.[44]

Ponting asked two crewmembers to pose within the iceberg to provide both a sense of scale and human interest within the stark environment. His framed view of the *Terra Nova* establishes the drama of perspective. By heightening the contrast of light and shadow and the tension between foreground and background, the artist transforms luck into a masterful work of art.

A version of this photograph without people, titled *The Arch Berg from Within,* was illustrated in *Scott's Last Expedition.* Another view, showing the cavern from the outside, *The Arch Berg from Without,* was also included.

Ponting set up a small darkroom for developing his photographs on board the ship and in Scott's 50-by-25-foot "hut" at Cape Evans. He also carried along two different movie cameras to shoot film footage, producing *Antarctica: The Great White Silence* (1924) and *Ninety Degrees South* (1933). In commemoration of the expedition's one hundred year anniversary, the BFI National Film Archive recently released the groundbreaking documentary *The Great White Silence* (2011). Digitally restored,

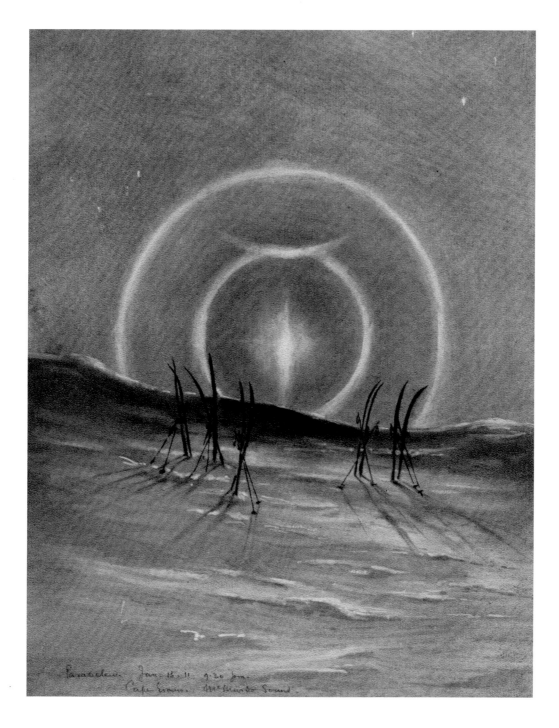

FIGURE 59

Edward Adrian Wilson, *Paraselene January 15, 1911, 9:30 pm,*
Cape Evans McMurdo Sound, illustration from *Robert Falcon*
Scott's Last Expedition, 1912.

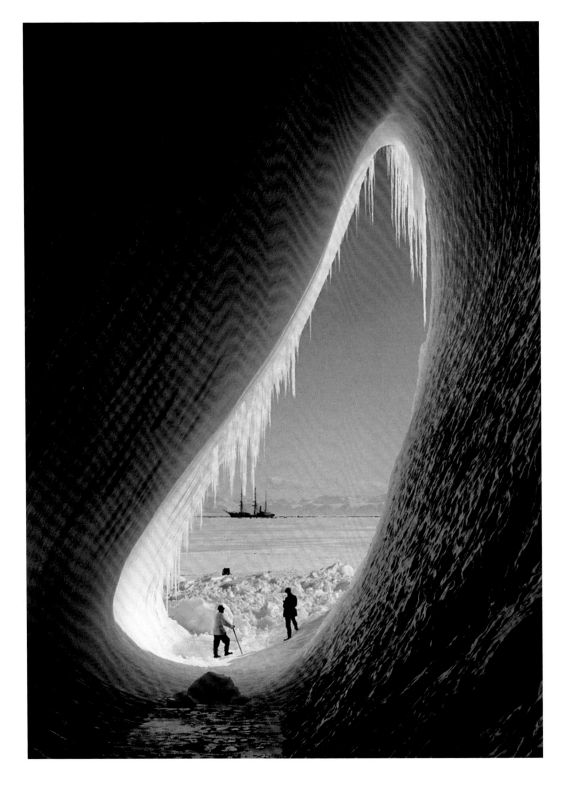

FIGURE 60

Herbert Ponting, *Grotto in berg,* Terra Nova *in the distance.*
Taylor and Wright (interior), January 5, 1911, platinum print
(printed in 2009 from the original negative).

it contains color-tinted imagery, music, and narrative subtitles written by Ponting.

Not long after Scott's last expedition, Ernest Shackleton (British, 1874–1922) launched the Imperial Trans-Antarctic Expedition aboard the *Endurance* in 1914. Organized to cross the continent (and pass through the South Pole) for the first time, it ended in disaster, but with no lives lost thanks to the determination of Shackleton.

Before landing on Antarctica, the *Endurance* was crushed by pack ice. After camping on drifting ice floes for more than a year, the crew journeyed by rescue boats to Elephant Island. From here, Shackleton and five comrades traveled eight hundred miles across rough, open seas in a twenty-foot lifeboat to reach South Georgia Island. The captain then climbed a rugged mountain range to reach a whaling station, where he hired a boat to rescue the stranded men.

Two artists accompanied the expedition, George E. Marston (British, 1882–1940) and Frank Hurley (Australian, 1885–1965). Working in watercolors and pencil drawings, Marston depicted the fate of the *Endurance*, but it is Hurley's photographs of the ship crushed by the ice that have come to symbolize this heroic journey. Photography's eclipse of more traditional media emerges once again during an expedition.

Hurley, a professional photographer and filmmaker with an established reputation, journeyed to Antarctica six times.[45] For *Endurance trapped in the ice at night*, he used twenty hidden flashlights to spotlight the stranded ship on August 27, 1915 (**fig. 61**). Shot during the twenty-four-hour blackness of a winter night, the resulting phantom image recalls the ship in Gustave Doré's (French, 1832–1883) *Rime of the Ancient Mariner* (**fig. 62**). Both artists take full advantage of their media to achieve dramatic contrasts of light and dark, merging reality with a sense of the fantastic. Hurley's description of his photograph as a "spectre ship" suggests that he knew the nineteenth-century artist's illustration.

In 1865, Doré's illustrations for a new edition of Samuel Taylor Coleridge's *Rime of the Ancient*

And now there came both mist and snow,
And it grew wondrous cold
And ice, mast-high, came floating by,
As green as emerald.

And through the drifts the snowy cliffs
Did send a dismal sheen:
Nor shapes of men nor beasts we ken-
The ice was all between,

The ice was here, the ice was there,
The ice was all around.
It cracked and growled, and roared and howled,
Like noises in a swound!

—SAMUEL TAYLOR COLERIDGE, *FROM RIME OF THE ANCIENT MARINER*, 1798

Mariner, first published in 1798, was unveiled during the height of public interest in polar exploration. Coleridge's quintessential romantic poem was inspired by accounts of Captain Cook's journey, related to the poet by William Wales (c.1734–1798), his tutor and the astronomer who documented the transit of Venus across the sun aboard the *Resolution*.

In his engravings, Doré dramatizes the fate of a captain and his crew whose ship veers off course toward Antarctica. An albatross appears suddenly, and their fortunes favorably turn out of danger. After their leader kills the albatross, all of the men perish. The surviving mariner eventually redeems himself, but must wander the earth espousing the love of all living things.

In *The Ice Was All Around*, a ghostly ship emerges from a darkened horizon framed by a frozen rainbow. The albatross, as guardian angel,

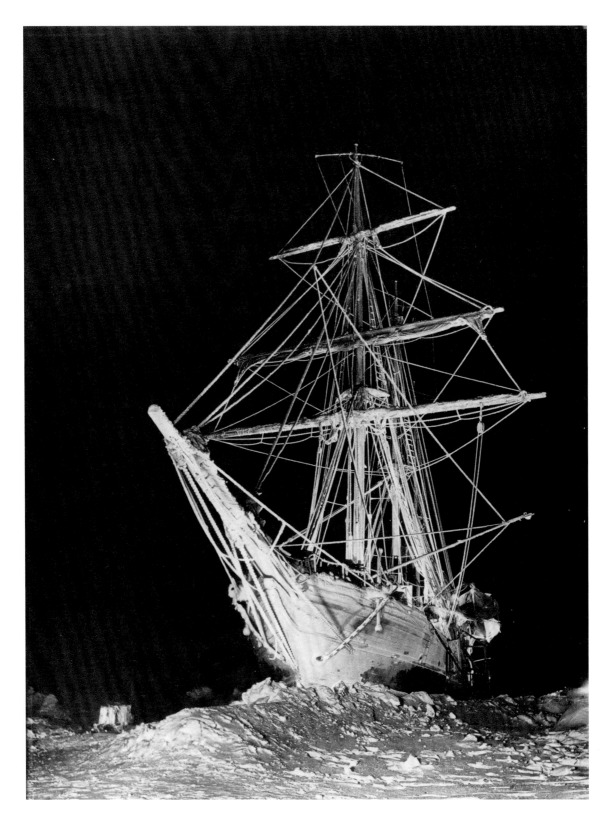

FIGURE 61

Frank Hurley, *Endurance trapped in the ice at night,* 1915,
black-and-white photograph.

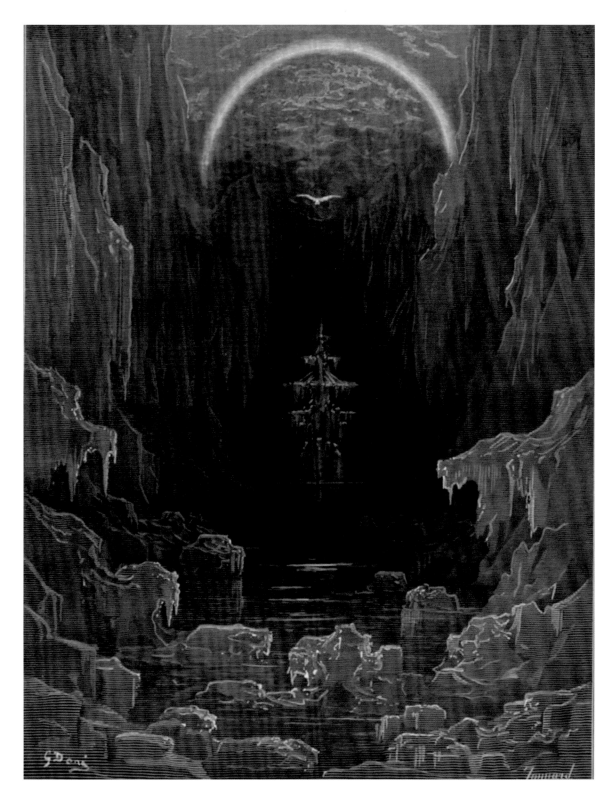

FIGURE 62

Gustave Doré, *The Ice Was All Around,* illustration from
Samuel Taylor Coleridge, *The Rime of the Ancient Mariner,*
New York: Harper and Row, 1877.

steers the ship through sheer, vertical cliffs of dripping ice. The deep central perspective heightens the work's theatricality.

The symbolism of the ship in the history of polar iconography finds contemporary expression in a photograph by Anne Noble (New Zealander, b.1954), who has made three voyages to Antarctica. Examining how the visual history of ice influences people's perceptions of this region, the artist studied the photographs of Hurley and Ponting. She has also visited Antarctic tourist centers, aquaria, and museums that interpret the polar environment.

For Noble, the ubiquitous ship at the heart of Antarctic imagery becomes both a real and surreal vision of exploration. In *Wilhelmina Bay* (2005), from a series called *ICEBLINK*, she juxtaposes Antarctica's seemingly inaccessible landscape with plastic outdoor furniture arranged for dining on the deck of a cruise ship (**fig. 63**). The empty chairs represent the droves of tourists who come to the region eager to witness the ice before climate change transforms the continent. A sense of loss pervades her work as Antarctica becomes yet another commodity for the taking.

Through her photographs, the artist underlines Antarctica as a place strongly embedded in the imagination through reconstructed experiences. Noble aims to help the public transcend perceptions of Antarctica as a sublime, untouched realm in order to grasp the realities of what is happening to the continent today.[46]

Like Noble, Paul D. Miller (aka DJ Spooky) challenges traditional representations of Antarctica. Miller, a digital-media artist, writer, and composer, journeyed to Antarctica in 2008 for four weeks aboard a decommissioned Russian naval ship that specializes in hydroacoustic research. This experience, described by the artist as "life-changing," sparked a series of projects that synchronize music, art, literature, science, and history.

For his multimedia symphonic *Terra Nova: Sinfonia Antarctica,* the artist included footage of early twentieth-century expeditions and sampled sounds from the continent to create a sonic landscape.[47] This work, which has been performed around the world, references Robert Falcon Scott's last expedition and Ralph Vaughn Williams's (British, 1872–1958) music from the film *Scott of the Antarctic* (1947). By mixing in clips from a Soviet expedition, the artist also exposes how the "spectacle of science" was used in Antarctica as part of Cold War propaganda. Miller brings the work up to date with sea-level charts that reference climate change.

Antarctica as a utopian archetype also fascinates Miller. Remarkably, no one owns or governs Antarctica. In 1961, the Antarctic Treaty was signed, setting aside the continent as a scientific preserve that bars military activity. Forty-nine treaty nations engage in research and international collaborations at research stations. The Protocol on Environmental Protection—added to the treaty in 1991—bans all mineral exploitation for fifty years.[48]

Inspired by this treaty, Miller created a series of digital prints that promote the coexistence between people and the planet. These posters also respond to the "propaganda war about climate change" perpetuated by deniers of scientific evidence.[49] In *A Manifesto for the People's Republic of Antarctica* (**fig. 64**), a dozen United States planes—C-130s employed for Antarctic transportation—fly above penguins standing in military formation. In its style, the artist's print references Alexander Rodchenko's (Russian, 1891–1956) revolutionary graphic design born from an idealistic vision of the future.

In 2010, Miller joined the Cape Farewell project and journeyed to the Arctic. His two polar experiences inform *Book of Ice* (2011), which also reflects the artist's interest in the transformational qualities of ice from solid and liquid states. Forging relationships with scientists who study the geometry of ice, the artist creates music from geometric patterns that he calls "acoustic portraits of ice." Fascinated by Johannes Kepler's first study of snow crystals and their symmetry, *The Six-Cornered Snowflake* (1611), Miller also looks forward to current scientific inquiry into interstellar ice. An essay by Brian Greene, physicist at Columbia University, further grounds the work in the science of ice.

FIGURE 63

Anne Noble, *Wilhelmina Bay, Antarctica,* from *ICEBLINK,*
2005, pigment print on paper.

Scientific inquiry and the American presence in Antarctica was pioneered by Admiral Richard Byrd (1888–1957), who led five expeditions to the continent from 1928 to 1956 and made the first flight to the South Pole in 1929. The explorer's accomplishments garnered widespread media attention and captured the imagination of the American public. His first celebrated expedition motivated the enterprising manager of Luna Park Amusement Company on New York City's Coney Island to

The afternoon may be so clear that you dare not make a sound, lest it fall in pieces. And on such a day I have seen the sky shatter like a broken goblet, and dissolve into iridescent tipsy fragments- ice crystals falling across the face of the sun.

— RICHARD BYRD, *ALONE,* 1938

commission, in 1930, the world's largest cyclorama, a panoramic view of Byrd's expedition base, called *Little America.*[50]

David Abbey Paige (1901–1979), an established artist and graphic designer in New York City, was selected to paint the panorama. Paige contacted crewmembers, studied expedition accounts, and personally conducted scientific research.

Paige's creative efforts, along with numerous letters written on the artist's behalf, won him a spot as the official artist on Byrd's second voyage in 1933–35. He set up his studio in the Science Hall, where he worked up his pencil sketches, annotated with observations about color, into pastels. Paige introduced himself as the "Official Artist on the Scientific Staff for Color Research with the Second Byrd Antarctic Expedition."[51] More than a hundred of the artist's drawings are housed in the Byrd Polar Archives at the Ohio State University in Columbus.[52]

Many of Paige's pastels introduce the importance of air power to the history of polar exploration and imagery. Byrd's achievements were dependent on five planes to survey and map the continent. From the air, he determined that Antarctica was a single continent without a channel between the Weddell and Ross Seas as explorers had previously speculated.

In *Halo; Wing of the Fokker airplane crashed on March 12, 1934,* the artist depicts a disastrous takeoff from the Little America base (**fig. 65**). The sun's radiance looms over an isolated wing rising from the ice. The artist interprets parhelia, the same

FIGURE 65
David Abbey Paige, *Halo; Wing of the Fokker airplane crashed
on March 12, 1934*, oil on board.

optical phenomenon captured by Edward Wilson
in moonlight, when ice particles in the cold air
refract light from the sun (or moon). Figures are
mere specs that provide scale within this mystical
landscape.

This wrecked "air ship" in a graveyard of
ice recalls paintings by Frederic Edwin Church and
Edwin Landseer that featured a fallen mast. All
three artists poignantly entwine emotions associated
with the fallibility of human endeavor and nature's
overwhelming majesty.

In his expedition account, Byrd did not
include a single reproduction of Paige's work. It
appears that the admiral cared little for the artist's
expressive style.[53]

In spite of Byrd's attitude, collaborations
between artists and scientists further developed dur-
ing the twentieth century with the establishment of
the National Science Foundation's Antarctic Artists
and Writers Program, which seeks to expand aware-
ness of Antarctica and polar research. In the 1970s,
Australia, Great Britain, and New Zealand followed

FIGURE 66

Stuart Klipper, *Seal research transponder, McMurdo Sound sea ice, Razorback Islands, near Ross Island, Antarctic,* 1999, C-print.

America's lead, initiating programs for artists to work on the continent with the hope of publicizing the region's significance for nature and culture.[54]

Stuart Klipper (American, b. 1941), who blends documentary photography and an otherworldly perspective paralleling Paige, visited Antarctica five times with the National Science Foundation's program. Continuing the legacy of Hurley and Ponting, the artist points his 110-degree lens at scientific experiments, expedition equipment, transport, and infrastructure at the American research base at McMurdo Station.[55]

In *Seal research transponder, McMurdo Sound sea ice, Razorback Islands, near Ross Island, Antarctic* (1999), Klipper documents a frozen landscape anchored by a temporary radio installation that tracks tagged seals (**fig. 66**). An image of extreme loneliness and isolation, the photograph suggests the feelings that compelled Klipper to return to the continent. As the artist writes: "By my lights, all that can be experienced in Antarctica can be infused with an innate, primal, and subsuming metaphysical experience—to its very core it bears a charge of the sacral."[56]

In this field of ice, Klipper establishes a relationship between the two mountain outcrops and the man-made installation. His camera frames a triangle, a classic Renaissance formula for establishing balance. The long lines of shadow on the ice extend the perspective into the viewer's space. They also suggest the fragile presence of the construction. Klipper includes this photograph in his book *The Antarctic: From the Circle to the Pole* (2008), a record of expedition infrastructure and the continent's varied geography.

While Klipper depicts the scientific footprint in this extreme environment, Anna McKee (America, b. 1959) and Chris Drury (British, b. 1948) interpret the new technologies available for scientific research. McKee's fascination with the analysis of ice led to a series of abstract prints that evoke the beauty and natural history of Antarctica (**fig. 67**). In 2009–10, the artist journeyed to the ice with the Antarctic Artists and Writers Program. Working in the West Antarctic Ice Sheet Divide field camp, she documented both the landscape and the ice core project.

In *Depth Strata V,* 2011, McKee mixes a variety of printing techniques to interpret two types of scientific data: ice penetrating radar (IPR) and ice core samples. Both have become invaluable research tools by providing a record of Earth's climate. IPR

measures the thickness of ice and helps scientists locate the best core samples. Long sections of ice, drilled out from glaciers and ice sheets, contain tiny bubbles of air, carbon dioxide, and methane trapped over thousands of years. The oldest ice core contains data extending back eight hundred thousand years. By examining layers of ice and sediment, scientists can analyze the steady rise in carbon dioxide since the beginning of the Industrial Revolution.

Combining her observations of this data, McKee addresses the "memory" of the natural world and the environmental records of human influence over time. The artist creates an abstract, vertical icescape composed of multicolored layers of "scientific data." From the bottom up, McKee interprets horizontal waves of IPR. Amoeboid-shaped bubbles that correspond to the gases encapsulated in ice float above. The artist also references ice core bands, which form the underpinning of her patterned composition. Related to tree rings, these bands provide a similar insight into past ages. With *Depth Strata V*, the artist interprets the symbiotic relationship between geology and biology.

John Grade (American, b. 1970) also makes the connection between ice cores and tree rings in his abstract sculpture *Core* (2013, **fig. 68**). Inspired by both the ice in cores and hanging glaciers, the artist elegantly layers wood and resin to create repeating, half-cylindrical forms. According to the artist, "The rings allude to the measurable time and annual layers of change."[57] Grade draws further parallels with the unique properties of ice by highlighting the sublimity of light traveling through the sculpture.

Like McKee, Chris Drury also interprets scientific data as it relates to climate change research. Having traveled to Antarctica with the British Antarctic Survey Artists and Writers Fellowship in 2007, he presents a unique perspective of the polar landscape and the research conducted by climatologists. In *Above and Below Carrara Nunatac, Sky Blu, Antarctica* (2006–7), the photographer interprets two views of the ice: what can be seen on the surface

FIGURE 67
Anna McKee, *Depth Strata V*, 2011, etching, collography, and chine collé.

and the composition of ice invisible to the naked eye (**fig. 69**). To express the vast emptiness of the environment and the continuous flux of a living earth, the artist pairs photographs of the desolate Antarctic surface with an echogram image of the ice below.

In the top part of this diptych, Drury portrays a lonely spot in Antarctica's interior, named Sky Blu, which serves primarily as a refueling station for twin otter planes destined for the South Pole. The artist lived here for three weeks, joining a group of scientists studying the changing climate. He focuses his camera on one of the tents used by pilots and crews for overnight accommodations.

FIGURE 68
John Grade, *Core,* 2013, wood and resin.
41 x 43 x 27 in. (104.14 x 109.22 x 68.58 cm)
Private Collection

FIGURE 69

Chris Drury, *Above and Below Cararra Nunatac, Sky Blu,*
Antarctica, 2006–7, inkjet print, including an echogram from
under the ice in East Antarctica.

Drury compares a landscape, punctuated by the Nunatac Mountains rising above solid ice, with an image interpreting ice penetrating radar (IPR), described by a scientist "as an image of the heartbeat of the Earth."[58] These signals, pulsed down from a transmitter attached to the wing of a twin otter plane, penetrates through two and a half miles (4 km) of ice to the bedrock, and then bounce back up into a receiver. The artist took this data and "placed them in layers, one in front of the other, building up a hidden landscape of the imagination." In such works, which balance abstraction and representation, Drury provides a connection between humans and the Antarctic environment.

The fusion of abstraction and naturalism also defines the photography of Jean de Pomereau (French, b. 1969), who has visited Antarctica five times, beginning in 2002 when he journeyed to New Zealand's Scott Base with the graduate program in Antarctic studies at the University of Canterbury. The artist subsequently received a master of arts degree from the Scott Polar Research Institute. As an artist, photoreporter, lecturer, and writer for the International Polar Foundation (IPF) scientific website, he draws attention to the importance of Antarctica as a symbol of international cooperation, archive of paleoclimate, and barometer of climate change.

Pomereu photographed *Fissure 2 (Antarctica)*, from the series *Sans Nom* (*Without Name*), during his participation in the Chinese National Antarctic research expedition in 2008–9 (**fig. 70**). In this minimalist interpretation of the landscape, he evokes the essence of the continent that provides "a breathing space for the planet, as much as for the human imagination."

Pomereu's description of the image reflects his transcendent state of mind at the time he composed the photograph:

> This photograph was taken in the Pridz Bay Region of East Antarctica between 1 am and 4 am, when the air was remarkably still, and a thin mist descended upon a group of neighboring icebergs locked into the winter sea ice. Traveling through this ice-scape on a skidoo and on foot felt like entering a lost city, resembling Atlantis, where the icebergs replaced monumental ruins. The silence and desolation were profound. They evoked a sense of eternity—as if time had stopped. Like stone ruins, the icebergs also spoke of cycles and the transience of all things. To me, the ice crack represents and embodies the first fissure in this world of stillness and silence: The first dramatic sign of the coming spring breakup of the sea ice.[59]

Reflecting the artist's concern for climate change, this crack also symbolizes the increasing vulnerability of certain regions on the continent.

Pomereu has collaborated on a number of other Antarctic projects, including initiating and coediting a new portfolio of platinum prints from the glass negatives of Ponting's *Terra Nova* expedition. One of these prints, *Grotto in berg. . .*, is included in *Vanishing Ice* (**fig. 60**). As the official photographer of Lita Albuquerque's *Stellar Axis, Constellation 1* installation, Pomereau accompanied the artist, a filmmaker, and an astronomer, courtesy of the National Science Foundation's Antarctic Artists and Writers program.

Albuquerque (American, b. 1946), known for her Earth art projects, creates sculptures in the landscape that often draw attention to the beauty of the site and the human relationship to the cosmos. For *Stellar Axis*, she collaborated with the astronomer Simon Balm and positioned ninety-nine ultramarine spheres on the Ross Ice Shelf with the aid of global positioning satellites (**fig. 71**). Corresponding to the brightest stars at 77 degrees latitude south on the day of the summer solstice at noon, the sculptures mapped the night sky that cannot be seen during six months of twenty-four hour sunlit days.[60]

On December 22, the day of the summer solstice in the Southern Hemisphere, fifty-one volunteers from McMurdo Station traced an Archimedean

FIGURE 70

Jean de Pomereu, *Fissure 2 (Antarctica)* from *Sans Nom*, 2008, archival inkjet print.

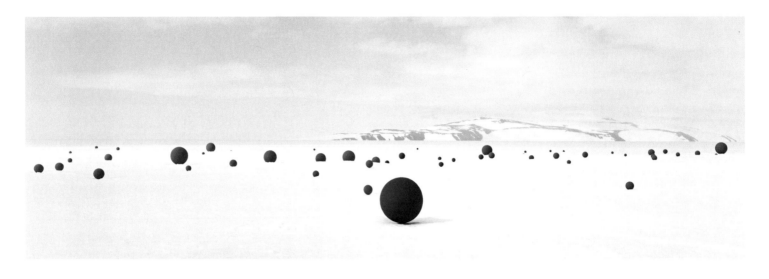

FIGURE 71

Lita Albuquerque, *Stellar Axis, Constellation 1,* 2006, archival
inkjet print by Jean de Pomereu.

spiral, by walking from the center of the installation
outward, unfurling clockwise toward the edge of the
artwork. This ten-minute performance was filmed
from a helicopter by Sophie Pegrum, who subse-
quently made *77 Below,* a documentary showing
Stellar Axis's constellation map that metaphorically
links art and astronomy.[61]

A year later, Albuquerque created a comple-
mentary installation, *Stellar Axis: North Pole Arctic
Circle,* 2007. A spiral drawn into an "island" of
frozen sea ice included a performance by people
tracing the unfolding line. In these two projects, the
artist called attention to Earth's rotation and the
axis between the two poles.

Using the ice as a blank canvas to create site-
specific installations represents a new direction in the
history of artists' interpretations of alpine and polar
landscapes. Xavier Cortada (American, b. 1964) also
extends the tradition of Earth art into the Southern
Continent. As a participant in the National Science
Foundation's Antarctic Artists and Writers Program,
the artist journeyed to the ice in 2007.

Cortada makes "ice paintings" by combining
traditional media with ice from the Ross Sea and
sediment gathered by scientists from Antarctica's

Dry Valleys (**fig. 72**). Applying an initial layer of
paint to the paper, the artist then sprinkles particles
of sediment. He uses ice as a brush, working the
mixture into the surface. Through repeated layers,
Cortada creates abstract compositions that physi-
cally embody the continent. Although abstract, they
suggest the movement of ice. The titles of artworks,
such as *Astrid,* were randomly selected from Ant-
arctica's geographic features, further embedding the
work in site.

• • • • • • • • • • • • •

The artist-explorer, working alongside sci-
entists in the extreme climates of the Arctic and
Antarctica, introduced the public to an alien but
alluring environment. Documenting the landscape
and expeditionary activities soon expanded to inter-
preting the poles as a symbol of emotions and ideas.
In this way, artists inserted new meanings and mes-
sages into the imagery of ice. The otherworldly
effect of ice under changing light conditions—auro-
ras, frozen rainbows, and gigantic halos caused
by the glow of the sun and moon—also informed

FIGURE 72

Xavier Cortada, *Astrid,* 2007, sea ice from Antarctica's Ross
Sea, sediment from the Dry Valleys, and mixed media on paper.

artists' spiritual relationship to the natural world.

Although they often use new media and strategies, contemporary artists continue to interpret the poles in the ways pioneered by early artists. Fascinated by historical expeditions, many have traced the routes of these voyages or shattered the myths surrounding their legacy. Similarly mesmerized by polar beauty, artists are now profoundly conscious of the threats to the region posed by climate change. Many journey to the ice hopeful that their art will help the public visualize the accelerating effects of this phenomenon. From the first images of "islands of ice" painted by William Hodges and Johann Georg Forster in 1773 to the *Last Iceberg* series by Camille Seaman (2003–11), art underscores the importance of the poles in our understanding of nature and culture.

1. See Imbert, *North Pole, South Pole*, which includes illustrations of Willem Barents's 1596 Arctic journey engraved and published by Theodor de Bry (1528–1598). De Bry illustrates how the crew built a house from salvaged timber from their ship, which had been crushed by the ice. They settled in for the long and sunless winter, relying on polar bears for food and protective clothing. In the spring, small boats were constructed to sail home, but Barents was not among the returning explorers.

2. One body of water in Labrador, Newfoundland, was named Red Bay by the Basque whalers who traveled from Europe to hunt whales in the early seventeenth century.

3. The vogue for Arctic imagery inspired home wallpaper designs of the polar sea. Jean Zuber (1773–1852) manufactured the *Sea of Ice (Mer Glaciale)* scene in 1854. A sample is housed in the Deutsches Tapetenmuseum, Kassel, Germany.

4. More information on Arctic expeditions can be found in Berton's *The Arctic Grail*, a penetrating account of European and American exploration. Berton attributes England's obsession with a Northwest Passage to the British navy. After the victory over the French at Waterloo and exile of Napoleon in 1815, the Admiralty sought a peacetime diversion to maintain the strength and prestige of the world's largest maritime power. It was also motivated by the humiliating possibility that Russia would find the Northwest Passage first (18–19).

5. Ibid., 627.

6. See the Linda Hall Library of Science, Engineering and Technology's *Ice: A Victorian Romance*, which is an valuable source of images and information about early exploration. http://www.lindahall.org/events_exhib/exhibit/exhibits/ice/4_parry.shtml

7. This expedition was examined in my doctoral dissertation and the article published as *Francois August Biard, Artist-Naturalist-Explorer*, in the *Gazette des Beaux Arts*, fevrier, 1985, VI Periode, Tome CV, pp. 75–87. Auguste Etienne Mayer (1805–1890) was the official artist on two major expeditions, the voyage to Iceland and Greenland in 1835–36 and the first phase of the Commission scientifique du Nord's expedition to Spitsbergen in 1838, when the ship *La Recherche* reached as far north as Bell-Sound.

8. See Conway, *No Man's Land*.

9. Biard also painted one of the earliest views of the aurora borealis, titled *Magdalena Bay; vue prise de la presqu'île des Tombeaux, au nord du Spitzberg, effet aurore boréale (Magdalena Bay; view taken from the peninsula of the Tombs, north of Spirtzberg, effect of the aurora borealis)*, exhibited at the 1841 Salon and currently on view in the Louvre, Paris.

10. This painting provokes comparison with John Webber's *A Party from His Majesty's ship Resolution shooting sea horses. . . 1778*, painted in 1784. As the official artist aboard Captain Cook's third voyage (1776–80), Webber documented an episode of hunting walrus, concentrating on the figures and not the landscape.

11. Another Frenchman, Pierre Huyghe (b. 1962) also works at the intersection of realism and fantasy. Merging video, sound, and performance, he produced *A Journey That Wasn't* (2005), filmed in Antarctica and New York City. The narrative revolves around the search for an imaginary albino penguin.

12. The culmination of Humboldt's inspiration for the artist dates to 1851 when Biard ventured into the rainforests of South America and published a book on his travels, *Deux années au Brésil (Two Years in Brazil,* 1862). Complete with illustrations, it documents the artist sketching and engaged in natural science activities.

13. Novak, in *Nature and Culture: American Landscape and Painting* (7), writes that "the sublime had been largely transformed from an aesthetic to a Christianized mark of the Deity resident in nature."

14. Described by Louis Legrand Noble, a writer and clergyman who was invited by Church to document his journey, in *After Icebergs with a Painter,* 1861.

15. For complete information on Church, see Carr, *Frederic Edwin Church* and Harvey, *The Voyage of the Icebergs*.

16. In his later painting, the *Aurora Borealis* (1865), Church also references the Civil War. The northern lights was interpreted as an optimistic symbol of Union victory. The painting also reflects the artist's friendship with the explorer, Isaac Israel Hayes (1832–1881), who named an Arctic mountain in Church's honor. The artist included this glaciated peak in the *Aurora Borealis*.

17. Schiff and Waetzoldt, *German Masters of the Nineteenth Century*, 112.

18. See the artists' website: http://www.eisbergfreistadt.com.

19. Berton, 111. During the excruciatingly long voyage, his nephew, James Clark Ross, discovered the North Magnetic Pole on the western coast of Boothia Peninsula.

20. Ibid, 57.

21. Beechey also provided drawings to illustrate the book, *Narrative of a voyage to the Pacific and Beering's straite, to co-operate with the polar expeditions: performed in His Majesty's ship Blossom in the years 1825–1828* (1830), which was written by his brother Frederick, who commanded the journey. See http://www.edmistontrust.org.nz/artwork/details/wreck-of-hms-orpheus-on-manukau-.html.

22. A long-standing debate on whether Peary ever reached the pole continues to rage.

23. See Berton's account of this expedition in *The Arctic Grail*, 551–86.

24. Julien appears to reference Robert H. Fowler's interview with Henson in "The Negro Who Went to the Pole with Peary," *American History Illustrated* (April and May, 1966): 45–51.

25. The explorer devised a strategy that depended on a three-prong approach: a small vanguard of men used to blaze a trail and construct igloos, and a supporting crew to carry supplies and establish caches at key intervals. The finish team, rested and equipped with the bare necessities, would make a run for the pole. See Berton, 553. This system was later used by Hillary and Tenzing to reach the top of Mount Everest in 1953. For the 2013 Venice Biennale, Tavares Strachan retraced the steps of Peary and Henson's expedition. His installation, *Polar Eclipse*, contains a 14-channel video of his journey.

26. The public, fascinated by everything Arctic, was treated to a series of lectures given by Bradford, who incorporated stereopticon slides of his paintings into his presentation. His "Life and Scenery in the Far North," based on his *Panther* adventures, was presented at the American Geographical Society in New York and printed in the organization's journal. All of the major New York newspapers, including the *New York Times*, covered the event, which was accompanied by a performance of Inuit and Old Norse songs. See Kilkenny. "Life and Scenery in the North," 106–8.

27. Kugler, et al, *William Bradford*, 21.

28. Ibid.

29. Bradford often referenced photographic glass plates, which were sometimes altered. See Adam Greenhalgh, "The Not So Truthful Lens: William Bradford's The Arctic Regions," in Kugler et al., 73–86.

30. Quote provided to the author by the artist's daughter, Zaria Forman.

31. Before her untimely death, Forman was planning an expedition to trace the route of Bradford's 1869 journey. Her daughter, Zaria, also an artist, led the expedition in her honor, in collaboration with the New Bedford Whaling Museum. An exhibition, *Arctic Visions: Away then Floats the Ice-Island* (2013), will feature artworks by mother and daughter alongside historical representations. In conjunction with the show, *Arctic Regions* will be republished in a smaller format.

32. Imbert, 32.

33. Fox, *Terra Antarctica*, 101–2.

34. Linda Hall Library of Science, Engineering and Technology website: http://www.lindahall.org/events_exh/exhibits/voyages/cook11.html

35. See Fox, 137

36. On February 24, 1773, it appears that Forster and Hodges were painting this scene side by side. This was revealed by art conservators while studying one of Hodges's tropical New Zealand landscapes with x-radiography. Under layers of paint, a ghostly image corresponding to Forster's composition emerged. Had it not been covered up, the work would have been the very first oil painting of the sea around Antarctica. Scholars speculate that Hodges painted over the iceberg because polar landscapes were not yet popular. See Pieter van der Merwe, "Icebergs and other recent discoveries in paintings from Cook's Second voyage by William Hodges," *Journal for Maritime Research* (March 2006).

37. Fox, 145.

38. Ibid.

39. See Linda Hall Library of Science, Engineering and Technology website: *Ice: A Victorian Romance*, http://www.lindahall.org/events_exhib/exhibit/exhibits/ice/27_hooker.shtml.

40. Ernest Ponting, the photographer and filmmaker of the *Terra Nova* expedition, devoted a long segment of his film, *South*, to these animals. Their remarkable adaptation to the hostile environment was later documented in the acclaimed film *March of the Penguins* (2005). Animated films with an environmental message, including *Happy Feet* (2006), soon followed the public clamor for images of these cute animals.

41. Adelie populations have suffered because of warming oceans that have shrunk the population of krill upon which the penguins and other life depend. See http://www.npr.org/2010/12/31/132523407/A-Visit-To-Antarctica.

42. From a conversation with the artist, September 24, 2012.

43. Arnold, *Photographer of the World*, 48.

44. Ponting, *The Great White South*, 67.

45. The artist's filmmaking career influenced the course of Australian pre–World War II documentary film. Most recently, archival footage of the Shackleton expedition was appropriated by Nina Katchadourian (American, b. 1968) for a video titled *Endurance* (2002). With her mouth wide open, the artist projects Hurley's footage on one tooth. Weaving together the extremes of body and environment, the video also documents the artist's painful trial of keeping her lips parted and teeth visible during her ten-minute performance.

46. While exploring the cultural construction of place, Noble writes: "When we look at Antarctica, from the deck of a ship, or in a make-believe tableau, and fix it in our gaze, what we see is a figment of the imagination. The sight we encounter is a sight already seen, image upon image fixed in the shadow of our dreaming by the medium of photography itself…. Photography confirms a 'having been there' that is desirable, touchable, and ultimately purchasable. It becomes the pre-text for travel and loads a geographic imaginary that renders the traveller blind." See http://www.thearts.co.nz/news.php&news_id=357.

47. The piece was commissioned by the Brooklyn Academy of Music (BAM) for the 2009 New Wave Festival along with the Hopkins Center/Dartmouth College; University of California Santa Barbara Arts and Lectures; Melbourne International Arts Festival; and the Festival dei 2 Mondi, Spoleto, Italy.

48. The threat of mining was of great concern to the photographer Eliot Porter, who wrote about his fears of the despoilation of the continent in his book *Antarctica*.

49. Interview with Alex Pasternack, December 2, 2009. See http://www.motherboard.tc/2009/12/2/dj-spooky-on-ice-a-q-a-with-the-nerd-turntablist-on-remixing-antarctica.

50. More information about the commission and the artist can be found in Scholl and Krause, *The Magic of Antarctic Colours*.

51. Ibid, 31.

52. Paige's expedition artworks can be viewed at http://library.osu.edu/projects/magic-of-antarctic-colors/paige.htm.

53. Although nearly forgotten today, Paige was recognized when he exhibited his Antarctic sketches and oil paintings at the M.H. de Young Memorial Museum in San Francisco in 1937. He later become a scenic artist for the Hollywood film industry and soon after a cinematographer for major motion picture studios, a career that spanned 1947–1970.

54. Fox, 205.

55. A veteran artist of the poles, Stuart Kipper has journeyed to the South Pole four times, spent time in Greenland and Spitsbergen, and reached the North Pole in 2009. His portfolio of ten thousand images documenting six Antarctic journeys between 1987 and 2000 underscores a passionate commitment to understanding the Southern Continent.

56. See Stuart Klipper, "The Grace of the Ice," in *The Antarctic*, 19.

57. From email correspondence with author, February 4, 2013.

58. See artist's website: http://chrisdrury.co.uk/double-echo/.

59. Email correspondence with the author, January 11, 2013.

60. Inversing light and dark, Albuquerque envisioned the white ice as the arc of the night sky and the deep blue balls as the shining stars. The artist fabricated her sculptures from cast resin and scaled them in a variety of sizes based on each star's luminosity, from four-feet in diameter to a mere ten inches. Encompassing a four-hundred-foot section of icescape, the installation was conceptualized by the artist to turn with the Earth on its axis, creating an invisible spiral.

61. See http://www.77below.com.

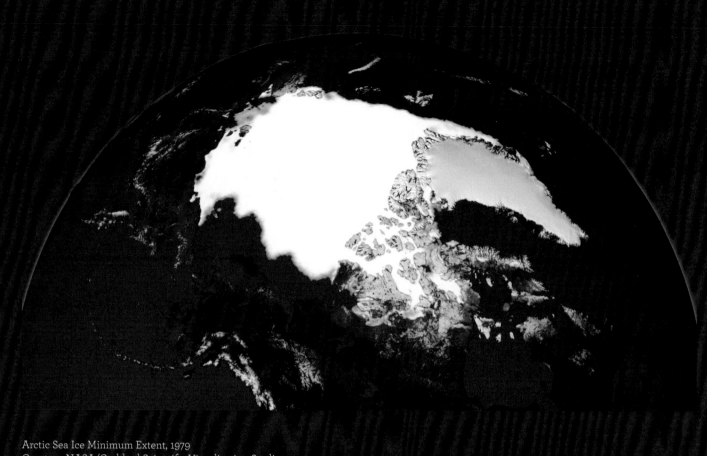

Arctic Sea Ice Minimum Extent, 1979
Courtesy NASA/Goddard Scientific Visualization Studio

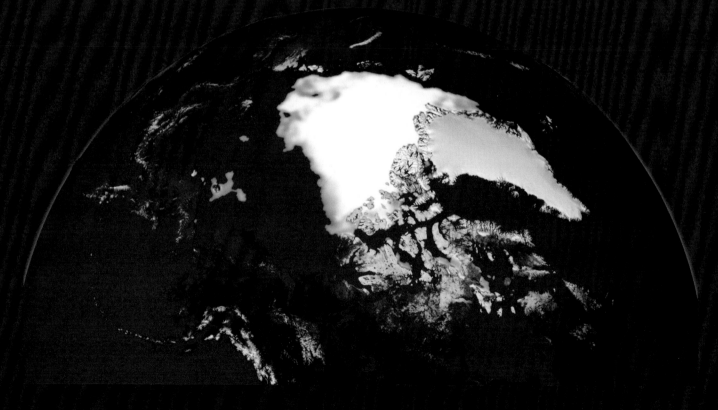

Arctic Sea Ice Minimum Extent, 2012
Courtesy NASA/Goddard Scientific Visualization Studio

ELEGY: THE OPEN POLAR SEA

Ice everywhere is talking to us—not politically or emotionally or conventionally—but in a language that we must understand and heed. Ice is a sleeping giant that has been awakened, and if we fail to recognize what has been unleashed, it will be at our peril.

—HENRY POLLACK, *A WORLD WITHOUT ICE*, 2009

IN THE SEVENTEENTH CENTURY, many explorers believed that a temperate ocean separated Arctic sea ice from the North Pole. The theory, known as the Open Polar Sea, periodically tantalized mariners. The leading American explorers, Elisha Kent Kane (1820–1857) and Isaac Israel Hayes (1832–1881), both claimed to have witnessed the Open Polar Sea.[1]

The Open Polar Sea fired the imaginations of many writers, including Mary Shelley, who wrote the novel *Frankenstein: or, the Modern Prometheus* (1818) while vacationing among the glaciers of the Alps. The story of a humanoid-monster created by the scientist Victor Frankenstein concludes with the pursuit of the creature into the Arctic. Shelley describes the North Pole as a paradise that beckons the voyager after crossing a placid sea.

Jules Verne (French, 1828–1905), credited with pioneering science-fiction writing, describes the Open Polar Sea in *The Adventures of Captain Hatteras* (1866), which was inspired by the expeditions in search of the lost explorer John Franklin. Verne's hero, obsessed with finding the North Pole, navigates though the ice-bound ocean before sailing across open waters to a volcanic island. After determining that the North Pole lay within the volcano, Hatteras jumps into the crater. He returns home a shattered man, living the rest of his life in an insane asylum, always walking northward.

Two hundred years later, the plausibility of an open polar sea has resurfaced. With the Arctic warming twice as fast as the rest of world, a navigable, warmer waterway may occur within decades. For thousands of years, the rhythm of Arctic life was defined by its cycle of freezing and thawing: new sea ice formed every winter, while older ice continued to build up. Each summer, some of this ice melted. Since 1979, the Arctic has lost forty-four percent of its summer sea ice, an area the size of all of the United States east of Texas.[2]

Artists offer a more emotional and metaphorical interpretation of these extraordinary changes. In *Grand Pinnacle Iceberg, East Greenland* (2006), Camille Seaman (Shinnecock tribe, b. 1969) presents a beautiful but sorrowful ode to the Arctic (**fig. 73**). The artist highlights the vulnerability of ice by focusing on the isolation of a dissolving berg. By

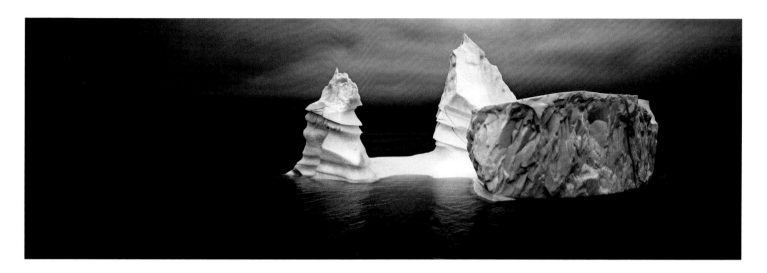

FIGURE 73

Camille Seaman, *Grand Pinnacle Iceberg, East Greenland,*
from the *Last Iceberg,* 2006, Ultrachrome archival inkjet print.

dramatically contrasting values of light and dark, she accentuates the iceberg's forlorn presence within a somber atmosphere.

Seaman's photograph belongs to a series called the *Last Iceberg,* which she shot over a period of eight years during numerous expeditions to Spitsbergen, Greenland, and Antarctica. Guided by the belief that everything contains a life force, she conceives her icebergs "as portraits of individuals, much like family photos of ancestors." This poetic conception reflects her Native American roots.

The fate of the Arctic is also documented by Olaf Otto Becker (German, b. 1959), who captures the rapid transformation of ice into water, a process currently destroying Greenland's ice.[3] In *River 2,07, Position 1, Greenland Icecap, Melting area, Altitude 931 m,* from the series, *Above Zero* (2008), the artist documents a channel of water created in the island's thick dome of ice by rising temperatures

and air-born pollutants (**fig. 74**). These rivers crisscross the landscape, undermining the largest ice shelf in the world after Antarctica. They often disappear into vertical conduits, called *moulins,* which eventually drain into the ocean and contribute to the recession of coastal glaciers.

During the summers of 2007 and 2008, Becker traversed crevasses and melting ice, one hundred miles northeast of Ilulissat, in search of these fleeting rivers that he spotted using NASA satellite imagery. *River 2* appears in Becker's most recent book, *Above Zero* (2010), which contains an essay by Dr. Konrad Steffen, professor of climatology at the University of Colorado, Boulder, and one of the founders of the Greenland Climate Network stations. The artist's photograph makes visible the information provided in a milestone study by an international group of scientists who discovered that Greenland has been losing five times as much ice each year as it did during the 1990s.[4]

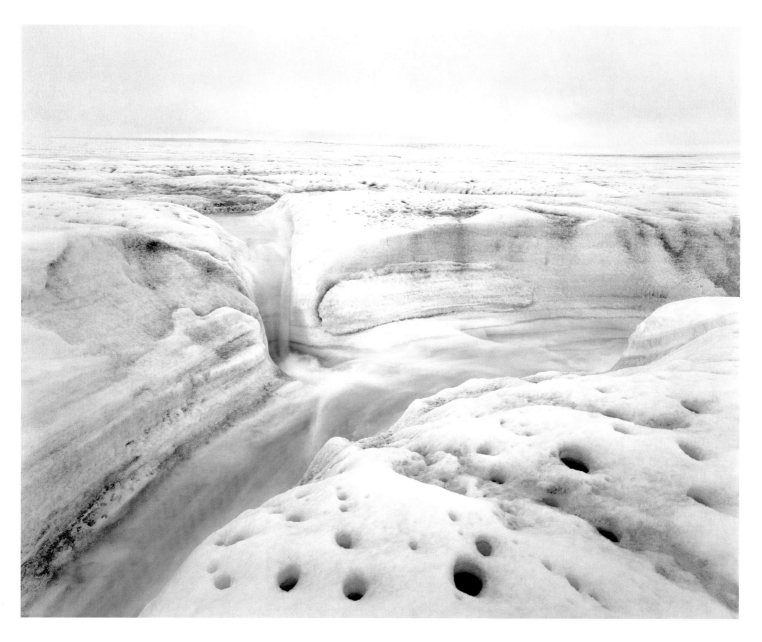

FIGURE 74

Olaf Otto Becker, *River 2, 07, Position 1, Greenland Icecap, Melting area, Altitude 931m,* from *Above Zero,* 2008, archival pigment print on Hahnemuhle Photo Rag.

• • • • • • • • • • • •

Contemporary artists belong to a venerable lineage of draftsmen, painters, and photographers whose icescapes captured peoples' imaginations. During the eighteenth and nineteenth centuries, the public first began to appreciate the planet's frozen frontiers when leading figures in the arts and sciences introduced the beauty and geology of these regions. They countered prevailing negative attitudes, in part, by communicating feelings of reverence generated by the majesty of ice formations. This stimulated a closer connection to the natural world, which ultimately led to the movement for environmental preservation.

Two hundred years later, artists, writers, and scientists once again highlight these icy landscapes now threatened by the accelerated process of climate change. Like their predecessors, they elevate consciousness about these vulnerable environments. By presenting a glimpse into the cultural history of alpine and polar landscapes, *Vanishing Ice* offers an interdisciplinary context in which to understand the importance of these regions for preserving biological and cultural diversity.

1. Hayes titled the account of his 1861 voyage *The Open Polar Sea: A Narrative of a Voyage of Discovery Towards the North Pole in the Schooner "United States"* (1867). The theory was cast aside by the time that explorer-scientist Fridtjof Nansen (Norwegian, 1861–1930) navigated the Arctic by drifting through sea ice in his specially designed boat, the *Fram,* in 1893–96.

2. National Snow and Ice Data Center, Sea Ice Index. http://nsidc.org/data/seaice_index/.

3. Initially inspired by the work of Caspar David Friedrich, Becker began his career as a painter before turning to photography. Unlike Friedrich, an early romantic artist who desired to explore Iceland but never made it, Becker spent four years (1999–2002) interpreting the landscape. He later photographed icebergs off western Greenland during the summers of 2003–6.

4. This study, described in the journal *Science* (November 29, 2012), was summarized by the *Christian Science Monitor,* November 23, 2012.

VANISHING ICE: A TIMELINE

ALPINE AND POLAR LITERATURE

1600

ALPINE EXPLORATION

1601 The first known close-up of a glacier, a topographical watercolor of the Rofener Glacier, is drawn by Abraham Jäger (Tiroler Landesmuseum, Innsbruck, Austria).

1670 The Hudson Bay Company becomes the de facto government for parts of North America and establishes trading posts along paths in the Rockies.

1700

POLAR EXPLORATION

1594–1610 Dutch and English explorers search for the Northwest and Northeast Passages to China for trade.

1596 William Barents (Dutch, 1550–1597), on his third attempt to find the Northeast Passage from Europe to Asia, discovers Spitsbergen (known today as Svalbard) and its rich whaling grounds.

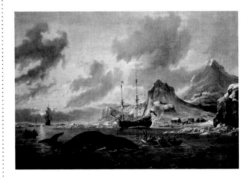

ARCTIC

FUELING THE ECONOMY

1670 With close to 150 whaling ships, the Netherlands becomes one of the richest nations. This status changes with the depletion of whales in the North Atlantic and Arctic waters.

CLIMATE SCIENCE

1729 Albrecht von Haller (Swiss naturalist and poet, 1708–1777) writes *Die Alpen (The Alps)*, a poem that celebrates mountain life and landscape.

1775 Jean Jacques Rousseau's (Swiss, 1712–1778) novel, *La Nouvelle Heloise (The New Eloise: Letters of Two Lovers, Inhabitants of a Small Town at the Foothills of the Alps)*, inspires a passion for alpine mountains and stimulates literary figures such as Lord George Byron (British, 1788–1924) and Mary and Percy Bysshe Shelley (British, 1792–1822) to experience Mont Blanc's glaciers.

1798 *Rime of the Ancient Mariner*, the epic poem by Samuel Taylor Coleridge (British, 1772–1834), which takes place in Antarctic waters, enjoys great popularity and is reprinted with illustrations by the artist Gustave Doré (French, 1832–1883) in the 1870s.

1741 William Windham (British, 1717–1761) joins Richard Pococke (British anthropologist and clergyman, 1704–1765) on an expedition to Chamonix; they name the Mer de Glace glacier. His *An account of the glaciers or ice Alps in Savoy* (1744) becomes the first record of tourists to the region.

1786 Jacques Balmat (Sardinian mountaineer, 1762–1834) and Dr. Michel Paccard (Sardinian doctor, 1757–1827) are the first to reach the summit of Mount Blanc (15,782 ft., 4,810 m). Over the next hundred years, Mont Blanc becomes the most popular and best-documented mountain.

1793 Sir Alexander Mackenzie (Scottish explorer, 1764–1820), the first European to successfully cross the Rocky Mountains, begins his journey into the upper Fraser River and reaches Bella Coola, British Columbia.

ARCTIC

1725–42 Russian Tsar Peter the Great sends Vitus Bering (Danish explorer, 1681–1741) to search for a Northeast Passage to North America. He maps the Arctic Coast of Siberia.

ANTARCTICA

1770s During three voyages of discovery, Captain James Cook (British explorer, 1728–1779) crosses the Antarctic Circle (1773) and charts the coasts of Alaska and northeast Siberia (1778). For the first time, artists and naturalists join an expedition. William Hodges (British, 1714–1782) and Johann George Adam Forster (German, 1729 –1798) create the first images of icebergs on the spot.

1712 Thomas Newcomen (British, 1664–1729) invents the first steam engine, which is used to pump water from coal mines. In 1769, James Watt (Scottish inventor, 1736–1819) improves the design for efficiency. Coal begins to replace other forms of energy—such as wood, wind, water, and whale oil—and propels the Industrial Revolution. Coal produces more carbon emissions than other fossil fuels.

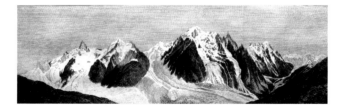

1800

1750 Joseph Black (Scottish chemist and physician, 1728–1799) identifies carbon dioxide (CO_2).

1781 Horace-Bénédict de Saussure (Swiss naturalist, 1740–1799) publishes *Voyages in the Alps*, the first extensive scientific study of the mountain chain. It is illustrated with realistic drawings of glaciers by artists such as Marc Theodore Bourrit (Swiss, 1739–1819), who was also a naturalist.

1770 CO_2 in atmosphere= 280 ppm

The concentration of CO_2 in the atmosphere is measured in parts per million (ppm). 1 ppm = 16.5 billion tons

ALPINE AND POLAR LITERATURE

1800

1816–17 Lord George Gordon Byron (British poet, 1788–1824) writes the epic poem *Manfred*, which takes place in the Alps.

1818 Mary Shelley (British, 1797–1851) stages parts of her gothic novel, *Frankenstein, Or the Modern Prometheus*, in the Alps and the Arctic.

ALPINE EXPLORATION

1802 Joseph Mallard William Turner (British, 1775–1851) crosses the Alps for the first time to paint the snowcapped mountains and surrounding atmosphere. He returns to the Alps in the early 1840s.

1804–1806 The Lewis and Clark expedition, the first scientific reconnaissance of the Rocky Mountains, paves the way for travelers from the East.

1826–27 Sir Woodbine Parish (British scientist, 1796–1882) and Joseph Barclay Pentland (Irish geographer, 1797–1873) survey a large section of the Bolivian Andes in South America.

POLAR EXPLORATION

ARCTIC

1819–1820 Edward Parry (English, 1790–1855) discovers a section of the Northwest Passage and reaches Melville Island, farther west than any previous expedition. Frederick William Beechey (British, 1796–1856), a military officer and artist, documents the voyage, which inspires Caspar David Friedrich (German, 1774–1840) to paint *Sea of Ice* (1823–24).

ANTARCTICA

1839–1840 Three rival expeditions are launched: Admiral Jules Dumont d'Urville (French, 1790–1842) sights the Antarctic continent and names the area where he lands Terre Adélie; Lieutenant Charles Wilkes (American, 1798–1877) sails along fifteen hundred miles of previously undiscovered coast, named Wilkes Land; Sir James Clark Ross (English, 1800–1862) discovers the Ross Ice Shelf and the volcano Mount Erebus. The sketches of Louis Lebreton (French, 1818–1866) become lithographs for the atlas of the French voyage and are used for large-scale exhibition paintings.

FUELING THE ECONOMY

1821 First natural gas well is drilled in the United States, in Fredonia, New York.

1830 The first commercial coal-powered locomotive is inaugurated in the United States.

CLIMATE SCIENCE

1800 CO_2 = 283 ppm

1824 Joseph Fourier (French physicist, 1768–1830) describes how Earth's atmosphere retains heat radiation, comparing it to a box with a glass lid. The phenomenon becomes known as the "greenhouse effect."

1838 Inspired by Antarctic exploration, Edgar Allan Poe (American poet and writer, 1809–1849) publishes *The Narrative of Arthur Gordon Pym of Nantucket*.

1849 Francis Parkman (American historian, 1823–1893) publishes *The California and Oregon Trail*. Thomas Hart Benton (American artist, 1889–1975) illustrates a 1946 edition.

1833 John Ruskin (British, 1819–1900) makes the first of nineteen journeys to the Alps, which inspire scientific studies on glaciers and poems extolling their majesty. Takes the first photographs of the region in 1849 and paints watercolors inspired by JMW Turner, who he promotes as an artist.

1848 First Survey of Mount Everest, known then as "Peak B" or "Peak XV," in the Himalayas.

ARCTIC

1836–1839 Commission scientifique du Nord, sponsored by the French government, explores Scandinavia and Spitsbergen. The artists Barthélémy Lauvergne (1805–1871), Charles Giraud (1819–1892), and Francois-August Biard (1799–1882) create drawings for the expedition atlas, exhibition paintings, and murals for the Museum of Natural History, Paris.

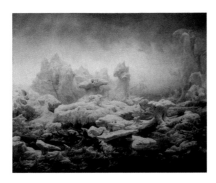

1845–47 John Franklin (British, 1786–1847) searches for the Northwest Passage and is never heard from again. From 1847 to 1859, Lady Jane Franklin persuades England, the United States, and Russia to launch a total of fifty rescue voyages for her husband. In 1859, Franklin's death is confirmed.

1830–1875 Rapid expansion of the Industrial Revolution with a corresponding rise in atmospheric carbon dioxide.

1849 Kerosene, distilled from oil by Abraham Gesner (Canadian geologist, 1797–1864), creates a new market for crude oil.

1850

1840 Louis Agassiz (Swiss scientist, 1807–1873) introduces and popularizes the idea of an ice age. The artist Joseph Betannier (French, 1817–after 1877) illustrates Agassiz's influential book, *Studies on Glaciers*.

1842 Joseph Alphonse Adhémar (French mathematician, 1797–1862) publishes *Revolutions of the Sea*, arguing that ice ages result from variations in the ways the earth moves around the sun.

1850 CO_2 = 290 ppm

ALPINE AND POLAR LITERATURE

1850

1856–57 *The Frozen Deep: A Drama in Three Acts,* inspired by John Franklin's Northwest Passage expedition, is written by Wilkie Collins (British, 1824–1889) and staged by Charles Dickens (British, 1828–1905).

1866 Jules Verne's (French, 1828–1905) science fiction novel *The Voyages and Adventures of Captain Hatteras* follows the protagonist to the North Pole. It includes illustrations by Edouard Riou (French, 1883–1900).

ALPINE EXPLORATION

1857 The Alpine Club in London, the first mountaineering organization, is established to promote better knowledge of the European Alps through literature, science, and art.

1860 Some of the first photographs of Mont Blanc are taken by Bisson Frères (Bisson brothers: Louis-Auguste Bisson and Auguste-Rosalie Bisson, French, 1814–1876 and 1826–1900). They document the expedition of Emperor Napoleon III and Empress Eugenie, who do not reach the summit.

POLAR EXPLORATION

ARCTIC

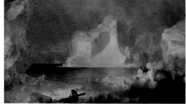

1860s The painter Frederic Edwin Church (American, 1826–1900) completes his tour de force, *The Icebergs* (1861), which tours New York, Boston, and London. In 1864, Edwin Landseer (British, 1802–1873) exhibits *Man Proposes, God Disposes* (1864), a social commentary on British polar exploration.

FUELING THE ECONOMY

1850s Peak of the American whaling industry, which fuels the economy and continental expansion. Five thousand sperm whales killed each year.

1859 Edwin Laurentine Drake (American, 1819–1880) drills the first commercial oil well in Titusville, Pennsylvania. This marks the beginning of the modern petroleum industry, which soon produces enough crude oil to displace whale oil for lighting.

1860 Invention of the first solar power system used to power a steam engine, by Augustin Mouchot (French, 1825–1912) in France.

1867 Nikolaus August Otto (German inventor, 1831–1891) patents the four-stroke internal combustion engine. Rapid mechanization of production spreads.

CLIMATE SCIENCE

1859 John Tyndall (Irish physicist, 1820–1893) recognizes that naturally occurring gases, such as water vapor and carbon dioxide, trap heat and emit some of it back into space.

1850 CO_2 = 290 ppm

1890 Mark Twain (American, 1835–1910) conveys his impressions of alpine glaciers in *A Tramp Abroad*, a travelogue that combines autobiographical and fictional events.

1897 Fridtjof Nansen (Norwegian, 1861–1930) publishes a diary of his three-year-long expedition to the North Pole, *Farthest North*. It recounts the hardships endured in an extreme climate coupled with his impressions of the magical Arctic landscape.

1867–79 Clarence King (American geologist, 1842–1901) leads the Geological Exploration of the 40th Parallel and discovers Mount Shasta's Whitney Glacier, the first known glacier in the United States. The photographer Carleton Watkins (American,1829–1916) accompanies the expedition and documents the glacier in 1870.

1889 Geographer Hans Meyer (German, 1858–1929) and mountaineer Ludwig Purtscheller (Austrian, 1849–1900) become the first to summit Mount Kilimanjaro (19,341 ft, 5,895 m) in Tanzania, Africa.

1892 John Muir (Scottish-American naturalist, 1838–1914) founds the Sierra Club, dedicated to environmental preservation. The artist Ansel Adams joins in 1919 and uses his photographs to lobby for conservation. The photographer Eliot Porter becomes its director in 1965 and serves to 1971.

1899 Mount Rainier National Park established.

ARCTIC

1873 Publication of *Arctic Regions*, a landmark photographic account of the painter William Bradford's (American, 1823–1892) expedition off the coast of northwest Greenland in 1869. The voyage inspires the Arctic expeditions and photography of Rena Bass Forman (American, 1948–2011).

1882–83 First International Polar Year, an international collaboration of research and exploration, is launched.

ARCTIC

1893–96 Fridtjof Nansen and Otto Sverdrup (Norwegian, 1854–1930) drift across the Arctic Ocean in the *Fram*, which was built to withstand pressure from the ice. Establishes a new farthest point north reached by a nonnative explorer.

ANTARCTICA

1895 Sixth International Geographical Congress passes a resolution urging exploration of Antarctica before the end of the nineteenth century. This spurs national expeditions.

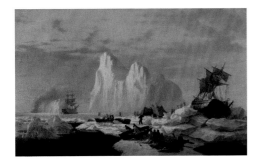

1882 Thomas Edison develops the first coal-fired electricity-generating station in New York City.

1888 Electricity is generated by a windmill for the first time, in Cleveland, Ohio.

1900

1870–1910 Second Industrial Revolution. Growth spurred by the expanded use of electricity, fertilizers and other chemicals, and improvements in public health.

1895 International Glacier Commission established and begins the first coordinated collection and publication of standardized information about glacier changes.

1896 Svante Arrhenius (Swedish, 1859–1927) publishes *On the Influence of Carbonic Acid in the Air upon the Temperature of the Ground*, which suggests that atmospheric temperatures will rise 5.4° F (3° C) if the concentration of atmospheric carbon dioxide doubles.

1900 CO2 = 295 ppm

ALPINE AND POLAR LITERATURE

1915 In *Travels in Alaska*, a compendium of nature essays, John Muir relates his experience with glaciers in the Pacific Northwest during trips in 1879, 1880, and 1890.

1922 An account by explorer Apsley Cherry-Garrard (British, 1886–1959) in *The Worst Journey in the World* describes Robert Falcon Scott's tragic expedition to the South Pole, but the "worst journey" is his own harrowing experience traveling in polar winter to a penguin rookery.

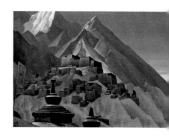

1900

ALPINE EXPLORATION

1902 American Alpine Club founded by a group of men and women, including Fannie Bullock Workman (1859-1925) and Annie Smith Peck (1850-1935), who is the first to summit Peru's Mt. Huascaran's north peak (21,830 ft. 6,653 m) in 1908.

1905 President Theodore Roosevelt (American, 1882–1945) creates Rocky Mountain National Park to preserve the wildlife within the mountain range.

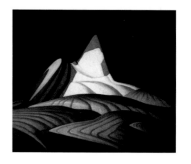

POLAR EXPLORATION

ARCTIC

1909 Robert Peary (American, 1856–1920), Matthew Henson (African-American, 1866–1955), and four Inuit guides (Ooqueah, Ootah, Egingwah, Seegloo) reach the North Pole but do not bring back sufficient evidence to definitively prove it. The artist Isaac Julian (British, b. 1960), in his video *True North* (2004), resurrects Matthew Henson, the neglected explorer.

ANTARCTICA

1911–1912 Roald Amundsen (Norwegian, 1872–1928) reaches the South Pole. Robert Falcon Scott (British, 1868–1912) arrives one month later. Scott and four expedition members, including the physician and artist Edward Wilson (British, 1872–73), die on the return. In 1913, *Scott's Last Expedition* includes moving journal entries of the fatal journey to the South Pole and reproduces photographs by Herbert Ponting (British, 1870–1935) and watercolors by Edward Wilson.

ANTARCTICA

1914–16 Ernest Shackleton (Irish, 1874–1922) leads the Imperial Trans-Antarctic Expedition but is curtailed when his ship, the *Endurance*, is crushed by the ice. It results in the heroic rescue of all crew members. The photographer Frank Hurley (Australian, 1882–1962) creates iconic images of the expedition.

FUELING THE ECONOMY

1903 Henry Ford (American industrialist, 1863 –1947) establishes the Ford Motor Company and starts building automobiles. The Model T, introduced in 1908, marks the beginning of automobile mass production.

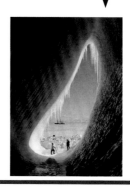

1920s Persian Gulf and Texas oil fields open, ushering in an era of "cheap oil."

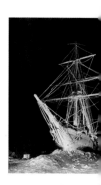

CLIMATE SCIENCE

1928 Chlorofluorocarbons (CFCs), destructive atmospheric chemicals, are invented and used in refrigerators and air conditioners. After the discovery of a hole in the ozone by British scientists over the Antarctic in 1985 and mounting public outcry, CFCs are banned in 1987

1900 CO_2 = 295 ppm

1933 *Lost Horizon,* a popular novel by James Hilton (British, 1900–1954), describes the utopian life of a Tibetan monastery isolated in the Himalayas.

1938 In *Alone,* Richard Byrd (American, 1888–1957) describes his life wintering in solitude, 125 miles south of his expedition base, in 1934.

1924 The artist Nicholas Roerich (Russian, 1874–1947) launches a four-year expedition through central Asia. The journey takes him to the Himalayas, which inspires his life's work. The painter Lawren Harris (Canadian, 1885–1970) makes his first trip to the Canadian Rockies and returns each year until 1927.

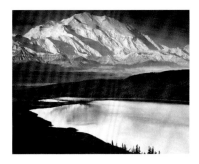

1947 Ansel Adams (American, 1902–1984) travels to Alaska and photographs Mount McKinley and Wonder Lake, Denali National Park.

1928–30 Admiral Richard Byrd (American, 1888–1957) establishes his base at Little America and flies to the South Pole in 1929. He returns to the continent in 1933–35 and is joined by the expedition's artist, David Abbey Paige (American, 1901–1979).

ANTARCTICA

1946–1947 Richard Byrd commands Operation Highjump with four thousand navy men who engage in aerial photography of the continent.

1950

1925 First modern whaling factory ships set sail from Norway. The industry grows, and approximately forty thousand whales are processed each year.

1938 US federal government regulates interstate natural gas sales with the Natural Gas Act (NGA) to protect against price gouging.

1946 International Whaling Commission, established by fifteen nations, is charged with the conservation of whales and the management of whaling, yet still in 1958, more than twenty thousand sperm whales are killed each year for margarine, cattle fodder, dog food, vitamin supplements, glue, leather preservative, and brake fluid.

1930s Media reports of global warming motivates Guy Steward Callendar (British engineer, 1898–1964) to study data. He reports that temperatures increased between 1890–1935 and returns to an earlier idea that carbon dioxide emissions and increased temperatures are linked.

1932–33 Second International Polar Year for nations to coordinate their observations and analyses.

1941 After thirty years of research, Milutin Milankovitch (Serbian scientist, 1879–1958) attributes the cause of ice ages to changes in Earth's orbit over thousands of years

1950 CO_2 = 310 ppm

ALPINE AND POLAR LITERATURE

1955 *The Last Kings of Thule: with the Polar Eskimos, as they face their destiny,* by Jean Malaurie (French, b. 1922), describes Inughuit culture in northern Greenland before and after the construction of an American air force base. Malaurie writes a foreword to *Inughuit* (2004), Tiina Itkonen's book of photographs on northern Greenland's people and environment.

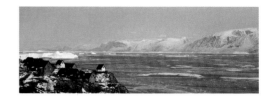

1950

ALPINE EXPLORATION

1953 Sir Edmund Hillary (New Zealand mountaineer and explorer, 1919–2008) and Tenzing Norgay (Nepali Sherpa mountaineer, 1915–1986) become the first men to summit Mount Everest.

1964–65 Thomas Hart Benton (American, 1889–1975) travels on horseback through Banff National Park in the Canadian Rockies.

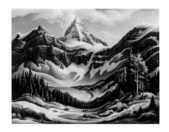

POLAR EXPLORATION

ARCTIC

1950–1986 Soviet Union establishes twenty-seven drifting research stations to explore the Arctic and study its climate.

1958 The US nuclear-powered submarine, *The Skate*, becomes the first vessel to surface at the North Pole.

1959 Antarctic Treaty signed by twelve countries (and since expanded to include fifty treaty member nations). It sets aside Antarctica as a scientific preserve, establishes freedom of scientific investigation, and bans military activity.

ANTARCTICA

1975 Eliot Porter is one of the first artists selected by the US National Science Foundation Antarctic Artist and Writers Program, established to expand awareness of polar research. Australia, Great Britain, and New Zealand create similar programs in the 1970s.

FUELING THE ECONOMY

1950 Petroleum becomes the most popular fuel used in the United States as a result of the growing dependency on automobiles.

1957 The world's first commercial nuclear power plant opens in the United States, in Pennsylvania. Disasters at reactors in Chernobyl, Ukraine (1986) and the Fukushima Daubu Nuclear Power Plant in Japan (2011) stimulate nations to reconsider nuclear energy.

1960s Hydrogen fuel cells are developed by General Electric (GE) to generate electricity during US space missions.

1969 After the Santa Barbara oil spill, public outcry results in stricter regulations on leases and cleanup.

CLIMATE SCIENCE

1958 First direct measurement of atmospheric carbon dioxide concentrations on the summit of Mauna Lao, Hawaii (13,123 ft.) begins and continues to this day. Beginning of the Keeling Curve, a graph that shows atmospheric concentrations.

1965 Causes of Climate Change, the first major conference to address climate, meets in Boulder, Colorado, and fails to attract political or media attention.

1970–1980s Scientists raise concern about rising greenhouse gases and the role of the oceans as a carrier of heat and carbon dioxide. In 1979, the National Academy of Sciences issues its first major report on global warming.

1980s First attempt to compile a world glacier inventory by the World Glacier Monitoring Service and National Snow and Ice Data Center.

The hottest decade on record

1958 CO_2 = 316 ppm

1979 CO2 = 337 ppm

1977 In *Coming into the Country*, John McPhee (American, b. 1931) presents a portrait of Alaska—people and landscape—from the wilderness to the city.

1986 Barry Lopez's (American, b. 1945) *Arctic Dreams: Imagination and Desire in a North Landscape*, a landmark study of the terrain, wildlife, and native people of the Far North, wins the National Book Award.

1988 In *The Arctic Grail: The Quest for the North West Passage and the North Pole, 1818-1909*, Pierre Bertin (Canadian, 1920-2004) brings to life the history of Arctic exploration.

1980s Widespread international interest in the geology of the Himalayas results in numerous expeditions, described by Mike Searle in *Colliding Continents: A Geological Exploration of the Himalaya, Karakoram, and Tibet* (2013)

1996 David Breashears (American mountaineer and filmmaker, b. 1955) co-directs the first IMAX documentary of Mount Everest, which premieres in 1998.

ARCTIC

1970–78 Arctic Ice Dynamics Joint Experiment (AIDJEX) organized by the University of Washington Polar Science Center, "the first major western sea ice experiment constructed specifically to answer emerging questions about how sea ice moves and changes in response to the influence of ocean and atmosphere."

ANTARCTICA

1983 Scott Polar Research Institute in Cambridge produces the first glaciological atlas.

ANTARCTICA

1996 Ice core samples from the Russian Vostok base show 420,000 years of Earth's atmospheric history.

2000

1973–74 After OPEC (Organization of Petroleum Exporting Countries) launches an oil embargo on the United States, consumers experience precipitous price increases. In 1977, US president Jimmy Carter encourages Americans to conserve energy and creates the Department of Energy and the Solar Energy Research Institute.

1986 Whaling moratorium takes effect. Meat and other whale products are effectively banned on the international commercial market. In 1994, a Southern Ocean Sanctuary is overwhelmingly adopted at the International Whaling Commission meeting.

1989 Exxon Valdez oil spill in Alaskan waters results in a massive loss of wildlife and habitat destruction. It remained the largest spill in the United States until a British Petroleum (BP) offshore oil rig explodes in the Gulf of Mexico in 2010.

1996–99 A solar operating plant in California, a joint project between the Department of Energy and US power utilities, demonstrates the potential to generate and store electricity efficiently.

1997 The electric car—EV1—makes its debut in California, but GM abandons the effort in 2002.

1988 Intergovernmental Panel on Climate Change (IPCC) established by the United Nations Environmental Panel and the World Meteorological Organization. The IPCC compiles all significant research published in the world and produces synthesis reports in 1990, 1995, 2001, and 2007.

1990 Dr. Konrad Steffen (Swiss, b. 1952), a professor at the University of Colorado, Boulder, sets up Swiss Camp, a field site on the Greenland ice sheet, where he and colleagues monitor climate change. Between 1993 and 2008, temperature rises about 4° F (2.2°C). The artist Olaf Otto Becker (German, b. 1959) photographs the camp as well as the melting ice sheet in 2008.

1997 Kyoto Protocol, an international agreement linked to the United Nations Framework Convention on Climate Change, sets binding targets for industrialized countries for reducing greenhouse gas emissions. In 2001, President George W. Bush withdraws United States support for the agreement.

1992 CO_2 = 356 ppm

2000

ALPINE AND POLAR LITERATURE

2007 An anthology of classic writings on the Arctic and Antarctic, *The Ends of the Earth*, by Francis Spufford and Elizabeth Kolbert (American, b. 1964 and b. 1961) includes narratives, cultural histories, nature and science writing, and fiction.

2009 In *A World without Ice*, the geophysicist Henry Pollack (American, b. 1936) provides an accessible and comprehensive examination of the properties of ice, ice ages, and climate change.

2012 *Arctic Voices: Resistance at the Tipping Point*, edited by the photographer Subhankar Banerjee (American, b. India, 1967), includes writings of notable authors, naturalists, and activists, along with photographs that convey the importance of preserving the region amid the onslaught of industrial development.

ALPINE EXPLORATION

2009 *Nova* and *National Geographic* produce *Extreme Ice*, which documents James Balog's (American, b. 1952) time-lapse photography of retreating glaciers.

2010 *Northwest Mountaineering Journal* publishes an article on climate change and the dangerous impacts on climbing.

POLAR EXPLORATION

ARCTIC

2003 David Buckland (British, b. 1949) establishes the Cape Farewell project and launches the first voyage to Spitsbergen (Svalbard) with a collaborative team of artists, scientists, and educators to study climate change. The artists Heather Akroyd and Dan Harvey (British, b. 1959) join the group, and in 2010, Paul D. Miller (aka DJ Spooky, American, b. 1970) journeys to the Arctic with the organization after traveling to Antarctica in 2008.

ANTARCTICA

2007 First zero-emissions polar science station built by the International Polar Foundation to conduct research on climate change.

2007–2009 Third International Polar Year spans two full years and stimulates over two hundred projects. It includes the most extensive Arctic climate change study to date, involving three hundred scientists and sixteen countries. Photographer Chris Linder (American, b. 1972) documents student scientists studying thawing permafrost in *The Polaris Project: Science in Siberia* (2009).

2011 International Congress Circumpolar Peoples sponsor by UNESCO (United Nations Educational, Scientific, and Cultural Organization).

FUELING THE ECONOMY

2005 Congress blocks oil drilling in the Arctic National Wildlife Refuge.

2009 President Barack Obama signs the American Recovery and Reinvestment Act, which allocates billions of dollars to alternative fuel development.

2012 The first Clean Air Act to limit carbon emissions for new power plants put forth by the Environmental Protection Agency (EPA) is made public.

CLIMATE SCIENCE

2002 Larsen B ice shelf, roughly the size of Rhode Island, collapses in Antarctica.

2006 Ice loss in Greenland doubles since 1996, according to NASA. *An Inconvenient Truth*, a film about global warming starring Al Gore, introduces climate change to a wider audience.

2007 Intergovernmental Panel on Climate Change (IPCC) reports that "the evidence for global warming is unequivocal and there is very high confidence that this is due to human activity." Over the past 150 years, the sea level has risen 8.66 inches (22 cm), and average global temperatures have risen 1.4° F.

2012 Warmest July since United States record keeping began fuels drought across the United States.

| 2000 | CO2 = 370.06 ppm | 2005 | CO2 = 379 ppm | 2006 | CO2 = 381 ppm | | 2010 | CO2 = 389.92 |
| 2011 | CO2 = 391.65 ppm | 2012 | CO2 = 393.84 ppm | February 2013 | CO2 = 396.80 ppm | May 9, 2013 = 400 pp |

The ice and the long moonlit polar nights, with all their yearning,

seemed like a far-off dream from another world—

a dream that had come and passed away.

But what would life be worth without its dreams?

—Fridtjof Nansen, *Farthest North,* 1897

ANTARCTIC
TREATY
SECRETARIAT

CHECKLIST OF THE EXHIBITION

*Works displayed as reproductions

Heather Ackroyd and Dan Harvey
British, both b. 1959
Ice Lens, Svalbard Archipelago, 2005
Archival inkjet print
24 x 32 in. (60.9 x 81.28 cm)
Courtesy of the artists

Ansel Adams
American, 1902–1984
Mount McKinley and Wonder Lake Denali National Park and Preserve, Alaska, 1947, printed c. 1972
Gelatin silver print
40 x 48 ½ in. (101.6 x 123.2 cm)
Courtesy of the Center for Creative Photography at the University of Arizona Libraries, Tucson
© 2012 The Ansel Adams Publishing Rights Trust

Lita Albuquerque
American, b. 1946
Stellar Axis, Constellation 1, 2006
Archival inkjet print by Jean de Pomereu
20 ¾ x 47 ¼ in. (53 x 120 cm)
Whatcom Museum, Gift of Jean de Pomereu, 2013.17.2

James Balog
American, b. 1952
Extreme Ice, 2009
Nova/National Geographic documentary, 52 minutes
Courtesy of PBS

Subhankar Banerjee
American, b. India, 1967
Caribou Migration from *Oil & the Caribou,* 2002
Color photograph from *Arctic National Wildlife Refuge: Seasons of Life and Land,* 2003
86 x 68 in. (218.4 x 172.7 cm)
Private collection

Brett Baunton
American, b. 1959
Coleman Glacier, Mount Baker, 2007
Archival inkjet print
11 x 20 in. (28 x 50.8 cm)
Courtesy of the artist

Olaf Otto Becker
German, b. 1959
River 2, 07, Position 1, Greenland Icecap, Melting area, Altitude 931m, from *Above Zero,* 2008
Archival pigment print on Hahnemuhle Photo Rag
58 ½ x 70 ½ in. (148.6 x 179.1 cm)
Courtesy of the artist

Frederick William Beechey
British, 1796–1856
HMS Hecla in Baffin Bay, illustration from *Journal of a Voyage for the Discovery of a Northwest Passage from the Atlantic to the Pacific Performed in the Years 1819-20 in His Majesty's Ships Hecla and Griper,* London, John Murray, 1821
11 x 9 x 1 ¾ in. (28 x 23 x 4.5 cm)
Courtesy of Linda Hall Library of Science, Engineering and Technology, Kansas City, Missouri

Thomas Hart Benton
American, 1889–1975
Trail Riders, 1964–65
Oil on canvas
67 ½ x 85 ⅜ in. (171.5 x 217 cm)
National Gallery of Art, Washington DC, Gift of the artist, 1975.42.1

Joseph Bettannier
French, 1817–after 1877
Hugi's hut on a medial moraine of the lower Aar glacier from Louis Agassiz, *Etudes sur les glaciers (Studies on Glaciers),* 1840
Lithograph
19 ¼ x 13 ⅛ in. (48.9 x 33.3 cm)
Courtesy of Linda Hall Library of Science, Engineering and Technology, Kansas City, Missouri

***Francois-Auguste Biard**
French, 1799–1882
Pêche au morse par des Groënlandais, vue de l'Océan Glacial (Greenlanders Hunting Walrus: View of the Polar Sea), Salon of 1841
Oil on canvas
51.2 x 64.3 in. (130 x 163.3 cm)
Musée du Chateau, Dieppe, France
Photo credit: Erich Lessing / Art Resource, NY

Albert Bierstadt
German-American,1830–1902
Mount Sir Donald, Asulkan Glacier, c. 1890
Oil on canvas
39 x 31 ⅝ in (99.06 x 78.74 cm)
Courtesy of The Haggin Museum, Stockton, California

Bisson Frères (Bisson brothers: Louis-Auguste Bisson and Auguste-Rosalie Bisson)
French, 1814–1876 and 1826–1900
Ascension au Mont Blanc (Ascent of Mont Blanc), 1860, printed 2013
Albumen print
9 x 15 in. (22.8 x 38.1 cm)
Courtesy of George Eastman House, International Museum of Photography and Film

Gary Braasch
American, b.1950
Athabasca Glacier, Jasper National Park from *Earth under Fire: How Global Warming Is Changing the World,* 2005
Archival inkjet print
14 x 20 in. (35.6 x 50.8 cm)
Courtesy of the artist, Portland, Oregon

William Bradford
American, 1823–1892
Caught in the Ice Floes, c. 1867
Oil on canvas
37 ½ x 55 ¼ in. (95.25 x 140.3 cm)
Courtesy of the New Bedford Whaling Museum (Kendall Collection), New Bedford, MA

David Breashears
American, b. 1955
West Rongbuk Glacier, 227°59'17"N, 86°55'31"E, 2008
Archival inkjet print on canvas
18 x 90 in. (45.7 x 228.6 cm)
Courtesy of GlacierWorks
Location: Northern Slope of Mount Everest, 29,028 ft. (8,847.7 m) Tibet, China
Range: Mahalangur Himal
Elevation of glacier: 17,300–20,341 ft. (5,273–6,200 m); average vertical glacier loss: 341 ft. (104 m), 1921–2008

David Buckland
British, b. 1949
Burning Ice, 2004-5
Archival inkjet print of projection on the wall of a glacier
24 x 32 in. (60.96 x 81.28 cm)
Courtesy of the artist

David Buckland
British, b. 1949
Art from a Changing Arctic, 2006
DVD, 60 minutes
Courtesy of the artist and Snag Films

Cynthia Camlin
American, b. 1960
Melted 4, 2008
60 x 52 in. (152.4 x 132 cm)
Watercolor and acrylic on paper
Courtesy of the artist

Martin Chambi
Peruvian, 1891–1973
Peregrino en Qoyllor Rit'i (Pilgrim at Qoyllur Rit'i), 1930s
Gelatin silver print
16 x 20 in. (40.6 x 50.8 cm)
Courtesy of Teo Allain Chambi

***Frederic Edwin Church**
American, 1826–1900
The Icebergs, 1861
Oil on canvas
64 ½ x 112 ½ in. (162.56 x 284.48 cm)
Dallas Museum of Art, Anonymous gift, 1979.28

Xavier Cortada
American, b. 1964
Astrid, 2007
Sea ice from Antarctica's Ross Sea, sediment from the Dry Valleys, and mixed media on paper (created onsite at McMurdo Station, Ross Island, Antarctica)
12 x 9 in. (30.5 x 22.9 cm)
Whatcom Museum, Gift of the artist and Juan Carlos Espinosa, 2013.19.1

Gustave Doré
French, 1832–1883
The Ice Was All Around, illustration for Samuel Taylor Coleridge's *The Rime of the Ancient Mariner,* New York, Harper and Row, 1877
18 x 15 in. (45.7 x 38.1 cm)
Whatcom Museum, 2012.34.1

Paul D. Miller (aka DJ Spooky)
Manifesto for a People's Republic of Antarctica, 2011–2012, archival inkjet print.

Chris Drury
British, b. 1948
*Above and Below Cararra Nunatac,
Sky Blu, Antarctica,* 2006–7
Archival inkjet print, including an
echogram from under the ice in East
Antarctica
29 x 35 in. (73 x 89 cm)
Courtesy of the artist

**John L. Dunmore and George
Critcherson**
American, active 1850s–1870s and
1823–1892
Untitled, c. 1873, printed 2013
Copy negative from *The Arctic
Regions* with drawing on the original
plate by William Bradford or the
photographers
16 x 20 in. (40.64 x 50.8 cm)
Courtesy of the Estate of Rena Bass
Forman

Jyoti Duwadi
American, b. Nepal, 1947
Melting Ice, site-specific installation
for the Whatcom Museum, 2013
Ice blocks
10 x 10 x 10 ft.
(304.8 x 304.8 x 304.8 cm)
Courtesy of the artist

Henry C. Engberg
American, 1865–1942
Coleman Glacier, Mt. Baker, 1909–18,
printed 2012
Black-and-white photograph
11 x 20 in. (28 x 50.8 cm)
Courtesy of Pacific Northwest Studies,
Western Washington University

William O. Field
American, 1904–1994
*Muir Glacier, Glacier Bay National
Park and Reserve's White Thunder
Ridge, August 13, 1941,* printed 2013
8 x 12 in. (20.32 x 30.48 cm)
From the Glacier Photograph
Collection. Boulder, Colorado USA:
National Snow and Ice Data Center/
World Data Center for Glaciology

Rena Bass Forman
American, 1948–2011
Greenland #3 Illulissat, 2007
Toned gelatin silver print
38 x 38 in. (96.5 x 96.5 cm)
Courtesy of Winston Wachter Fine
Art, Seattle

***Johann Georg Adam Forster**
German, 1754–1794
Ice Islands with ice blink, 1773
Gouache on paper
14 x 21 ¼ in. (35 x 54 cm)
Mitchell Library, State Library of New
South Wales

***Caspar David Friedrich**
German, 1774–1840
Das Eismeer (Sea of Ice), 1823–24
Oil on canvas
38 x 50 (96.7 x 126.9 cm)
©Hamburger Kunsthalle, Photo: Elke
Walford/ Art Resource, NY

Lawren Harris
Canadian, 1885–1970
Isolation Peak, Rocky Mountains, 1930
Oil on canvas
42 x 50 in. (106.7 x 127 cm)
Hart House Permanent Collection
University of Toronto, Purchased
by the Art Committee with income
from the Harold and Murray Wrong
Memorial Fund, 1946

Helen and Newton Harrison
American, b. 1929 and 1932
*Tibet Is the High Ground Part IV: The
Force Majeure,* 2008–present
Archival coloring on vinyl
90 x 90 in. (228.6 x 228.6 cm)
Courtesy of the artists

***William Hodges**
British, 1744–1797
*The Resolution and Adventure, 4
January 1773, taking ice for water,
latitude 61 degrees South*
Ink and wash on paper
14 x 22 in. (35.6 x 55.9 cm)
Courtesy of Mitchell Library, State
Library of New South Wales, PXD
11.f.30

Christian Houge
Norwegian, b. 1972
Winternight, 2001
Digital C-print
39 ½ x 118 in. (100.6 x 299.7 cm)
Courtesy of the artist and Hosfelt
Gallery, San Francisco & New York

Frank Hurley
Australian, 1882–1962
Endurance trapped in the ice at night,
1915, printed 2013
Black-and-white photograph
22 x 16 in. (55.88 x 40.64 cm)
Courtesy of Royal Geographical
Society, London

Tiina Itkonen
Finnish, b. 1968
Uummannaq 6, 2010
C-print
27 ½ x 78 in. (70 x 200 cm)
Courtesy Galerie Kashya Hildebrand,
Zurich

Len Jenshel
American, b. 1949
Narsaq Sound, Greenland, 2001
C-print
26 x 30 in. (66 x 76 cm)
Courtesy of the artist and Joseph
Bellows Gallery, La Jolla, CA

Eirik Johnson
American, b. 1974
La Cordillera Colquepunko, Peru, from
the series *Snow Star,* 2004
Archival pigment print
22 x 40 in. (55.9 x 101.6 cm)
Courtesy of the artist and G. Gibson
Gallery

Chris Jordan
American, b. 1963
Denali Denial, 2006
Depicts 24,000 logos from the GMC
Yukon Denali, equal to six weeks of
sales of that model SUV in 2004
Archival inkjet print
60 x 75 in. (152.4 x 190.5 cm)
Courtesy of the artist, Chris Jordan

Isaac Julien
British, b. 1960
True North, 2004
16mm film transfer to single screen
DVD video, 14:58 minutes
Courtesy of the artist and Metro
Pictures, New York

**Nicholas Kahn and Richard
Selesnick**
British and American, both b. 1964
Currency Balloon, from
Eisbergfreistadt, 2008
Archival pigment print
10 x 72 in. (25.4 x 182.9 cm)
Courtesy of Yancey Richardson
Gallery

Rockwell Kent
American, 1882–1971
Resurrection Bay, Alaska, c. 1939
Oil on canvas on board
28 x 44 ½ in. (71.1 x 113 cm)
Frye Art Museum, Seattle,
Washington. Museum Purchase,
1998.010
Rights courtesy Plattsburgh State
Art Museum, State University of New
York, USA, Rockwell Kent Collection,
Bequest of Sally Kent Gorton. All
rights reserved.

Rockwell Kent
American, 1882–1971
*Wilderness: A Journal of Quiet
Adventure in Alaska,* 1920
Revised signed and numbered edition,
Ward Ritchie Press,1970
Private collection

Darius Kinsey
American, 1869–1945
Crossing a glacier near Monte Cristo,
1902
Black-and-white stereograph
3.5 x 7 in. (8.89 x 17.78 cm)
Whatcom Museum, 1978.84.6417

Stuart Klipper
American, b. 1941
*Seal research transponder, McMurdo
Sound sea ice, Razorback Islands, near
Ross Island, Antarctic,* 1999
C-print
12 x 38 in. (30.5 x 96.5 cm)
Courtesy of the artist

***Edwin Landseer**
British,1802–1873
Man Proposes, God Disposes, 1864
Oil on canvas
36 x 96 in. (91.4 x 243.7 cm)
Royal Holloway, University of London,
The Bridgeman Art Library

Sydney Laurence
American, 1865–1940
Cordova, Alaska, 1909
Oil on canvas
44 x 111 in. (111.8 x 281.9 cm)
Whatcom Museum, Gift of Barbara
Royal Blood from the estate of Alan
Royal Jenkins, 1968.107.1

Barthélémy Lauvergne
French, 1805–1871
*Vue prise dans la baie de Smeremberg
(View of Smeremberg Bay),* 1839, from
*Voyages de la Commission scientifique
du Nord en Scandinavie, en Laponie,
au Spitzberg, et aux Feroe, pendant
les annees, 1838, 1839 et 1840, sur la
corvette la Recherche,* commandee
par M. Fabvre/ publies par order du
Gouvernement sous la direction de Paul
Gaimard, Paris: Arthus Bertrand, *Atlas
Pittorèsque,* c. 1842–55
Lithograph
21 ½ x 15 x 2 ¾ in.
(54.5 cm x 38 cm x 7 cm)
Courtesy of Linda Hall Library of
Science, Engineering and Technology,
Kansas City, Missouri

Louis Lebreton
French, 1818–1866
*Debarquement sur la Terre Adélie, le 21
Janvier 1840 (Landing on Adelie Land
January 21, 1840)* from *Voyage au Pôle
Sud et dans l'Océanie sur les corvettes
L'Astrolabe et La Zélée. . .1837-1840
sous le commandement de M. Dumont
d'Urville, Atlas Pittorèsque,* Paris, 1846
Lithograph
21 ⅝ x 14 ½ x 1 ½ in. (55 x 37 x 4 cm)
Courtesy of Linda Hall Library of
Science, Engineering and Technology,
Kansas City, Missouri

***Xavier Leprince**
French, 1799–1826
*Paysage du Susten en Suisse
(Landscape of Susten, Switzerland),* 1824
Oil on canvas
32 x 41 in. (81.5 x 105 cm)
Louvre, Paris, France
Photo Credit: Hervé Lewandowski
© Réunion des Musées Nationaux -
Grand Palais / Art Resource, NY

Nerys Levy
American, b. Wales, 1945
Antarctic sketchbook: Penguins and Elephant Seals, Penguin Island, Antarctic Peninsula, December 2007
Watercolor and water soluble pen
6 x 20 ¼ in. (15.2 x 51.4 cm)
Courtesy of the artist

Nerys Levy
Arctic Sketchbook, Hornsund, Spitzbergen, Norway, July 2009
Watercolor and water soluble ink
6 x 20 ¼ in. (15.24 x 51.4 cm)
Courtesy of the artist

***Jean-Antoine Linck**
Swiss,1766–1843
Vue prise de la voûte nommé le Chapeau, du glacier des Bois et des Aiguilles du Charmoz (View of the Glacier des Bois and the Needles of Charmoz from the arch, called the Cap), 1799
Colored etching
14 ¼ x 19 in. (36.2 x 48.7 cm)
Bibliothèque publique et universitaire de Genève

Chris Linder
American, b. 1972
The Polaris Project: Science in Siberia, 2009
DVD, 10:40 minutes
Courtesy of the artist

Chris Linder
American, b. 1972
Siberian permafrost thaw, Duvannyi Yar, Kolyma River, Siberia, July 21, 2010
Archival inkjet print
13 ¼ x 20 in. (33.65 x 40.6 cm)
Courtesy of the artist

Anna McKee
American, b. 1959
Depth Strata V, 2011
Etching, collography, and chine collé
Image size: 24 x 18 in. (61 x 45.7 cm); paper size: 30 x 22 in (76.2 x 55.9 cm)
Courtesy of the artist and Francine Seders Gallery

Paul D. Miller (aka DJ Spooky)
American, b. 1970
Manifesto for a People's Republic of Antarctica, 2011–12
Four archival inkjet prints
Each: 36 x 24 in. (91.4 x 60.9 cm)
Courtesy of the artist

Paul D. Miller (aka DJ Spooky)
American, b. 1970
Artisode 2.5/ DJ Spooky, 2010
DVD video, 3:05 minutes
Courtesy of KNME-TV, New Mexico PBS

Bruce F. Molnia
American
Muir Glacier, August 31, 2004
8 x 12 in. (20.32 x 30.48 cm)
Archival inkjet print
Courtesy of US Geological Survey/ Bruce F. Molnia

Anne Noble
New Zealander, b. 1954
Wilhelmina Bay, Antarctica, from *ICEBLINK,* 2005
Pigment print on paper
30 ¾ x 39 ¼ in. (78 x 100 cm)
Courtesy of the artist and Stills Gallery, Sydney

David Abbey Paige
American, 1901–1979
Halo; Wing of the Fokker airplane crashed on March 12, 1934
Oil on board
16 x 20 in. (40.6 x 50.8 cm)
Courtesy of The Ohio State University Archives, Papers of Admiral Richard E. Byrd, 455-53

William Parrott
American, 1843-1915
Mount Hood, Crimson Sunrise, c. 1895
Oil on canvas
37 x 33 in. (94 x 84 cm)
Whatcom Museum, Gift of Mildred Simonds, 1968.100.1

Jean de Pomereu
French, b. 1969
Fissure 2 (Antarctica) from *Sans Nom,* 2008
Archival inkjet print
42 x 50 ¾ in. (107 x 129 cm)
Whatcom Museum, Gift of the artist, 2013.17.1

Herbert Ponting
British, 1870–1935
Grotto in berg, Terra Nova *in the distance.* Taylor and Wright (interior), January 5, 1911
Platinum print made in 2009 from the original negative
31.50 x 22.83 in. (80 x 58 cm)
© Scott Polar Research Institute, University of Cambridge, England

Eliot Porter
American, 1901–1990
Noctilucent Clouds over Mount Baker, Washington, July 30, 1975
Dye-imbibition print
23 x 26 in. (58.4 x 66 cm)
Whatcom Museum, Gift of Safeco Insurance, a member of Liberty Mutual Group, and Washington Art Consortium, 2010.53
©1990 Amon Carter Museum of American Art, Fort Worth, Texas

Eliot Porter
American, 1901–1990
Livingston Island and Green Iceberg from Royal Vessel Hero, Antarctic Peninsula, March 19, 1976
Dye imbibition print
Framed: 16 x 20 in. (40.64 x 50.8 cm); image: 8 ⁵⁄₁₆ x 8 ³⁄₁₆ in. (21.11 x 20.79 cm)
Amon Carter Museum of American Art, Fort Worth, Texas

Alexis Rockman
American, b. 1962
Adelies, 2008
Oil on wood
68 x 80 in. (172.72 x 203.2 cm)
Collection of Robin and Steven Arnold

***Nicholas Roerich**
Russian, 1874–1947
Tibet Himalayas, 1933
Tempera on canvas
29 x 46 in. (74 x 117 cm)
Nicholas Roerich Museum, New York

Sir John Ross
British, 1777–1856
Snow Cottages of the Boothians, illustration *from Narrative of a Second Voyage in Search of a North-west Passage, and of a Residence in the Arctic Regions during the Years 1829, 1830, 1831, 1832, 1833.* London: A.W. Webster, 1835.
13 x 10 ¼ x 2 ¼ in. (33.02 x 26.04 x 5.72 cm)
Special Collections, University of Washington Libraries, Seattle, WA

Camille Seaman
Shinnecock tribe, b. 1969
Grand Pinnacle Iceberg, East Greenland, from the *Last Iceberg,* 2006
Ultrachrome archival inkjet print
26 x 80 in. (66.04 x 203.2 cm)
Courtesy of the artist and Richard Heller Gallery, Santa Monica

***Joseph Mallard William Turner**
British, 1775–1851
Mer de Glace, in the Valley of Chamouni, Switzerland, 1803
Watercolor and graphite with gum on wove paper
27 ¾ x 41 in. (70.6 x 103.8 cm)
Yale Center for British Art, Paul Mellon Collection/The Bridgeman Art Library

Jules Verne
French, 1828–1905
Voyages et aventures du Capitaine Hatteras. Les Anglais au pôle nord; Le Désert de glace (The Adventures of Captain Hatteras.The English at the North Pole; The Desert of Ice), Paris, J. Hetzel, 1867.
Illustrator: Edouard Riou
7 ¼ x 11 in. (18.5 cm x 27.7 cm)
Courtesy of Special Collections, Lemieux Library and McGoldrick Learning Commons, Seattle University

Spencer Tunick
American, b. 1967
Aletsch Glacier #4, Switzerland, 2007
Inkjet print on canvas
8 x 10 ft. (2.43 x 3.04 m)
Courtesy of the artist

Carleton E. Watkins
American, 1829–1916
Mount Shasta and Whitney Glacier in California, seen from the crater (Shastina), from US Geological Exploration of the 40ᵗʰ Parallel (King Survey), 1870, printed 2013
Black-and-white photograph
12 x 18 in. (30.48 x 45.72 cm)
Courtesy of the US Geological Survey

Arthur Oliver Wheeler
Canadian, 1860–1945
Athabasca Glacier, Jasper National Park, 1917, printed 2013
Black-and-white photograph
14 x 20 in. (35.6 x 50.8 cm)
Courtesy of the National Archives of Canada

Edward Oliver Wheeler
Canadian, 1890–1962
West Rongbuk Glacier, 227°59'17"N, 86°55'31"E, 1921, printed 2013
Black-and-white photograph
18 x 90 in. (45.7 x 228.6 cm)
Courtesy of Royal Geographical Society, London
Location: Northern Slope of Mount Everest, 29,028 ft. (8,847.7 m), Tibet, China
Range: Mahalangur Himal
Elevation of glacier: 17,300–20,341 ft. (5,273– 6,200 m); average vertical glacier loss: 341 ft. (104 m), 1921–2008

Edward Adrian Wilson
British,1872–1912
Paraselene January 15, 1911, 9:30 pm Cape Evans McMurdo Sound, illustration from *Robert Falcon Scott's Last Expedition,* 1912
9 ½ x 6 ½ in. (24.2 x 16.5 cm)
Private collection

WILDERNESS

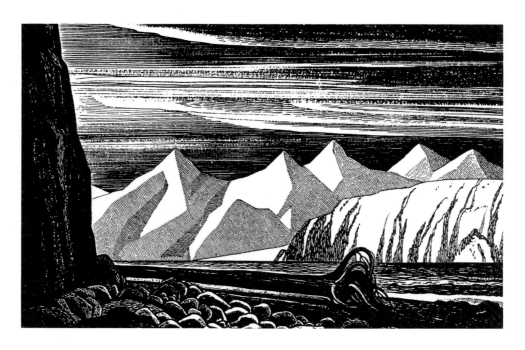

A JOURNAL OF QUIET ADVENTURE
IN ALASKA

BY ROCKWELL KENT

INCLUDING EXTENSIVE HITHERTO UNPUBLISHED
PASSAGES FROM THE ORIGINAL JOURNAL

PUBLISHED BY THE WILDERNESS PRESS AND
DISTRIBUTED BY THE WARD RITCHIE PRESS
LOS ANGELES · CALIFORNIA

BIBLIOGRAPHY

Adams, Ansel, and John Szarkowski. *The Portfolios of Ansel Adams*. Boston: Little, Brown/Bulfinch, 1977.

Adamson, Jeremy, Katerina Atanassova, Steven N. Brown, Lucie Dorias, Charles C. Hill, Joan Murray, Roald Nasgaard, Dennis Reid, David P. Silcox, and Shirley L. Thomson. *Canadian Art: The Thomson Collection at the Art Gallery of Ontario*. Toronto: Skylet, 2008.

Agassiz, Louis, and Albert V. Carozzi. *Studies on Glaciers: Preceded by the Discourse of Neuchâtel*. New York: Hafner, 1967.

Andres, Alberto de. *Alpine Views: Alexandre Calame and the Swiss Landscape*. Williamstown, MA: Sterling and Francine Clark Art Institute; New Haven: Distributed by Yale University Press, 2006.

Andrews, Lynne. *Arctic Eye: The Visual Journey*. Mount Rumney, Tasmania: Studio One, 2007.

Arnold, H. J. P., and Herbert George Ponting. *Photographer of the World: The Biography of Herbert Ponting*. London: Hutchinson, 1969.

Ashworth, William B. Jr. *Ice: A Victorian Romance, An Exhibition of Rare Books from the Collection of the Linda Hall Library*. Kansas City, MO: 2008. http://www.lindahall.org/events_exhib/exhibit/exhibits/ice/index.shtml.

Aunet, Léonie, d'. *Voyage d'une femme au Spitzberg*, 3ed. Paris, 1867.

Baigell, Matthew. *Albert Bierstadt*. New York: Watson-Guptill, 1981.

———. *Thomas Hart Benton*. New York: Abrams, 1973.

Banerjee, Subhankar. *Arctic Voices: Resistance at the Tipping Point*. New York: Seven Stories Press, 2012.

———. *Seasons of Life and Land: A Photographic Journey by Subhankar Banerjee*. Seattle: The Mountaineers Books, 2003.

Barth, Nadine, ed. *Vanishing Landscapes*. Frances Lincoln, 2008.

Beattie, Andrew. *The Alps: A Cultural History*. New York: Oxford University Press, 2006.

Becker, Olaf Otto, Freddy Langer, and Konrad Steffen. *Above Zero*. Ostfildern: Hatje Cantz, 2010.

Berton, Pierre. *The Arctic Grail: The Quest for the North West Passage and the North Pole, 1818-1909*. New York: Viking Penguin, 1988.

Boime, Albert. *The Magisterial Gaze*. Washington and London: Smithsonian Institution Press, 1991.

Borsch-Supan, Helmut. *Casper David Friedrich*. New York: George Braziller, 1974.

Bourrit, Marc Theodore. *A Relation of a Journey to the Glaciers in the Dutchy of Savoy, 1775*. Translated from the French by C. and F. Davy. Norwich: Richard Beatniffe, 1775, from Miall, David. S and Duncan Wu. *Romanticism: The CD-ROM*. Oxford: Blackwell, 1997.

Braasch, Gary. *Earth under Fire: How Global Warming Is Changing the World*. Berkley: University of California Press, 2007.

Bradford, William. *The Arctic Regions, Illustrated with Photographs Taken on an Art Expedition to Greenland*. 1873. Facsimile of the first edition, edited by Michael Lapides. Boston: David R. Godine, in association with the New Bedford Whaling Museum, 2013.

Breashears, David. *High Exposure: An Enduring Passion for Everest and Unforgiving Places*. New York: Simon & Schuster, 1999.

Brinkley, Douglas. *The Quiet World: Saving Alaska's Wilderness Kingdom, 1879–1960*. New York: HarperCollins, 2011.

Buckland, David, MacGilp, Ali, and Parkinson, Sîon, eds. *Burning Ice: Art and Climate Change*. London: Cape Farewell, 2006.

Carr, Gerald L. *Frederic Edwin Church: The Icebergs*. Dallas: Dallas Museum of Art, 1980.

Chambonniere, Sophie and Studievic Helene, eds. *Ferdinand Hodler: Le paysage*. Paris: Somogy editions d'art, 2003.

Coleridge, Samuel Taylor. *The Annotated Ancient Mariner: The Rime of the Ancient Mariner*. New York: Bramhall House, 1965.

Conway, Sir Martin. *No Man's Land: A History of Spitsbergen from Its Discovery in 1596 to the Beginning of the Scientific Exploration of the Country*. Mansfield Centre, CT: Martino Publishing, 2005.

Cooke, Alan and Clive Holland. *The Exploration of Northern Canada, 500 to 1920: A Chronology*. Toronto: Arctic History Press, 1978.

Cosgrove, Denis and Veronica della Dora, eds. *High Places: Cultural Geographies of Mountains, Ice and Science*. London: I.B. Tauris, 2009.

Costello, Peter. *Jules Verne: Inventor of Science Fiction*. New York: Scribner, 1978.

Decker Julie. *True North: Contemporary Art of the Circumpolar North*. Anchorage: Anchorage Museum, 2012.

Dee, Elaine Evans. *To Embrace the Universe: Drawings by Frederic Edwin Church*. New York: The Hudson River Museum at Yonkers, New York, 1984.

Downie, David L., Kate Brash, and Catherine Vaughan. *Climate Change: A Reference Handbook*. Santa Barbara, CA: ABC-CLIO, 2009.

Euclaire, Sally. *The New Color Photography*. New York: Cross River Press, 1981.

Fagan, Brian, ed. *The Complete Ice Age: How Climate Change Shaped the World*. New York: Thames and Hudson, 2009.

———. *The Great Warming: Climate Change and the Rise and Fall of Civilizations*. New York: Bloomsbury Press, 2008.

Fels, Thomas Weston. *Fire and Ice: Treasures from the Photographic Collection of Frederic Church at Olana*. New York: Dahesh Museum of Art and Cornell University Press, 2002.

Ferris, Scott R. and Ellen Pearce. *Rockwell Kent's Forgotten Landscapes*. Camden, ME: Down East Books, 1998.

Fox, William L. *Terra Antarctica: Looking into the Emptiest Continent*. San Antonio, TX: Trinity University Press, 2005.

Gage, John. *J.M.W. Turner: A Wonderful Range of Mind*. New Haven: Yale University Press, 1987.

Gamble, Cynthia. "John Ruskin, Eugene Viollet-le-Duc and the Alps." *The Alpine Journal*, 1999.

Gorner, Veit and Eveline Bernasconi, eds. *Issac Julien: True North, Fantome Afrique*. Kestnergesellschaft, Hannover: Kestnergesellschaft, 2006.

Gunnarsson, Torsten. *Nordic Landscape Painting in the Nineteenth Century*. New Haven: Yale University Press, 1998.

Gunnarsson, Torstem, et al. *A Mirror of Nature: Nordic Landscape Painting 1840–1910*. Denmark: Narayana Press, 2006.

Harris, Bess, ed. *Lawren Harris*. Toronto: Macmillan, 1969.

Harris, Lawren. *North by West: The Arctic and Rocky Mountain Paintings of Lawren Harris 1924–1932*. Calgary: Glenbow Museum, 1991.

Hartmann, Hans and Röthlisberger, Marcel. *The Alps in Swiss Painting*. Chur: Verlag Bündner Kunstmuseum, 1977.

Harvey, Eleanor Jones. *The Voyage of the Icebergs: Frederic Church's Arctic Masterpiece*. Dallas: Dallas Museum of Art, 2002.

Hendricks, Gordon. *Albert Bierstadt: Painter of the American West*. New York: Abrams, 1974.

Henson, Matthew A. *A Black Explorer at the North Pole: An Autobiographical Report by the Negro Who Conquered the Top of the World with Admiral Robert E. Peary*. New York: Walker and Company, 1969.

Hill, Charles C. *The Group of Seven: Art for a Nation*. Toronto, Ont: McClelland & Stewart, 1995.

Horch, Frank. "Photographs and Paintings by William Bradford." *American Art Journal* 5, no. 2 (Nov. 1973): 61–70.

Howat, John K. *Frederic Church*. New Haven and London: Yale University Press, 2005.

Imbert, Bertrand. *North Pole, South Pole: Journeys to the Ends of the Earth*. New York: Abrams, 1992.

Imhof, Patrizia. "Glacier Fluctuations in the Italian Mount Blanc Massif from the Little Ice Age Until the Present." Master's thesis, University of Bern, 2010. www.climatestudies.unibe.ch/students/theses/msc/33.pdf.

Jacobs, Michael. *The Painted Voyage: Art, Travel, and Exploration 1564–1875*. London: Published for the Trustees of the British Museum by British Museum, 1995.

Junker, Patricia A. *Albert Bierstadt: Puget Sound on the Pacific Coast: A Superb Vision of Dreamland*. Seattle: Seattle Art Museum in association with University of Washington Press, 2011.

Kelly, Franklin, Stephen Jay Gould, James Anthony Ryan, and Debora Rindge. *Frederic Edwin Church*. Washington: National Gallery of Art, 1989.

Kent, Rockwell. *The Mythic and the Modern*. Manchester: Hudson Hills Press, 2005.

———. *Wilderness: A Journal of Quiet Adventure in Alaska*. Los Angeles: Wilderness Press and War Ritchie Press, 1970.

Kilian, Bernhard. *The Voyage of the Schooner Polar Bear: Whaling and Trading in the North Pacific and Arctic, 1913–1914*. New Bedford, MA: Old Dartmouth Historical Society and the Alaska Historical Commission, 1983.

Kilkenny, Ann-Marie Amy. "Life and Scenery in the Far North: William Bradford's 1885 Lecture to the American Geographical Society." *American Art Journal* 26, no. 1/2: 106–8.

King, Clarence. *Mountaineering in the Sierra Nevada*. New York: Scribner's, 1902.

Klipper, Stuart D. *The Antarctic: From the Circle to the Pole*. San Francisco: Chronicle Books, 2008.

Kolbert, Elizabeth. *Field Notes from a Catastrophe: Man, Nature, and Climate Change*. New York: Bloomsbury USA, 2006.

Krause, Reinhard A. and Lars U. Scholl. *The Magic of Antarctic Colours*. Bremerhaven, Germany: H.M. Hauschild GmbH, Bremen, 2004.

Kugler, Richard C., et al. *William Bradford: Sailing Ships and Arctic Seas*. Seattle and London: University of Washington Press, 2003.

Larisey, Peter. *Light for a Cold Land: Lawren Harris's Work and Life: An Interpretation*. Toronto: Dundurn Press, 1993.

Linder, Chris. *Science on Ice: Four Polar Expeditions*. Chicago: The University of Chicago Press, 2011.

Lopez, Barry Holstun. *Arctic Dreams: Imagination and Desire in a Northern Landscape*. New York: Scribner's, 1986.

Lynch, Lawrence. *Jules Verne*. New York: Twayne Publishers, 1992.

Macfarlane, Robert. *Mountains of the Mind*. New York: Pantheon Books, 2003.

Marsh, Joanna. *Alexis Rockman: A Fable for Tomorrow*. Washington, DC: Smithsonian American Art Museum, 2010.

Matilsky, Barbara. *Fragile Ecologies: Contemporary Artists' Interpretations and Solutions*. New York: Rizzoli, 1992.

———. "Francois-Auguste Biard: Artist-Naturalist-Explorer." *Gazette Des Beaux-Arts*, February 1985.

———. "Sublime Landscape Painting in Nineteenth Century France: Alpine and Arctic Iconography and Its Relationship to Natural History." Michigan: University Microfilms International, 1983.